Decentring Dancing Texts

Decentring Dancing Texts

The Challenge of Interpreting Dances

Edited by

Janet Lansdale

palgrave
macmillan

First published in 2008 by
PALGRAVE MACMILLAN
Houndmills, Basingstoke, Hampshire RG21 6XS and
175 Fifth Avenue, New York, N.Y. 10010
Companies and representatives throughout the world.

PALGRAVE MACMILLAN is the global academic imprint of the Palgrave
Macmillan division of St. Martin's Press, LLC and of Palgrave Macmillan Ltd.
Macmillan® is a registered trademark in the United States, United Kingdom
and other countries. Palgrave is a registered trademark in the European
Union and other countries.

ISBN-13: 978–0–230–54259–4 hardback
ISBN-10: 0–230–54259–X hardback

This book is printed on paper suitable for recycling and made from fully
managed and sustained forest sources. Logging, pulping and manufacturing
processes are expected to conform to the environmental regulations of
the country of origin.

A catalogue record for this book is available from the British Library.

Library of Congress Cataloging-in-Publication Data

Decentring dancing texts : the challenge of interpreting dances /
edited by Janet Lansdale.
 p. cm.
Includes bibliographical references and index.
ISBN-13: 978–0–230–54259–4 (alk. paper)
ISBN-10: 0–230–54259–X (alk. paper)
 1. Choreography – Cross-cultural studies. 2. Dance – Cross-cultural
studies. I. Lansdale, Janet.

GV1782.5.D43 2008
792.8′2—dc22 2008015941

Printed and bound in Great Britain by
CPI Antony Rowe, Chippenham and Eastbourne

Contents

Preface

The contributors to this text have all benefited from engaging in conversations, debates and conference presentations, in various ways and at various times, and in various countries where we have able to present versions of this material and we are grateful to colleagues for their contributions to the evolution of these essays.

The University of Surrey Department of Dance Studies bi-annual research seminars for doctoral students and staff have been particularly productive in generating stimulating debate and clarifying ideas in these and other areas over an extended period of time.

It is timely for me to acknowledge a great debt of gratitude to the many generations of postgraduate students, and the many academics, who have shared my journey over some twenty five years. Some are represented here – all remain warmly in the memory.

As editor, I wish to thank the contributors for the pleasure of this intellectual engagement, in many cases of long standing. Edited texts are notoriously difficult to bring to fruition but this one has had prompt and willing cooperation from its contributors.

JANET LANSDALE (*formerly Adshead*)
Emeritus Professor
Department of Dance Studies
University of Surrey

Professorial Research Fellow
School of Oriental and African Studies
University of London

Notes on the Contributors

Toni D'Amelio trained as a dancer in North America then moved to Europe to dance and to pursue undergraduate and postgraduate study in Paris. She obtained her PhD from the University of Surrey for a thesis on ghost bodies in French contemporary dance. She lectures at London Metropolitan University and teaches in Paris.

Alexandra Carter is Professor in Dance Studies at Middlesex University, London. She has edited two books, *The Routledge Dance Studies Reader* (1998) and *Rethinking Dance History* (2004). Her book *Dance and Dancers in the Victorian and Edwardian Music Hall Ballet* was published in 2005. In addition to exploring the interface between popular culture and ballet, her recent research interests focus on debates in historiography and their relationship to dance studies.

Dr Deveril has an MA and a PhD in Dance from the University of Surrey. Since doing an MA in Screen Arts at the Northern Media School, he has been teaching children how to make films while practising the art himself, as an editor, director and writer. He has worked with the choreographer Litza Bixler since 1999 and together they made *Heart Thief* in 2003 for Channel 4.

Dr Sherril Dodds is a Senior Lecturer at the University of Surrey. Her teaching and research interests lie in popular dance, dance on screen and cultural theory. She published *Dance on Screen: Genres and Media from Hollywood to Experimental Art* in 2001 and contributed to *Dance in the City* (1997), *Dancing Texts* (1999), *Music, Sensation and Sensuality* (2002), *Indeterminate Bodies* (2003) and *Anarchic Dance* (2005).

Joanna Louise Hall is a Senior Lecturer at the Royal Academy of Dance. In 2002 she gained an MA in Dance Studies from the University of Surrey, where she is currently completing doctoral studies, supported by the Arts and Humanities Research Council. Her research analyses vernacular dance practices in English Drum 'n' Bass club culture and presents the dance floor as a site for the construction, reiteration and appropriation of racial and class based corporealities.

Janet Lansdale is Emeritus Professor in dance studies at the University of Surrey. She was Head of Department and then Head of the School of

Performing Arts between 1992 and 2002, initiating a large doctoral programme. She is also Professorial Research Fellow at the School of Oriental and African Studies, University of London. She has published books on *The Study of Dance* (1981); *Dance Analysis* (1986); *Dance History* (1983; 1994), on intertextuality in interpretation in *Dancing Texts* (1999) and a full-length interpretive study in *The Struggle with the Angel: A Poetics of Lloyd Newson and DV8s Strange Fish* (2007).

Janet O'Shea is a Reader in dance studies at Middlesex University. She holds an MA in Tamil and South Asian Studies from the University of Califurnia, Berkeley and a PhD in Dance History and Theory from University of California, Riverside. Her articles have appeared in *The Drama Review, Dance Research Journal* and *Asian Theatre Journal*. She has recently published a monograph on twentieth-century *bharata natyam*, *At Home in the World: Bharata Natyam on the Global Stage* (2007). In addition to investigating the politics of representation in *bharata natyam* and contemporary South Asian dance, O'Shea's recent research focuses on dance festival programming.

Daniela Perazzo Domm has a PhD in dance studies from the University of Surrey, where she lectures in *Arts and Society* and *Critical Theory and Analysis*. In 2004 she was awarded an MA in Performance and Culture from Goldsmiths College, University of London. Her main interests lie in the analysis and criticism of contemporary experimental dance. Current research looks at strategies of signification and the reconfiguration of choreography in the work of Jonathan Burrows. She has presented at international conferences and published in dance periodicals in the UK and Italy (*Dance Theatre Journal, Danza & Danza*).

Giannandrea Poesio is Senior Lecturer and Head of theatre studies and performing arts at London Metropolitan University. He started writing on dance after a brief performing career. In 1990 he moved to the UK, where he received a PhD in dance history at the University of Surrey. He is dance critic for *The Spectator* and chairman of the European Association of Dance Historians. His publications include four entries in Martha Bremser's *Fifty Contemporary Choreographers* (2000), the chapter on Italy in *Europe Dancing* (ed. A. Grau and S. Jordan, 2000) and *Enrico Cecchetti, an Artist in Context* (2007).

Henia Rottenberg is a Lecturer in relationships between dance and the arts and dance history at the Kibbutzim College of Education, Israel. She was awarded a PhD from the University of Surrey for her thesis 'Hybrid Relationships between Dance and Painting', focussing on the

work of Lea Anderson. Her main research interests are in aesthetic ideas and discourses related to relationships between dance and painting. She is currently writing a book on dance.

Lorna Sanders is based at the School of Oriental and African Studies, University of London, where she is a research assistant on a cross-college interdisciplinary research group on issues of embodiment. She was awarded a PhD from the University of Surrey on 'Dance Education Renewed' and has published two books: *Akram Khan's Rush: Creative Insights* (2004) and *Henri Oguike's Front Line* (2004). Her main research interests are in analytical issues, hybridity and cross-cultural contemporary dance forms.

Acknowledgements

The authors, editor and publisher wish to thanks the following for permission to reproduce copyright material.

Illustrations

1 Chris Nash for Shobana Jeyasingh Dance Company in *Phantasmaton* (chapter 3)
2 Damian Chapman for Akram Khan Dance Company in *ma* (chapter 4)
3 Jonathan Burrows and Matteo Fargion, *Both Sitting Duet* (chapter 8)

Interview material

Jonathan Burrows and Matteo Fargion for *Both Sitting Duet* (Chapter 8)

1
Intertextual Narratives in Dance Analysis

Janet Lansdale

Past and present

My aim in bringing together the essays that comprise this volume is to clarify the conceptual landscape of intertextuality in dance and to explore what I regard as a potentially rich set of analytic methods which take into account its relationship with hypertextuality.[1] Interestingly, Landow's proposal that hypertext is indeed essentially an intertextual system opens up a methodology that is 'a rich means of testing' claims to openness in an information systems world (1997, p. 36). To test such claims the analytical links between materials have to be made visible – the materials themselves lose their connection with an individual and become texts within a new discourse. Paradoxically such a discourse is still one constructed by a particular author; hence the interest in authorial position and research method in each of these chapters.

There is a concern in all the essays not just with a narrative of the past, in terms of time period, but with the specificity of historical moments and the cultural traces embedded in them. While the contributors are concerned with how we construct narratives of the social and artistic past, whether as artists or as scholars or readers, they also focus on the present, the *fin de siècle*, the turn of the millennium. It is quite an extensive past that we draw into this present from pre-Christian European and Asian cultures to 2007.

If time is one significant dimension in this book, geography is another. These essays explore dance from Sweden in the far north, from India, and from England, Belgium and France; however, the geographical spread, while extensive, is not as comprehensive as that of time. There is nothing of Africa here or of the Americas or the Pacific Rim, of the Far East, Indonesia, Japan or Korea. The focus is on contemporary

dance forms of the turn of the twentieth century into the twenty-first as we find them performed in England, and to some extent across Europe. For instance, the work of Khan and Jeyasingh reflects the impact in the latter part of the twentieth century of aspects of Indian culture deriving initially from colonisation, but embodied and re-embodied in England through immigration and cultural association. Essentially, we consider how European culture has been inflected and changed by Asian arte-facts and populations. In another dimension, chapter 6 on Jérome Bel and Loïc Touzé reveals deep differences between art philosophies and dance practices in countries separated only by the English Channel.

The critical focus

No text of this kind can be comprehensive; nor should it aim to be. Crucially, a narrow focus allows greater depth of analysis of current work and consideration of the way these examples interact, if not directly on the stage then in their concerns and in those of contempo-rary scholarship. A network of overlapping themes permeates this book, constructing a finely woven tapestry. We address diversity and differ-ence on a small scale, since it is through such specificity that sustained and convincing analysis can operate.

In order to address the diversity and difference readily apparent across selected works and choreographers, the contributors draw on a number of theoretical positions and methodological procedures. It is another thread of this deliberately intertextual approach that theory, like the practice on which it comments, has to be chosen for its appropriateness to the questions addressed and the work studied. The aspects of inter-textual theorising in parts of the book are distinct. Positions arising from intertextuality and hypertextuality have been associated with both negative and positive developments. A welcome freedom, or too much freedom in interpretation; a subversive opportunity or superficial fantasy as the individual creates her/his own response to art, tracking whatever ideas s/he chooses, on the web or in writing, without interfer-ence or control by others.

A significant question in this enterprise is to ask what kind of narra-tives operate in analysis and how they are constructed or, to put it another way, what kinds of logic drive the construction of argument. How are intertextual systems used and what kinds of narratives result from these processes? Intertextuality allows an explicit delineation of the shape of discourse, of its organisation, of the voices that contribute to it, and the mode in which these voices function. In itself, it rests on the

invocation of references to earlier cultural positions, pre-existing icons, previously developed genres, settings for performance and other dominant performance modes.[2] It encourages a 'transient, restless self, a multiply-positioned subject' who is constantly aware of the meta-narrative implications of adopted narrative courses (Meyer, 2000, p. 145).[3] Irony, parody and ambiguity – the result of unravelling potentially contradictory threads – are common in the intertextual landscape.[4]

Decentring, a key term in the title of this book, has multiple connotations. It can suggest *either* that there is no centre to an act of dance or theatre or its theorising, or this book as a whole, *or* that it is possible to refer in many directions simultaneously. It may imply that there are *many* centres or perhaps *none* at all. In this ambiguity lies one of a number of reasons for selecting decentring both for this book and, prior to it, for a recently completed Arts and Humanities Research Board-funded project,[5] which focused on intertextuality and hypertextuality.[6] These three terms – decentring, intertextuality and hypertextuality – are richly problematic. Each has a history linked to an equally problematic set of ideas of 'text'. Together, they frame the particular notion of dance analysis explored here. Decentring should not, in this instance, be equated with incoherence, but with difference and diversity and, furthermore, should be seen in the context of poststructuralist theory.

Poststructuralism challenges certainties of meaning arising, in our case, from, and in, dance. It invites constructions of how multiple meanings might be created in a particular set of performance circumstances, as experienced by a particular individual. Roland Barthes, in making a distinction between 'work' and 'text', talks of the 'displacement' of 'previous categories' and of the 'text' as a 'methodological field' and as discourse, not object (Barthes, 1977, p. 157). While the work is held in the hand, 'the text is held in language: it exists only as discourse' (trans. Harari, 1979, p. 157). He goes on to say: 'thus is the Text restored to language: like language, it is structured but off-centered, without closure' (Barthes, 1979, p. 159).[7] Additionally, clarifying its relationship to intertextuality, he argues that 'every text, being itself the intertext of another text, belongs to the intertextual' (Barthes, 1979, p. 77). The complexity and ambivalence of this statement is indicative of the debates underpinning the essays that follow.

In dance, the artistic and cultural practices we address here, the emergence of the idea of decentring, can be located first of all in the work of the choreographer Merce Cunningham, who famously 'decentred' the dancing space so that the spectator no longer had a clearly directed, or singular, if shifting, focus. Neither, of course, did the dancers. The

creation of multiple spatial perspectives on the dancing stage, from both the performers' and the spectators' viewpoint, can be seen therefore to have a history dating from the 1950s.[8] Multiplicity of perspective is also evident in the independent conception and, therefore, random relationships, between movement, sound, and design, all of which could be independently conceived in Cunningham's collaborations. This logic entails that each element might subsequently direct the spectator's attention differently.[9] Together – or simply existing side by side – they create 'an open field'. This idea was followed not only by Cunningham, but by other American choreographers in the 1950s, revealing a shared concept or sensibility that extended beyond dance into the visual arts and music (Hodson, 1987). It has continued to influence avant-garde or postmodernist dance forms ever since, notably through the Judson Dance Theatre and its inheritors (Banes, 1993).

Cunningham's multiple spatial perspectives invite a constantly shifting perception of line, direction and shape on the part of the audience, which, by analogy, also offer the potential for *a response* based on diverse (and multiple) critical perspectives. Indeed, such work, one might argue, *demands* a set of diverse critical positions to match its own processes.[10] Dance theory throughout the twentieth century largely ignored political and cultural change, clinging to a modernist inheritance. It tended to develop expressionist accounts, particularly in writings on modern dance, in order to emphasise the relevance and power of the Graham/ Humphrey inheritance.[11] In contrast, both formalist and abstract expressionist accounts highlighted unique and distinctive qualities of movement on which an argument about the intrinsic value of dance might rest.[12] This is the approach most usually used in discussion of Cunningham's work, although some critics also find, for example, 'images of human volition and passion' (Jowitt, 1994, p. 174).[13] The resulting dislocation from wider cultural change, it might be argued, often led to a mystified response, as well as slow acceptance and understanding, of dance-making such as Cunningham's.

The perspectives that were pursued, one might argue erroneously, in discussion of his work, relied on fairly obvious parallels with artists working in other forms, namely with the visual arts, often drawing on the work of Jackson Pollock, Robert Rauschenberg and Jasper Johns, and with new music of the time, notably by John Cage and David Tudor. This is hardly surprising, nor is it necessarily a matter for criticism, but these similarities were often barely pursued beyond a superficial reference.[14] It might be argued that the common cultural and historical moment gives some justification for seeking parallels both among

practitioners within a particular art and across the arts, yet artists may also be proceeding along different tracks, even while sharing certain presuppositions. It now seems that Cunningham, in many respects, was not operating in the same sphere, but diverging in ways of his own.

It is short step from Cage's and Cunningham's encouragement to the audience to perceive several things at once to a critical framework based in poststructuralist thinking; but strangely one that even now has barely been articulated. Critical theory in dance has taken a long time to catch up with Cunningham's revolutionary stance of the 1950s. The classical principles of unity and variety along certain well-defined lines (e.g. variety of dynamic) remain entrenched, supporting classical and modernist value systems still apparent even in much new dance practice and dance writing.[15] There are exceptions, and increasingly a major shift in scholarship is evident in the latter part of the twentieth century, for example in the writings of Ann Daly, Jane Desmond, Susan Foster and Susan Manning.

The timeliness of Cunningham's artistic and theoretical position can be explained, if by extrapolation, through Jacques Derrida's writing on the human sciences. Derrida argues that such positions could only have come into being

> at the moment when a decentering had come about: at the moment when European culture – and, in consequence, the history of metaphysics and of its concepts – had been *dislocated*, driven from its locus, and forced to stop considering itself as a culture of reference.
> (Derrida, 1978, p. 356)[16]

In other words, Derrida places the decentring movement in the widest possible political context, in a world that we increasingly acknowledge is no longer controlled by Europe, and is becoming less and less so by the United States. To an extent the essays included here, written at the beginning of the twenty-first century, take this new critical landscape for granted. In this brave new world we cannot escape our history or refuse sensitivity to our past, either personal or political, any more than we can escape our cultural positioning locally, whether as creators of dance or as authors of texts about dancing.

Theoretical frames

These essays, therefore, read the present in terms of the past, quite self-consciously; and in reverse, the past in terms of the present, as a

demonstration of the problem of devising appropriate modes of analysis. For the process of analysis to be thorough and insightful, an understanding of the many contexts of a dance – that is, its immediate dance context and how this appears within the work, as well as the wider artistic framing and sub-cultural context – is always necessary. The world of high modernism, real or imagined, has receded from the central place it once occupied for artists, critics and scholars, moved aside in favour of forms of analysis that take account of this cultural and historical positioning, making it doubly complex. Analysis is always equally concerned, on the other hand, with the internal workings of dances, since otherwise it would not be *dance* analysis, but analysis of something else. By virtue of the works the contributors choose to address in these essays, and through each specific mode of address, processes of analysis can be refined. As a result we create highly specific methodologies appropriate to the issues and questions. Since these debates are raised in relation to distinctive, even unique, events, the form of the analysis in each case is uniquely tailored to its subject.

As part of the consequence of decentring, a simplistic distinction between the 'author', 'text' and 'reader' ceases to be helpful, as Ott and Cameron suggest, although, paradoxically, they then resist the idea. They argue that the use of intertextuality as a 'stylistic device' (commonly through 'parodic allusion, creative appropriation, and self-reflexive reference', 2000, p. 429) is weakened by its conflation with intertextuality as an audience practice.[17] The different rhetorical processes of creating work and being spectator to it are left unformulated. In this book we make the relationship between the researcher and the dance makers an object of study so that the distinction might have greater subtlety. In addition, Ott and Cameron's argument is based on the use of intertextuality in media scholarship, where it is restricted to a few pre-identified sources.[18] Such discussion, while called intertextual, may merely be a form of source criticism and not a form of intertextuality at all.[19] In returning to the relationship between text and reader, Ott and Cameron helpfully focus on the contribution intertextual readings make to the construction of a distinctive and personal postmodern identity by 'marking membership in particular cultures' (2000, p. 440). Further, they emphasise an 'aggregative rather than a sequential way of seeing and knowing' (2000, p. 441); a non-linearity reminiscent of surfing the web, and therefore of hypertextuality, and a very different epistemology from that based on Greek culture.

The formalist theories of art typical of high modernism tie in closely with structuralist philosophy, and share a drive towards a type of

scientific objectivity, encapsulated in the emphasis on the medium, movement and notions of structure. Meaning on this view is held within the frame of universal and previously existing structures, and operates through a clearly defined system of codes and sub-codes. It is based on the use of language in everyday communication.[20] This obsession with systems, it is often stated, has led to neglect of the dynamics of signification and the role of the reader in creating meaning. Although semiotics offers analysis of a full range of human behaviour it, too, tends to control the possible readings of these acts of communication.[21] This model has been extensively reworked for the study of performance by de Marinis (1993), who rejects a purely linguistic model for analysis of acts of theatre. Instead, he conceives of theatrical performance as

> a complex discursive event, resulting from the interweaving of several expressive elements, organised into various codes and subcodes (which together constitute a textual structure) through which acts of communication and signification take place, while also taking into account the different pragmatic contexts of enunciation.
>
> (de Marinis, 1993, pp. 1–2)

Although de Marinis is attracted to the idea of a scientific theory and even to a socio-biological approach, he also characterises the act of performance, and of reading, as one in which 'communicative strategies are played out' (1993, p. 48). In sum, this is a set of theories that appears to hover over a structuralist and poststructuralist agenda.

Some writers on Cunningham, whose reception has always hovered in this way, see clearly that his improvisatory movement is not an attempt to return to 'nature', which would again reinforce a biological argument.[22] When a return to nature is combined with an ideal of sincerity of expression, manifest in the total unity of the contributing arts, the dangers are obvious.[23] Copeland, for example, aligns Cunningham more closely with Brecht, pointing to a shared denial of the Wagnerian *Gesamtkunstwerk* than with Martha Graham. Brecht and Cunningham, it might be argued, work with the separation of elements and both welcome the 'disunity' that arises in the theatre, and in dance, from such a position. Here lies the start of a postmodern dance and theatre form, and a poststructuralist form of theorising that might support it.

The implications for narrative construction, in line with the arguments of this book, it may be argued, are that poststructuralist narrative, or *hypertext*, provides 'an infinitely recenterable system whose provisional point of focus depends upon the reader' (Landow, 1997, p. 36) – a

convincingly poststructuralist claim. While the *system* may be infinitely recentrable (although this is arguable), the content, or the material, of the dance has a continuity of existence. These materials do not prescribe a particular narrative, but they may control (in some senses) the number of diverse narratives it is possible to produce, the types of narrative and the forms they take. While decentring implies a displacement of the centre, it does not necessarily imply a total loss of direction or the absence of logic. Both intertextuality and hypertextuality place the emphasis more on relationships among things than on the things themselves. In similar vein, Worthen, writing on hypertextuality and performance of Shakespeare, suggests that 'contemporary dramatic performance takes place in the *intersections* between texts and bodies, writing and enactment, literature and theatre', although quite what this means is ambiguous (2002, p. 7; my emphasis). It is a common expression found within poststructuralist literature that events or meanings occur in gaps, in absences (a Derridean influence), in effect, in the relationship between states or objects. It points up the importance of the engagement of the participant in creating not only the discourse, but also the text of the dance itself.

Content and context

Deveril meets the challenge of hypertext head on in chapter 12, presenting a differently distributed text that opens the materials to many narrative constructions simply in consequence of its layout on the page. Deveril's position is complex and complicated. He is the creator of the *Heart Thief* with Litza Bixler, not as choreographer, but as collaborative analyst and film-maker, so the positions of author–text–reader are already slippery. He places texts in disconnected juxtapositions: texts relating to the process of making the work, conversations that occurred, motivations for choices; texts that reflect on his own role; texts that revisit two previous pieces of research; texts on the nature of narrative; texts on models of analysis and the role of the body; texts on the themes of *Heart Thief* and sources used in its creation; texts on how hypertextuality and intertextuality might be understood. There is neither beginning nor end to this chapter; its pages, and the blocks of content on them, might be placed in a very different order without damage. There is an absence of overarching narrative, an absence of the writer's voice. Or is there? What becomes evident is that the choice of texts in itself, however they are placed, is a kind of narrative construction or a presumption of meaningfulness that is the author-function.

It may be that inter-/hypertextuality simply complicates direction and logic by offering more possibilities, perhaps too many routes, more threads to unravel and create than the human mind can encompass. Landow's notion of the 'network', and its analogies of 'interweaving', of 'web' and 'path' (1997, p. 43), are common threads in writings on hypertextuality and intertextuality, which open up the created materials to this non-linearity, a crucial component of poststructuralist thinking.[24] Worthen argues, however, like Eco on interpretive practice, that 'the choice of options is limited, and limited in ways that implicate the "author-function" of hypertext'.[25] As is widely evident, the selection of some words, as links, and not others is an authorial choice based on a process – a process capable of articulation. Worthen describes these links as far from finite, in fact as a fixed 'if exponentially large…number of journeys through the document'. The uses of hypertext, he argues, are 'governed by formal limits and rhetorical practices' (2002, p. 11).

The network constructed here has both geographical and historical parameters. The broadest time span across which traces are drawn appears in essays on two contrasting cultures, over almost equivalent time spans: the first is chapter 2, Alexandra Carter's study of Kenneth MacMillan's *The Judas Tree*, which refers to the story of Judas' betrayal of Christ, but in a version that came into existence as a ballet in the latter part of the twentieth century, in England on the stage of the Royal Opera House, itself a site of tradition of an artistic kind reaching back to the sixteenth century. Carter's essay is positioned early in the book, in part because the ballet is a work of modernist tendencies rather than postmodernist sensibilities. This work takes its abstract expressionism and attempt at social realism seriously. It explores the choreographer's obsession with female sexuality, as he demonstrated earlier in *Manon*, among others – an obsession that borders on gratuitous violence and intimidation of women, as many reviewers noted. Although created as late as 1992, and therefore after some of the other works analysed here, there is not a vestige of the irony or parody that typifies the postmodern. The context, subject matter, treatment and mood could not be more different, partly a consequence of genre, since the concerns of modern ballet were manifestly different from those of contemporary dance/theatre. The term modern, as distinct from classical or romantic, had only recently and rarely been attached to 'ballet' at this time.

In chapter 3 Janet O'Shea's discussion of Shobana Jeyasingh's contemporary choreography makes problematic the relationship between the dance that has come to be associated with the ancient and revered *Natya Shastra* (probably written between 200 BC and 200 AD) in India and late

twentieth-century European dance forms (which she began creating in 1988) based on *bharata natyam*. Again, the relationship between archaic narratives and two distinctive dance forms, of ballet and contemporary dance, is already complex, developing from political and religious storytelling of more than 2,000 years ago, into written text and then into performance. These narratives have been passed on and reinterpreted countless times by peoples of many diverse cultures across massive geographical spans and, indeed, across all arts. Their reinterpretation in England at the end of the twentieth century by Kenneth MacMillan and Shobana Jeyasingh reverberates with this rich cultural interweaving. Each has distinctive history and experiences, in life and in art; each carries traces from very different historical forms into the making of these new works, *The Judas Tree* (1992) and *Romance with Footnotes* (1993), respectively.

Any idea that it might be possible to retrace these steps with a degree of accuracy or veracity is clearly untenable, pointing to one of the features of intertextuality that makes is especially valuable in analysis. Such an approach allows the reader/critic/scholar to bring many separate threads into relationship, without a presumption of certainty that this one construction might be more valid than another, or that it must necessarily relate to the artist's process. However, this does not imply that any flight of fancy might be justified. These traces exist, albeit as new constructions, that are more or less convincing, or interesting, or appropriate, in the work being considered.

This reference to the past, and the method of drawing it into the present, can be supported through a type of theorising that recognises that our present is layered in complex ways with threads from other times. It is only with the advent of postmodernism that artists shed the modernist need to 'make it new', whether in abstract, expressionist or social realist modes. They consequently reconciled the historic tradition of their own art with themselves as *products* of it, while simultaneously becoming the *makers* of new work. The view of the artist as original creator, in some god-like sense, has dissipated in recent years, to accommodate both cultural and historical awareness in the construction of self, most notably in postcolonial studies such as O'Shea's.

Lorna Sanders, on Akram Khan (in chapter 4), invites a reconsideration of *kathak*, another traditional dance form of India, in a similar way, not to examine it as it might, or might not, ever have been performed originally, but seeing it as a new practice of the period from the early 1990s. In fact, neither artist attempts to recreate or reconstruct the dance of another time and place. Sanders introduces an element of

argument typical of our postmodernist times, that we face a construction of layers of culturally disparate materials, whether in social, political or personal life. Sanders makes these layers visible in her analysis of *ma* (2004), by exposing its overlapping texts of dance, music, history, politics and globalised arts. Both Jeyasingh and Khan are artists of the late twentieth century, working in England, but with dancing feet planted in a huge cultural history; a history that, in one sense, is that of England and its colonial past, and in another, that of a parallel and long-standing South Asian world. They take flight and are no longer grounded, given a new freedom to explore the interwoven texts of life and art, past and present, in England and in India.

Giannandrea Poesio's essay on Mats Ek (chapter 5) has a tighter geopolitical frame, showing how narrative texts of mid-nineteenth-century ballet have been resurrected, modified, challenged and reworked in the mid- to late twentieth century to create a tapestry of dances which shift context, genre and form to create Expressionist modern dance. While each speaks to its own times, Ek's work is loaded with poetic references to twentieth-century intellectuals and political activists, such as Sigmund Freud and Karl Marx, and a century of violence and political tension among nation-states. It is also a clear example of the later emergence of postmodernism in its challenge to ideas of an original text, its contestation of hierarchical value systems, ideas of individual originality and ownership. Where we used to have new versions of *Swan Lake* which deviated little from a supposed Petipa/Ivanov original, acknowledging their inheritance from it, preferably remaining as close to the text as possible, we now have a form of choreographic revisionism. *Swan Lake* in Matthew Bourne's version, first performed in December 2004 at Sadler's Wells then taken to the West End, is itself a sometimes satirical commentary on previous versions, and not a reincarnation of them.

In chapter 6 Toni D'Amelio examines subtleties of significance within notions of premise and *prémisse* (English and French) as illuminated in the works of Bel and Touzé. She shows that despite the similarity of linguistic origin, the contemporary directions that these terms take in England and France diverge. She returns to questions that we are suspicious of these days – generalisations about what characterises nations – in this case 'French' and 'English', in habits of thought as well as artistic practice. Cultural difference on the most minutely specific scale is on view here in the fine detail of these new dance works. Difference in attitude and use of the medium of dance, in economic positioning of dancers, in ideas and buildings, about the relationship between individual and collective, abound.

My own essay on *Fugue* (chapter 7), while concerned with a conceptual span of only a few centuries rather than millennia, and of an essentially European nature, reflects on Ian Spink and Caryl Churchill's danced and theatrical musings on mid-eighteenth-century music architecture, which resulted in the making of a dramatic film (1988). Early twentieth-century psychoanalytic themes are made manifest in spoken dialogue, movement and music in *Fugue*. We depend on the work not just of Freud, but also of Jacques Lacan, since understanding is reliant on constructs such as the fugue state of mind, a psychoanalytic construct which clearly owes something to the Europe of the nineteenth century. Its musical source pre-dates this in the eighteenth-century musical fugue, adding to its cultural complexity.

In a similar mode, Daniela Perazzo's study of Jonathan Burrows' *Both Sitting Duet* (chapter 8) speaks to dialogues between the arts, with an emphasis on dance/music collaboration, with both dancer and composer performing on stage. Significantly, there is neither text nor music in the production, but both are clearly implicated in the choreography, as its starting point, and in its structure. In the performance discussed here the creators re-create a specific moment in 2002 when they first made the work, a moment that is not only haunted by their previous performances and dance/music experiments and those of their immediate European contemporaries, but is also laden with a history of conventions of collaboration. Bach's *Fugue* is nowhere audible, as in Spink's *Fugue*, but it is an inescapable historical trace in *Both Sitting Duet*.

Absence of music is mirrored by the presence and absence of painting in the late twentieth-century work of Lea Anderson *The Featherstonehoughs Draw on the Sketchbooks of Egon Schiele* (1998; chapter 9). Like Perazzo on Burrows and Fargeon, Henia Rottenberg constructs multiple narratives revealing Anderson's subtle and shifting references to past styles of dance. Here it coincides with past styles of painting, specifically in the context of a vibrant historical moment in Vienna. While the work refers to the end of the nineteenth and early twentieth centuries she filters images through the lens of postmodern dance forms from the later part of the twentieth century. Anderson, as Henia Rottenberg shows, in a study of hybridity across time and art forms, mixes painting and dance through reference to his sketchbooks, in other words to the *traces* of works he painted, not to the paintings themselves. The fact that she works with such traces, of a different artistic medium, and a male artist, and someone who can hardly be said to be connected to the dance world, is itself a comment on how far dance has travelled and on the challenges of past–present, dance and the visual.

What is present and what absent in the traces these sister arts leave are part of the theoretical conundrum of postmodernism and of our experience of our own performing art. It is no longer seen as illegitimate to make extensive reference to other arts, to other dances, even to paraphrase or plagiarise, within one's own work. The perceived cleverness of postmodernism and its witty references help us to enjoy the intertextual play.

Into this environment is the youth of today born, and life, as experienced by young people in New York, is the focus in chapter 10, where Sherril Dodds reaches back into another dance history, another cultural moment, to a time when social dance dominated the dance landscape. Dancing masters were key social figures in the sixteenth and seventeenth centuries in Europe, just as in the film she analyses, *Mad Hot Ballroom* (2005), dance functions as a facilitating agent in social life. The engagement of young people in ballroom dancing, unlikely as this seems in itself at the present time, becomes the focus of an essay based in a political economy critique. Dodds revisits the supposed capacity of dance to encourage a disciplined and communicative personality adapted to contemporary norms of behaviour, a justification long employed since the seventeenth-century dancing masters. In the interim, the emergence of ballroom dancing in the early twentieth century and forms of educational dance in the middle of the century answered similar needs. The nature of the dance may change, but the purposes remain remarkably similar.

In various ways all these essays raise questions of genre, that long unloved, but re-emergent construct of art analysis, revived by John Frow (2006). For some years one has hesitated to mention genre for fear of accusations of pigeonholing works in some semi-automatic manner, in order to 'sort' them or even dismiss them. The importance of understanding existing categories of art, as explanatory of relationships that we perceive in new works as well as existing ones, has never in fact disappeared. For example, in my first explorations of analysis we stated that genre is a construct we cannot manage without:

> Genres are 'crystallisations' of specific knowledge, beliefs, ideas, techniques, preferences, or values around which particular traditions and conventions for producing and receiving dance have grown.
>
> (Hodgens, in Adshead 1988, p. 72)

Jo Louise Hall maps the genres of a relatively new social form of dance, that found in dance music club cultures (chapter 11). Synthesised

tracks, grouped together as 'dance music' and primarily produced for consumption on the club dance floor, emphasise poly-rhythmic structure, bass line, cyclical repetition and timbre. Since the 1990s there has been a rapid proliferation of sub-styles of dance music, although their delineation is problematic as they are often transient and evolutionary in nature. Whilst there are inherent difficulties in mapping a dance/music culture that is both multifaceted and constantly evolving, it is possible to articulate trends significantly different in style and appeal to attendant club communities. Drawing on genre theory, Hall attempts to capture the performative characteristics and moods of these practices through a diachronic and synchronic analysis of dance music cultures.

Conclusions

The question for this project has been to examine the nature of the links set up in reasoning and structuring intertextual processes. Whether they become as open as Gilles Deleuze and Félix Guattari's *A Thousand Plateaus* implies is questionable. Landow (1997) supports the lack of transcendence that they argue for and finds their rhizome analogy fruitful. Clearly, Deleuze and Guattari's emphasis on the 'multiple entryways' of the rhizome and the 'performance' required to make a map (1987, p. 12) suggests analogies with intertextuality, but it is somewhat undermined by its endless potential for modification. Landow offers a sceptical position, however, on the possibility of fulfilling these terms, characterising the result as a 'quasi-anarchic networked hypertext' that dissolves in constructs of 'dimensions' and 'directions in motion' (1997, p. 42). At this metaphoric level anything with objects to display or account for, with fragments to share, might be seen to be relevant. Punter, in a similarly metaphorical style, suggests that in choosing among inter/hypertextual routes we may see the links themselves, or we may not. If they are not visible, Punter suggests, we have a sense of 'falling through a gap in the text … falling into the insides of a word, falling into its guts … a new and more sophisticated form of enclosure' perhaps (2001, p. 81).

It is through the strategies of intertextuality that attention can be drawn to the politics of such a critical discourse at the meta-level, a discourse that can deal with metaphor but can cut through its assumptions of reality. How far the reader is conscious of the control that discourses, materials and structures exert is the crucial factor in avoiding

manipulation.[26] Feminist scholars (an obvious example) have found useful applications for intertextuality in the 'quest to uncover women's counternarratives, as an attempt to restore the suppressed, hidden voices of other women' (Meyer, 2000, p. 144).[27]

The idea of constantly turning back to uncover assumed positions is based on Derrida's notion of deconstruction. It requires an act of 'contortion, at the level both of the concept and of the critical trajectory' (Harari, 1979, p. 35), an appropriate analogy perhaps for a dance project. But more seriously, the difficulties of such a project lie in the danger of falling into the very trap one seeks to avoid.[28] It is necessary constantly to

> backtrack at each stage of the journey and dismantle the position on which one was relying, while waiting to attain a new position where one stops only long enough to deconstruct the position one has just left, and so on.
>
> (Harari, 1979, p. 36)

Our purposes, although perhaps more modest, rely on these paradoxical movements in that we read our works and texts closely (taking the Barthesian distinction on board) and comment on our own practices of writing, simultaneously. Languages (of every kind) are continually at work in this process and are continually questioned.

Dance, as represented here, can be seen to be a part of a much bigger cultural, political and historical landscape than can possibly be encompassed by our local experience and its forms cannot be seen separately from the shared postmodern culture of the late twentieth century, which has driven industry and technology across much of the world. Our consciousness of this larger world, in an era of globalisation, is inescapably bound up in our contemporary forms of expression, as we show in this text. It is the framework of intertextuality that encourages a form of analysis that reaches into these fields yet retains a hold on the form of expression that it considers.

An underlying thread in this chapter, and indeed in this book, is the need to specify carefully how conceptual frameworks are chosen and used in what might broadly be called analysis. Such terms as 'dance analysis', 'dance cultural studies' or 'dance history' are of little use unless given clear characterisation in particular instances. All these essays are analytical, cultural and historical forays, but no two are the same in content or method.

Notes

1. Few scholars have written on these relationships, a notable exception being George Landow in the field of literary criticism in relation to hypertextuality (1992; 1997). None has addressed the performing arts.
2. See Briggs and Bauman (1992) for this discussion.
3. The usefulness of intertextuality as a conceptual frame and method extends to ethnography. Meyer uses it to read three narrative performances of stories and songs in Varanasi, a north Indian city. She finds the term 'discomforting duplicity' particularly useful, rather than a focus on multiplicity. She draws out the 'agency, mischief and guile' of intertextual forms, and the 'disorder and slipperiness of the utterance' (Meyer, 2000, p. 145).
4. The oft-quoted 'deep' and 'surface' analytical tools of structuralism that feature in early anthropology are not adequate to the task here. A more flexible and multilayered analysis is required, one that allows fragments to gather and disperse in the construction of readings.
5. The project was funded under an AHRB (now AHRC) scheme called 'Innovation Awards'.
6. Intertextuality is a shifting construct employed across a wide range of disciplines, for example, in structuralist, poststructuralist, semiotics, deconstructive, postcolonial, Marxist, feminist and psychoanalytic theories. Some progress has been made on its application to dance (Adshead-Lansdale, 1999), based on models from French literary theory (Worton and Still, 1996) reworked to reflect the performative nature of dance.
7. In the version translated by Harari (1979) the term 'decentred' is used rather than 'off-centred', which seems to have a slightly different connotation.
8. See Cunningham's 1952 statement, *Space, Time and Dance* in Kostelanetz (1992).
9. See Klosty (1975) for an illustrated account of Cunningham's works in this early period. Cunningham's own views on the creation of many works can be found in Cunningham with Lesschaeve (1985).
10. I have made this argument in a number of places, stressing the close relationship between choice of theoretical or analytical perspectives and the work being studied (e.g. Adshead-Lansdale, 2000).
11. John Martin (1936; 1939) the dance critic, was closely allied temperamentally in his writing with the Expressionist philosopher Susanne Langer (1953).
12. The possibility of a completely abstract dancing body is constantly challenged, for example, by Deborah Jowitt (in Adshead-Lansdale. and Layson, 1994), tracking the reaction to Duncan's 'rampant' self-expression, a conception which itself may have been more exaggerated than real (Daly, 1995). She goes on to say that even Yvonne Rainer's hallmark work of detachment, *Trio A*, is 'inherently expressive' (1994, p. 175).
13. See Croce (1969) and Siegel (1977) for views typical of the New York critics of the time.
14. Copeland (1994) gives a succinct analysis of the relationship (or absence of it) between certain painters and Cunningham's work.
15. The substantial contribution made by Sparshott (1988; 1995) is a reflection of such ideas.

16. This is a quotation that Landow also finds useful.
17. The audience, on this argument, is seen as a 'site of textual production' (Ott and Cameron, 2000, p. 429), but a largely unconscious one in a postmodern landscape. Members of an audience simply read what is already given by previous texts and contexts (see Fiske, 1987; 1989). This would indeed be a limited notion of the intertextual freedom of the audience.
18. Notably in an attack on the work of Fiske (1987; 1989).
19. For distinctions between intertextuality and source criticism, see Worton and Still (1996, chapter 1). The use of intertextuality in readings of popular game show programmes leads to claims of its particular relevance to popular culture (Fiske, 1989) and from others, to accusations of its (literal) superficiality as an analytic tool. There is a tendency too to assume that it is useful only with postmodern works. Fiske's assumption that popular texts are more intertextual than existing art works forgets the multiplicity of meanings and readings that so-called 'classic' or 'modern' works of art engender. If only by virtue of their age they have acquired many more tangential threads of reference in the 'mosaic' that is the more usual epitome of intertextuality. Ott and Cameron (2000), in defence, focus on the stylistic devices of intertextuality rather than the audience creation of meaning. Their accounts of parodic allusion, creative appropriation or inclusion, and self-reflexive reference are worth pursuing.
20. Many accounts of structuralism have been written, but they usually refer back to Claude Lévi-Strauss in anthropological writing (1963) and to Ferdinand de Saussure in literary theory.
21. Classics in this field are the writings of Umberto Eco (e.g. 1984). He places an emphasis on reading the text as it, the text, foresees. The reader's cooperation is activated on this account. It is not a version of the reader as creating the text, as a more radical poststructuralist position might argue.
22. Cited by Copeland in a criticism of Selma Jean Cohen's *Next Week Swan Lake* (1982, p. 34).
23. For example, Martha Graham and her critics constantly seem to see this as a valuable aspiration.
24. Landow (1997) himself makes reference to Bakhtin, Barthes, Derrida and Foucault to support these commonalities of terms.
25. Eco's (1990) text deals specifically with the character of these limits.
26. This would seem a strong argument for education in reading with an extremely critical and sceptical eye, conscious of the political implications of all texts.
27. Where feminism has sometimes emphasised the distinctive qualities of women's discourse (if such there are), the result can be a further dismissal and marginalisation of women's work and writing, based on the continuing binary of male (important) and female (insignificant). Intertextuality complicates the situation and does not permit ignorance of previously 'constructed, historically located, and strategic subject positionings' (Meyer, 2000, p. 145).
28. Harari describes it thus. 'Contortion takes place for two reasons: first, because it is not easy to inhabit old concepts and to refashion words which carry the weight of history without falling back on the traditional significations of these words and concepts; and second, because all Derridean

concepts are anti-concepts of the type "neither–nor"...[which] escape definite classification' (1979, p. 36).

References

Adshead, J. (ed.) 1987 *Choreography. Principles and Practice.* Report of the Study of Dance Conference 4, University of Surrey: National Resource Centre for Dance
—— (ed.) 1988 *Dance Analysis: Theory and Practice.* London: Dance Books
Adshead-Lansdale, J. and Layson, J. (eds) 1994 *Dance History. An Introduction.* London: Routledge
Adshead-Lansdale, J. (ed.) 1999 *Dancing Texts: Intertextuality in Interpretation.* London: Dance Books
—— 2000 Narratives and Metanarratives in Dance Analysis. In G. Berghaus (ed.), *New Approaches to Theatre Studies and Performance Analysis.* Theatron 23. Tublngen: Niemeyer Verlag, pp. 189–203
Ahmad, K. 1997 Deconstructing Knowledge and Scientific Writing. *11th European Symposium on Language for Special Purposes.* Denmark, August. Ed. Undquist, Picht and Qvistgaard. Copenhagen: Copenhagen Business School, pp. 25–53
Allen, G. 2000 *Intertextuality.* London: Routledge
Banes, S. 1993 *Democracy's Body. Judson Dance Theatre 1962–1964.* Durham, NC and London: Duke University Press
Barthes, R. 1977 From Work to Text. *Image, Music, Text.* Trans. Heath. London: Fontana
—— 1979 From Work to Text. *Textual Strategies.* Trans. Harari. London: Methuen
Briggs, C. and Bauman, R. 1992 Genre, Intertextuality and Social Power *Journal of Linguistic Anthropology* 2 pp. 131–172
Cohen, S. J. 1982 *Next Week Swan Lake.* Middletown, CT: Wesleyan University Press
Copeland, R. 1994 Beyond Expressionism: Merce Cunningham's Critique of 'the Natural', in J. Adshead-Lansdale, and J. Layson (eds), *Dance History. An Introduction.* London: Routledge, pp. 182–97
Croce, A. 1969; 1978 *Afterimages.* London: A. & C. Black
—— 1987 *Sight Lines.* New York: Knopf
Cunningham, M. with J. Lesschaeve 1985 *The Dancer and the Dance.* New York: Boyars
Cunningham, M. www.merce.org
Daly, A. 1995 *Done into Dance. Isadora Duncan in America.* Bloomington: Indiana University Press
de Marinis, M. 1993 *The Semiotics of Performance.* Bloomington: Indiana University Press
Deleuze, G. and Guattari, F. 1987 *A Thousand Plateaus.* Minnesota: University of Minnesota Press
Derrida, J. 1967 Structure, Sign and Play in the Discourse of the Human Sciences. In *Writing and Difference* Trans. A. Bass, 1978, London and New York: Routledge. pp. 351–370

Desmond, J. (ed.) 1997 *Meaning in Motion. New Cultural Studies on Dance*. Durham, NC and London: Duke University Press
Eco, U. 1979, 1984 *The Role of the Reader. Explorations in the Semiotics of Texts*. Bloomington: Indiana University Press
—— 1990 *The Limits of Interpretation* Bloomington: Indiana University Press
Fiske, J. 1987 *Television Culture*. New York: Routledge
—— 1989 *Understanding Popular Culture*. Boston, MA: Unwin Hyman
Foster, S. L. (ed.) 1995 *Choreographing History*. Bloomington: Indiana University Press
—— 1996 *Choreography and Narrative. Ballet's Staging of Story and Desire*. Bloomington: Indiana University Press
—— (ed.) 1996 *Corporealities: Dancing Knowledge, Culture and Power*. London: Routledge
Frow, J. 2006 *Genre*. London and New York: Routledge
Gross, A. 1996 *The Rhetoric of Science*. Cambridge, MA and London: Harvard University Press
Harari, J. 1979 *Textual Strategies*. London: Methuen
Hodson, M. 1987 Composition by Field, Merce Cunningham and the American Fifties in J. Adshead, *Choreography. Principles and Practice*. Report of the Study of Dance Conference 4, University of Surrey: National Resource Centre for Dance. pp. 80–92
Hunta, S. de la 2002 Software for Dancers: Coding Forms. *Performance Research* 7, 2, pp. 96–102
—— http://huizen.dds.nl/~sdela/sfd
Jowitt, D. 1994 Expression and Expressionism in American modern dance in J. Adshead-Lansdale, and J. Layson (eds), *Dance History. An Introduction*. London: Routledge, pp. 169–181
Klosty, J. 1975 *Merce Cunningham*. New York: Saturday Reviews Press/Dutton
Kostelanetz, R. (ed.) 1992 *Merce Cunningham. Dancing in Space and Time*. London: Dance Books
Landow, G. 1992; 1997 *The Convergence of Contemporary Critical Theory and Technology*. Baltimore. MD: Johns Hopkins University Press
Langer, S. K. 1953, 1970 *Feeling and Form*. London: Routledge & Kegan Paul
Lévi-Strauss, C. 1958, 1963 *Structural Anthropology* New York: Basic Books
Lunefeld, P. (ed.) 1999 *The Digital Dialectic: New Essays on New Media*. Cambridge, MA and London: MIT Press
Manning. S. 1993 *Ecstasy and the Demon. Feminism and Nationalism in the Dances of Mary Wigman*. Berkeley, CA: University of California Press
Martin, J. 1936, 1968 *America Dancing*. New York: Dance Horizons
—— 1939, 1965 *Introduction to the Dance*. New York: Dance Horizons
Meyer, R. 2000 Fluid Subjectivities. Intertextuality and Women's Narrative Performance in North India. *Journal of American Folklore* 113, 448, pp. 144–63
Ott, W. and Cameron, W. 2000 Intertextuality; Interpretive Practice and Textual Strategy. *Critical Studies in Media Communication* 17, 4, pp. 429–46
Punter, D. 2001 e-textuality Authenticity after the Postmodern *Critical Quarterly* July 43, 2 pp. 68–91
Siegel, M. 1977 *Watching the Dance Go By*. Boston, MA: Houghton Mifflin
—— 1991 *The Tail of the Dragon. New Dance, 1976–1982*. Durham, NC and London: Duke University Press

Sparshott, F. 1988 *Off the Ground. First steps to a Philosophical Consideration of the Dance*. Princeton, NJ: Princeton University Press
—— 1995 *A Measured Pace. Towards a Philosophical Understanding of the Arts of Dance*. Toronto: University of Toronto Press
Worthen, W. 2002 Hyper-Shakespeare. *Performance Research* 7, 1, pp. 7–21
Worton, M. and Still, J. (eds) 1996 *Intertextuality: Theories and Practices*. Manchester: Manchester University Press

2
Betraying History? An Historiographic Analysis of *The Judas Tree* (1992)

Alexandra Carter

The purpose of this chapter is to consider the ways in which the historian engages with dance analysis. 'Historian' and 'analyst' are malleable terms, for reconstructors of dance, among others, also engage with history and analysis. For example, in order to 'build' the dance for performance, reconstructors amass historical evidence and make informed guesses about gaps, whether in details of the choreography or the performing style. For the purpose of this discussion, however, the 'historian' is conceived as someone whose aim is to examine the dances of the past for reasons other than remaking them in present-day performance. Close examination of a specific dance can position it more securely as a culturally significant activity or support claims for its place on a continuum or as innovative practice. Discerning the characteristics of dances can identify their theatrical, social or ritual function. Analysis of dance events might form an integral aspect of biography. The reasons why historians explore the detail of past dances are multifarious for each can set their own distinct research trajectories.

It is only during recent decades that research in dance history has accommodated systematic analysis. Given the breadth of their remit, history books tended to be overviews of periods, places, people or genres. I remember the frustration encountered in my own studies when, having read extensively on Isadora Duncan, I was no closer to knowing what she actually did on stage. Ann Daly's text (1995) has remedied this. Similarly, Susan Manning's (1993) close examination of the work of Mary Wigman attends to the detail of the dances. More recently, autobiographies by British contemporary practitioners such as Liz Aggiss and Billy Cowie (2006) and Emilyn Claid (2006) have addressed, in

some detail, the choreographic content of their works. Despite these excellent endeavours, however, there is a problem for the historian who wishes to 'get back to the dance', for such an aim is, in strict logical terms, impossible. Often, the ephemeral nature of dance is cited as its own special problem in terms of its retrievability. The theatre has its script and music has its score, but even though dance has its notation, this is far less readily used or understood. However, neither score nor script is the same as the performance event, and in this sense theatre and music performance is as elusive as dance performance. Worthen claims that 'all writing about performance must face its own impossibility: the event is gone, the records are always partial and suspect, and the only thing we know is that nothing we say happened actually took place in precisely that way' (Worthen, 2003, p. 6). In fact, neither dance nor any type of performance can make special claims, for all of the past is retrievable only in the evidence that remains. As Jenkins (1991, p. 11) claims, 'as the past has gone, no account can ever be checked against it but only against other accounts... there is no fundamentally correct "text" of which other interpretations are just variations; variations are all there are'. Therefore, because 'the past itself is beyond reach, the historian is always reading the shadowy remains, the images on the cave wall' (Postlewait, 1992, p. 356).

To take an example, our primary source history of trench warfare in the First World War is accessible by recourse to written, oral and bodily memoirs, official documents, statistics, photographs, illustrations, poetry, fiction, and so on. Our history of the dances that were popular during the First World War is accessible by recourse to written, oral and bodily memoirs, official documents, criticism, photographs, illustrations, poetry, fiction. The past, therefore, resides in its evidence. The historian's role in creating history from evidence has led to the claim that the past is simply a construct, a now common claim that has rendered the past a nebulous nothingness. However, despite Elton's (1969) rigorous claim that the past has an independent existence and is not solely a construct of the historian, and Evans' (1997) more recent riposte to the views of Jenkins and other postmodern historians, it is a persuasive argument that the past cannot be accessed independently of all the sources which comprise the record of its existence.

These sources are what Manning (1993) and others call the 'traces' of performance. Each of these traces she argues, 'marks, indeed distorts, the event of performance, and so the scholar pursues what remains elusive as if moving though an endless series of distorting reflections' (1993, p. 12). Although this sentiment might seem so much common

sense, I would argue that the notion that the evidence or source material which comprises these traces somehow 'distorts' the 'original' event can be contested when dealing with historiography of any kind. As Postlewait (1992, p. 356) argues, 'the historian redescribes and reinterprets what the traces of the past delineated, illustrated, exhibited, described and interpreted'. Therefore, 'even "primary" evidence expresses, within its possible modes of collocation and representation, a historical set of values, assumptions, beliefs and viewpoints' (1992, p. 366). As such, any historical project which tries somehow to see 'through' the sources, to trace back through them to a 'true' event, is misconceived. In relation to dance, Matluck Brooks (2002) argues persuasively for a 'sympathetic' approach which allows the text, the dance, to 'speak'. It is the job of the historian, she suggests, 'to hear the text's voice and bring it respectfully to life in the present' (2002, p. 42). However, the text/dance has already been re-presented through others: through the eye of the artist who illustrated it, the writing of the critic and the recorded perceptions of the collaborators, participants or audience. As Muntz (1997) argues, the notion that primary sources are somehow closer to the 'truth' of events is problematic, for historical actors had their own bias, self-interests and stories to tell about the performance. Furthermore, different kinds of dance will produce different kinds of stories or 'traces'. Works rich in narrative will tend to produce description of narrative; formalist work will evoke formalist description. It is here that the concepts of personal memory and 'social memory' are useful. Burke (1997, pp. 43–4) notes that 'the historian's function is to be custodian of the memory of public events', but admits that 'both history and memory have come to appear increasingly problematic... neither memories nor historians seem objective any longer'. These arguments are well rehearsed, but importantly he continues by discussing the concept of 'social memory', a construct through which events are remembered, which shows they are remembered – and how they are forgotten. In other words, the traditions of a dance genre will contribute to the 'social memory' which constructs how dances are remembered by individuals. For example, the ballet critic will look at a ballet in ways in which ballet has traditionally been perceived, and record those perceptions accordingly.

The historian, therefore, does not deal with evidence that 'distorts' a performance which is no longer extant. This evidence reveals the ways in which performance was received and these ways might conflict. Even what might seem to be 'purely descriptive' is not so 'pure' for, as Bourdieu (1989, p. 2) suggests, description – or the capacity to 'see' – is based on perception, which is acquired by those equipped with the

appropriate cultural competence. When engaging with the details of the dance, therefore, the historian is retrieving not the dance, but perception of an event. By presenting the multiplicity of perceptions on performance, the historian can destabilise the solidity of performance as a 'fact'. This is the excitement of the historical project and a way of escaping from the nihilism to which some of the postmodern arguments might lead. Let us celebrate 'distortion', for although the reconstructor might have to resolve contradictions or conflicting evidence in order to produce a coherent work, the historian can seek or speculate on reasons for such evidence. When engaging with analysis, it might be argued that the historian's primary concern is not only to describe, but also to interpret and explain, and by so doing construct 'new' histories. As such, she can afford 'an indulgence in contradictory evidence, a savouring of the telling detail, a cultivation of the artifice of documentation' (Foster, 2003, p. 208).

The task of constructing histories can only be achieved by recourse to the cultural context in which the dance work is created, presented and received. Critical strategies drawn from fields such as cultural and gender studies, and analytical stances from semiotics and intertextuality, have alerted us to the problems of strict formalist analysis (see, for example, Jordan and Thomas, 1994; Adshead-Lansdale, 1999; Desmond, 2001). This can have its place in dance, but the historical project I outline here borrows from the key tenets of New Historicism. This term was coined to describe a mode of literary analysis which attempts to 'combat empty formalism by putting historical considerations to the centre stage of literary analysis' (Aram Veeser, 1989, p. xi), aiming to demonstrate that 'social and cultural events commingle messily' (1989, p. xiii). Although the strategies of New Historicism have been strongly critiqued,[1] the notion that 'every expressive act is embedded in a network of material practices' and that 'literary and non-literary "texts" circulate inseparably' is a useful tool for the historian researching the performing arts, for literary 'texts' can be replaced with performance as a culturally expressive act. This also counteracts the view of some who represent the field of historiography itself who mistrust the artistic event as 'true' evidence. Husbands, for example, suggested that 'the assumptions or prejudices of authors or artists…confound the usefulness of much evidence as a window on the past' (1996, p. 4). It is only recently that historians are beginning to accommodate 'expressive acts' as key, rather than tangential or misleading evidence which confounds the past.[2] We might also plunder a famous phrase from the New Historicists which neatly describes the historical, rather than the

formalist literary endeavour. That is, a concern with 'culture in action' (Aram Veeser, 1989, p. xi).

Although the status of dance as 'culture in action' has long been recognised, attention to ballet has been limited. It has tended to escape both analytical and cultural readings. Perhaps because of the longevity of the *danse d'ecole* and the repertoire itself, the description of choreography has often seemed to be redundant. The focus in the records, therefore, tends to be on the performance skills and qualities. Understandably, even if key choreographic features are addressed, in popular criticism space does not allow for such in-depth consideration. So ingrained is this focus that even new works are hostage to description of narrative or theme and to criticism of performance rather than choreography. This tendency is compounded by the trend in theatre dance scholarship to focus on other dance forms and, increasingly, on a culturally diverse repertoire rather then a ballet repertoire. Those who are engaged directly in the ballet world and have expertise and 'insider' knowledge are not likely to have travelled the academic route into scholarly research. These possible reasons for the low profile of ballet in, for example, edited collections of writing on dance are generalised, of course, for there are many exceptions and the situation is changing.[3] For the purpose of illustrating how an historian might approach dance analysis, I have chosen to focus on a work from the British ballet repertoire, *The Judas Tree*, choreographed by Kenneth MacMillan and first produced in 1992. It is a work which has given rise to diverse responses and it is this feature, together with its cultural and gendered resonances, which renders it interesting for the historian.

The sources used for this analysis comprise mainly written reviews of the 1992 and 2003 productions and some anecdotal perceptions. The role of the critic in the creation of the history of the arts is often undervalued. Seen as a personal view, and therefore biased, the review can be dismissed as a distortion of events, a problematic view in terms of the tenability of the notion of 'distortion'. Furthermore, the newspaper or journal criticism is not only often the sole evidence we have of past performance but there is also a sense that critics, albeit usually more informed and knowledgeable, represent audience members. No single person can represent a whole audience, of course, but their views can capture the tenor of how an audience in general received a work (though there are occasions when a critic might be at odds with a popular response). Their views, therefore, are not biased distortions of the dance event, but exemplify how the event was received. Nevertheless, as the following discussion will demonstrate, critics' views are not only formed

by their knowledge, personal tastes and interpretative strategies, like every audience member, but they are also mindful of both the publishing context in which their review will appear and their readership. In this sense, a review in a newspaper or journal will not only present a critic's response but also the anticipated tastes of its readers. Neither of these can nor need be circumvented in order to get back to the 'true' nature of the work.

The Judas Tree

Premiered at the Royal Opera House, London, on 19 March 1992, this was Kenneth MacMillan's final work. He died later that year. It was revived in the Royal Ballet repertoire in 1997 and again in 2003. Music was commissioned from Brian Elias, set design was by Jock McFadden and lighting by Mark Henderson. In the first version, its two protagonists, the Foreman and the Woman, were danced by Irek Mukhamedov and Viviana Durante (Leanne Benjamin and Gillian Revie also took this role). The work was restaged for Birmingham Royal Ballet by Monica Parker and is available on video cassette (1998). Arguably, therefore, in order to 'analyse' the work the historian could go directly to the screen medium, but this is not the point of the historical research which this chapter aims to illustrate. Although such a strategy might seem to offer arbitration in conflicting perceptions, it would be a case of the historian abdicating their responsibility by privileging their own perception. As such, the historical resonance of the work, in its own time, would be lost. The whole point is not to judge the many ways of seeing the work as 'right' or 'wrong' in order to get back to 'the' dance, but to reveal those diverse perceptions and explore their significance.

The significance of audience/critic perception is contingent on the social and artistic context of the production of a work; information which contributes to social memory. In general terms, *The Judas Tree* depicted 'an urban horror story familiar from the films of Stephen Frears, Hanif Kureishi and Derek Jarman' (McMahon, 1992a). Or, put a little more bluntly, 'it's sex and violence wherever you look these days' (Taylor, 1992). Although not quite counting as 'sex and violence', the psychodrama of human relationships as exposed to the public was perhaps typified at the highest level by the publication of Andrew Morton's book on the memoirs of Princess Diana. *The Judas Tree* was not MacMillan's first foray into the realm of psychodrama in dance. On the contrary, he was well known for ballets which dealt with the emotional undertones under the surface of society; the psychological and sexual

drives of individuals and their often destructive impact on intimate relationships. In works such as *Danses Concertantes* (1955), *The Burrow* (1958), *My brothers, my sisters* (1978), *Playground* (1979) and most explicitly *The Invitation* (1960), MacMillan captured close and often claustrophobic relationships with sexual undertones. Even the subject matter of a rape, central to *The Judas Tree*, had been dealt with in *The Invitation*. MacMillan was not alone in addressing these themes in his earlier works. As Jann Parry claims, he was part of a generation of artists as Angry Young Men and 'other choreographers were following the same path: Jerome Robbins in the United States, Maurice Bejart in Belgium and Peter Darrell in Britain' (Parry, 2002, p. 6).

Although when MacMillan created *The Judas Tree* rape was a topical, public issue, his explicit choreographic depiction of sexual abuse still shocked its audiences, who now viewed such works with a far heightened consciousness of gender politics.[4] By the early 1990s, the political tenets of feminism had arguably become mainstream and the disturbing subject matter of *The Judas Tree* lay perhaps more in its abuse of a woman, now politically untenable, rather than in the actual representation of rape. The bones of the narrative which enfold this act concern three main characters: the Foreman, his Friend and the Woman. Set on a kind of building site, it tells of the jealousy of the Foreman, whose object of desire, the Woman, is involved with his closest friend. Although there may be significant events in a dance work which provide its 'bones', the muscle of what a piece is 'about' is contingent on the viewer's interpretation and, as this example demonstrates, on the choice of language. Even description is not neutral.

> The Judas figure ... (*the Foreman*) ... is besotted with the woman ... who actually belongs to his friend. While she virtually has sex with all the other men in the gang, she crudely puts off Mukhamedov's advances. Maddened, he gets her to himself and possibly rapes her. This unleashes the excitement/aggression/contempt of the other men who put on their anoraks (to keep their trousers clean?) and rape her too. Mukhamedov kills her, after which the gang attack Nunn (the Friend) and Mukhamedov puts on his own anorak and hangs himself.
>
> (Mackrell, 1992a)

Mackrell's obsession with anoraks, although seemingly descriptive, reveals something of her cynical judgement about the work as a whole. Furthermore, it is obvious that if historians are attempting to build a

'picture' of the dance from detailed description, then reviews are not helpful. Time, space for print and, most of all, the critical imperative prohibit full description of a work. Historians must deal, therefore, with the source as it stands rather than lament its apparent shortcomings, for neither critics, their readers nor audience members are engaged in comprehensive analysis. They see what they see, based on their social memory and the conventions for writing/viewing. As suggested, the technical vocabulary of ballet is usually taken for granted, even when deployed in a distinct stylistic manner. In works such as *The Judas Tree* the impact of the subject matter overrode other perceptions and this formed the heart of most critical response.

In the minimal description of actual movement material, what dominated critical memories were Mukhamedov's big jumps, twisting leaps and turns and the angry quality with which these were executed. Quality of movement can thus be gleaned from interpretative comments, such as Percival's (1992b) observation that the Foreman appears 'angry and vengeful rather than treacherous'. This is contrasted with the more gentle character of Michael Nunn who danced the role of the Friend. Not surprisingly, the largeness of movement renders it large in the memory, for jumps for the other men in the cast were also noted, as well as the fact that they 'mostly stamp, stride and strut in a threatening macho manner, despite being dressed like the Men from MacFisheries' (Gaisford, 1992). For the Woman, she is 'sinuous and steely ... something of a "toughie"' (Dougill, 1992). Reviews of the revival are more helpful about her movement material, which comprised the splits and 'crotch splitting contortions'; she was 'kicking ... [the men] ... in the face ... or enfolding them in her long bare legs like a hyper-articulated blow-up doll' (Levine, 2003). (Perhaps the reviewer had Lloyd Newson's *Enter Achilles* of 1995 in mind, in which a real blow-up doll does feature. Here, also, 'bare legs' is somewhat misleading – see below.) Whilst the characters of the men seem straightforward, the 2003 critics granted the woman more complexity though their interpretation was based on an age-old binary image: 'a kind of virginal whore' (Percival, 1992b); 'a redemptive Madonna, virgin innocent or manipulative whore' (Christiansen, 2003).

As such comments demonstrate, description of movement is intricately bound up with interpretation of events or character. It might be expected that description of set or costume would be more straightforward, but even here the experiences of the viewer colour their perception, their 'intertextual' memory. A photograph of the set depicts a building site with scaffolding, scrap cars and a graffiti-covered wall.

Some critics described this as London's Docklands, others as reminiscent of an updated set of *West Side Story*, the film of which has become part of social memory. A reader/researcher working in Greece might have been truly puzzled by the location of the ballet, for the English language *Greek Review* (Anon., 1992c) described it as 'a building society [*sic*] littered with car wrecks'.[5]

Description of costume is similarly wrapped in interpretative/evaluative tones. Durante is 'dressed inexplicably in a bathing costume' (Anon., 1992a); 'her main garment is a luridly coloured swimsuit worn over tights and toeshoes; just the thing for a night out with the builders' (Percival, 1992b). Of course, consulting the photographs and images of the work in publicity material will reveal the 'actual' costumes, but what is of interest to the historian is how the costume was perceived – and why. By the end of the twentieth century, the conventions of ballet costume which had long forgone verisimilitude were no longer readily accepted in new work. Here, the conventional tights and toe shoes combined with a modern body- and movement-revealing top were not perceived as credible, especially on a building site.

With the exception of a full review of the music written by the specialist Noel Goodwin (1992), accounts of the music/choreography relationship are rare. Sources reveal it was commissioned from Brian Elias who worked from the basic structural blocks of the narrative provided by MacMillan. As 'part symphony, part music drama' (programme note, 1992) it may have been unmemorable and therefore, paradoxically, successful. More likely, the choreographic action on stage dominated visual perception to the exclusion of aural acuity.

Although historians are concerned with how events are remembered and recorded, explanations for how and why they are constructed are also important. In the case of dance, there are often very pragmatic reasons for choreographic choices. For example, as so often in large companies, casting for *The Judas Tree* and therefore its resultant subject matter and staging was contingent on who was available. MacMillan chose a large male cast for the supporting workmen because the men in the Royal Ballet were particularly strong at that time (Mackrell, 1992b). Also on a more pragmatic note, the anoraks lamented by Mackrell were worn because the Foreman's harness which helps him to commit a safe suicide at the end of the ballet had to be disguised. For him alone to don an anorak would have looked odd, so all the men did (Percival, 1992a).

From the perceptions and memories of critics it is possible to build pictures of the many inflexions of *The Judas Tree*. How it was presented to the public who had not yet seen the work, and may never see it, gives

a distinct flavour of how it was perceived in the spirit of the times. Despite the serious subject matter of the ballet and the gravity of the quotation from Kahlil Gibran which was presented in the programme,[6] the amalgam of rape, murder and the Royal Ballet sent newspaper editors into a frenzy of screaming subtitles, even in anticipation of the premiere. All from 1992, they included such phrases as: 'The man's asking for it' (*Independent,* 21 March); 'Love, lust and death in the Docklands' (*Daily Telegraph,* 21 March); 'Ugly scenes at the Royal Ballet' (*Independent on Sunday,* 22 March); 'Rape and murder at the ballet' (*Wolverhampton Express,* 13 March) and 'Covent Garden shocks with gang rape dance of death' (*Evening Standard,* 12 March). Although there is a similar tenor to all of these, the headlines speak to their readership. The *Gay Times* (May 1992) review, for example, is captioned 'Raunchy Ripplings'.

Despite MacMillan's undoubtedly serious intentions, as the written/ spoken language leaves the meaning-domain of the author, who is rendered metaphorically 'dead', so too the meanings of dance become manifest not in relation to choreographic intention but to viewer reception, whether or not, in the case of some of the headlines, the work has actually been 'received'. The late twentieth-century imperative for eye-catching headlines about murder and death was not new; they have been used since the inception of the popular press. Now, however, there is no squeamishness about the once delicate subject or word usage of 'rape'. Paradoxically, the arts of 'high' culture, including opera and ballet, have regularly dealt with such human evils without causing critical consternation but the bastion of 'high' art, the Royal Opera House, was no longer immune from the scandal-loving concerns of popular culture. (One could have fun applying tabloid-style headlines to dance works from the past: 'Crazed hordes of women lure men to drowning in lake'; 'Double vision drives Prince's desires', etc.)

If newspapers were able to feature headlines in anticipation of the premiere, so too audiences made judgements about the work based on its subject matter alone. This is inevitable, for we all make choices about what to see and do based on personal taste, though critics and scholars may have to engage with dances and material of all kinds which they might find distasteful. There were many, including myself, who were deterred from seeing the work by its thematic content. It is a little unusual, however, for an audience member to leave the theatre just before this particular work was shown as part of a triple bill, as a colleague of mine confessed to doing. As I indicate later, newspaper reviews suggest she was not alone. In general terms, the historian of the performing arts tends to deal with what was seen, as recorded, rather than reasons why

a production was not seen. In the case of *The Judas Tree*, many might have been deterred by its theme in general terms, or by a concern for the appropriateness of the theme for a ballet at the Opera House; others like myself, by a feminist revulsion for anything which appeared to deal with the exploitation of women.[7]

As mentioned earlier, dance works with a dominant narrative will guide perception and memory to that narrative, which in this case was deeply troublesome. As Percival (1992a) says, 'it is some of MacMillan's best choreography for a long time – or would have been if it could be considered as movement, ignoring its content. But that is not possible'. A handful of critics interpreted the work as having biblical connotations. Guided by the title, they noticed gestures such as the Foreman's kiss of betrayal on his Friend's cheek or the Madonna/Magdalene conflict embodied in the Woman (Taylor, 1992). However, in our secular, not to say sceptical, age this religious resonance was not treated seriously and was even described as a 'gimmick' (Percival, 1992b).

Taking their cue from the Royal Opera House flyer, the shared critical interpretation of the work was that it was about betrayal, a theme which, despite the depiction of rape and murder, was strangely described by one critic as 'the most unforgivable of sins' (Thorpe, 1992). Sub-themes of guilt and, guided by the quotation from Gibran, the complicity of the group in individual action were also discerned. Although interpretations were diverse, they did not conflict but there is certainly a sense that the work was ambiguous: 'I cannot really tell you with any certainty who betrayed whom' (Dougill, 1992); 'so many contradictory themes are chasing each other through MacMillan's choreography' (Percival, 1992b); the Judas kiss of betrayal, given by the Foreman to his Friend, 'makes no dramatic sense' (McMahon, 1992b).

The themes of seduction and gang rape were perceived with the heightened gender consciousness of the late twentieth century: 'basically it is about masculine power' (Dromgoole, 1992). Although both male and female critics noted the sexual politics, it was the latter who wrote at greater length and more angrily about them. Mackrell's (1992a) response is to the point: 'Doesn't MacMillan realise how offensive it is to watch a woman so crudely "inviting" abuse? And what does he think it's like to be raped by thirteen men?' McMahon (1992a) finds the choreography for the Woman 'brutally manipulative' and 'rather chilling as she is thrown, mauled and manoeuvred by the men'. She places *The Judas Tree* in relation to MacMillan's *oeuvre*: 'In too many of MacMillan's works the woman is presented as a victim, frequently a humiliated one in her sexual relationships' and in *The Judas Tree* 'she welcomes erotic

humiliation even if, as in other of MacMillan's works, it leads to violence and death'. The years between the 1992 and 2003 productions did not temper the female critics' responses. Craine (2003) found the choreography 'vile' and the work 'an ugly, egregious cocktail of violence, abuse and gang rape ... a mess of misplaced symbolism and cliché that wallows in sado-masochistic excess'. The Woman is seen as 'a preposterously slutty woman goading a male gang' (Mackrell, 2003). This unequivocal view might be due to the different nuances given to the role by different dancers, but more likely reveals Mackrell's impatience with the work.[8] She continues, 'what is shocking about this ballet is not its "realism" but its failure to spot its own vicious misogyny and voyeurism'. McMahon (1992b) offers an interesting observation that would offer a clue to the historian who wished to explore the significance of the work in its wider social and artistic context as she notes 'the fact that so many choreographers are unable to portray mature sexual relationships except in terms of distorted hysteria is a cultural conundrum of our times'.

Again, reviewers wrote with cognisance of their readership. In the politically aware *Time Out* (Anon., 1992b) the reviewer found the choreography to be 'some of MacMillan's most impressive, but the sexual politics of this piece are truly appalling'. Reading against the grain, the reviewer in the *Gay Times* (Anon., 1992a) was the only one to note 'a gay encounter ... two men hump side by side without touching each other'. Unlike most of the visual images which accompanied the reviews, here the image is not of Durante and Mukhamedov but of the moment when Mukhamedov kisses Nunn, with a 'dead' Durante at their feet. This review and chosen image are exceptional in the general tenor of responses. (Luke Jennings' comment in 2003 that the work 'features a cast whose look appears to be inspired by gay porn' is obviously tongue-in-cheek.) The *Gay Times*' review is an obvious example of the significance of the nature of the source, an easy task to identify here but not as straightforward when dealing with sources of the longer-term past or those of other cultures. Furthermore, it is important not to discount such sources as 'extreme' and therefore unviable or somehow not 'true' representations of the work. They are valid as one kind of perception, one 'view' in an actual as well as interpretative sense.

There were some writers who found the work successful. Mary Clarke's (1992) opinion that it was 'a tremendously powerful piece of theatre, entirely of our time' was an unusual response not only from a female critic but also one a generation older than most of the writers cited above. Similarly, in 2003, Lucy Wells thought the work 'a shadowy, sober masterpiece'. Most interestingly, the judges of the 1993 Olivier

Award voted it the Best New Dance Production in 1992, a case of a quasi-institutional response going against the grain of the judgements of the majority of individual critics. These positive responses, however, were rare. Some writers reflected on the tension surrounding a work with such a narrative presented in a ballet on the Royal Opera House stage: '*The Judas Tree* is a staggering tribute to male dancing but it's a lousy indictment of the male sex' (Mackrell, 1992a). The overwhelming critical response, in 1992 and in 2003, was one of personal distaste for the general theme and artistic judgement on the incomprehensible choreographic treatment of it. Again, MacMahon (1992a) offered a long-term view: 'thirty-five years after *Look Back in Anger* MacMillan is still engaged on his mission to shock. But we've grown up since then. I wonder if Sir Kenneth has.'

The above typifies the response to *The Judas Tree* as gleaned from the 'hard' sources of written reviews in the mainly British press. What did the general audience think? Again, it is to written records that the historian must turn. In 1992, 'on Thursday several people left early' (Gaisford, 1992); 'the Royal Opera House audience was shocked to judge from the politeness of the applause' (Nugent, 1992); 'the applause was somewhat muted; some people left before the piece was over and others tutted loudly' (Anon., 1992c). Audience response is obviously open to interpretation and may be contingent on what the writer noticed, where they sat in the theatre and on what evening they attended. What is of interest, however, is that by 2003 'the wild applause of the audience seemed to confirm that *The Judas Tree* is finally hitting the mark. People are no longer shocked into silence. They are wowed by seeing ballet grapple with unspeakable ideas' (Gilbert, 2003). Again, this observation may be misleading but it does accord with some personal anecdote. The colleague who left the auditorium when the ballet was presented as part of a triple bill in 1992 did see the work later and admitted that it was not as bad as she had expected. A professional critic who had written very warily about the work now uses it with her students. She acknowledges that 'the more I see it…[on video]…the more it impresses me. It certainly speaks to today's students' (personal email, 11 May 2006). A few accounts of audience response and a couple of personal anecdotes do not comprise a solid foundation for speculation. However, despite the fact that critical response in 2003 still focused on the shocking and, to many, distasteful nature of the subject matter, it may be that audiences were a little more desensitised, more accustomed to the shock value of such stories, or acclimatised to seeing ballets of a more innovative nature at the Royal Opera House. Here, I am engaging in the historian's

strategy of speculation and in doing so must be wary of over-generalisation. With respect to *The Judas Tree*, as a critic in 1997 pointed out, 'some people continue to be fascinated by this dark and violent urban parable, others hope that they will never have to sit through it again' (Anon., 1997).

This examination of *The Judas Tree* has served to exemplify one approach to dance analysis within an historical project. To return to the debates raised in my introduction, it has presented 'a multiplicity of perceptions on performance'. A range of evidence has demonstrated the different ways in which the work was perceived and remembered. Even if all viewers saw the 'crotch splitting contortions' (the splits, or wide second position of the legs) of the Woman, how they remembered them, both at the time and over time, renders this action not static but permanently 'on the move' in public perception. To quote Foster (2003) again, 'telling detail' has revealed how small detail can illustrate larger issues such as, in the case of the wearing of the anoraks, how narrative impels production choices, which in turn colour artistic judgement of the work. Attention is drawn to the 'artifice of documentation', an artifice which does not distort a true image of a dance but one which reveals how knowledge is constructed not 'through' but by documentation or any kind of source. The analytical project for the historian, then, is not one of analysing 'the' dance but analysing the evidence. The concern is not with a stable text of the past but with understanding the nature of the performance event. As such, the historian does not offer resolution but, through transparent processes of redescription and reinterpretation, within the framework of selected evidence, can only but attempt explanation.

Notes

1. New Historicists, in their analysis of literary texts, have concerned themselves with small detail rather than the large-scale analysis manipulated to accommodate monolithic theoretical constructs. In exposing the 'surprising co-incidences' between micro-events they are charged with performing 'amazing contortions in order to avoid causal, deterministic equations' (Aram Veeser, 1989, p. xii). Hayden White also issues a damming indictment of New Historicism, seeing it as simply a muddled attempt to 'supplement prevailing formalist practices by extending attention to the historical contexts in which literary texts originate' (in Aram Veeser, 1989, p. 293). See Hamilton (1996) for a detailed overview of the key ideas and responses to New Historicism.
2. For example, in 2006 BBC Radio 4 broadcast a series of programmes entitled *History and Poetry* in which, each week, one poem was examined for how it re-presented a particular historical moment or period.

3. See, for example, the DVD presented by Stephanie Jordan and Geraldine Morris (2005) on selected ballets of Frederick Ashton in which they take a detailed formalist approach.
4. In December 1991, William Kennedy Smith, nephew of Senator Edward Kennedy, was acquitted of rape. His trial touched the current public debate about 'date rape'. In March 1992, Mike Tyson, world heavyweight boxing champion, was sentenced to five years for rape (Mercer, 1995, p. 188). These are selected news stories but they exemplify public and judicial interest in the crime.
5. Translation is a long-recognised problem for the historian, but becomes even more so when the translation is undertaken by the writer in the process of writing.
6. The programme included a quotation from the American-Lebanese poet Gibran Kahlil Gibran: 'As a single leaf turns not yellow but with the silent knowledge of the whole tree, so the wrongdoer cannot do wrong without the hidden will of you all.'
7. Arlene Croce's famed 'review' of Bill T. Jones' work *Still/Here* (1994), about which she wrote not having seen it or rather, she wrote about her reasons for not seeing it, is an interesting case. Although much attacked, her response is significant in historical terms as a reflection on public taste for certain kinds of subject matter; in this case, for what Croce called 'victim art'.
8. Sally Banes (1998) alerts us to the often forgotten point that we do not access unmediated choreography, but the dancer's presentation of it. It is s/he who puts the muscle on the skeleton of the movement and, as such, the choreography may be rendered differently by each performer.

References

Anon.. 1992a *Yorkshire Post,* 21 March
Anon.. 1992b *Time Out,* 25 March
Anon.. 1992c *Greek Review,* 2 May
Anon.. 1992d *Gay Times,* May
Anon.. 1997 *Time Out,* 14 May
Adshead-Lansdale, J. (ed.) 1999 *Dancing Texts: Intertextuality in interpretation.* London: Dance Books
Aggiss, L. and Cowie, B. (eds) 2006 *Anarchic Dance.* London: Routledge
Aram Veeser, H. (ed.) 1989 *The New Historicism.* New York: Routledge
Banes, S. 1998 *Dancing Women: Female Bodies on Stage.* London: Routledge
Bourdieu, P. 1979, 1989 *Distinction: A Social Critique of the Judgement of Taste.* London: Routledge
Burke, P. 1997 *Varieties of Cultural History.* Cambridge: Polity Press
Christiansen, R. 2003 *Mail on Sunday,* 4 May
Claid, E. 2006 *Yes? No! Maybe ... Seductive Ambiguity in Dance.* London: Routledge
Clarke, M. 1992 *The Guardian,* 21 March
Craine, D. 2003 *The Times,* 2 May

Daly, A. 1995 *Done into Dance: Isadora Duncan in America*. Bloomington: Indiana University Press

Desmond, J. (ed.) 2001 *Dancing Desires: Choreographing Sexualities on and off Stage*. Madison, WI: University of Wisconsin Press

Dougill, D. 1992 *Sunday Times*, 22 March

Dromgoole, N. 1992 *Sunday Telegraph*, 22 March

Elton, G. R. 1969 *The Practice of History*. Oxford: Blackwell

Evans, R. J. 1997 *In Defence of History*. London: Granta Books

Foster, S. 2003 Improvising/History. In B. Worthen and P. Holland (eds), *Theorizing Practice: Redefining Theatre History*. Basingstoke: Palgrave Macmillan, pp. 196–212

Gaisford, S. 1992 *Independent on Sunday*, 22 March

Gilbert, J. 2003 *Independent on Sunday*, 11 May

Goodwin, N. 1992 review of *The Judas Tree, Dance and Dancers*, May, pp. 20–1

Hamilton, P. 1996 *Historicism*. London: Routledge

Husbands, C. 1996 *What is History Teaching? Language, Ideas and Meaning in Learning about the Past*. Buckingham: Open University Press

Jenkins, K. 1991 *Rethinking History*. London: Routledge

Jordan, S. and Thomas, H. 1994 Dance and Gender: Formalism and Semiotics Reconsidered. *Dance Research* XII, 2: 3–14; reproduced in A. Carter 1998 *The Routledge Dance Studies Reader*. London: Routledge, pp. 241–9

Levine, L. 2003 *Sunday Telegraph*, 4 May

Mackrell, J. 1992a *The Independent*, 21 March

—— 1992b *Vogue*, March

—— 2003 *The Guardian*, 2 May

Manning, S. 1993 *Ecstasy and the Demon: Feminism and Nationalism in the Dances of Mary Wigman*. Berkeley, CA: University of California Press

McMahon, D. 1992a *What's On*, 25 March

—— 1992b *Spectator*, 28 March

Matluck Brooks, L. 2002 Dance History and Method: A Return to Meaning. *Dance Research* 20, 1 Summer, pp. 33–53

Mercer, D. (ed.) 1995 *Chronicle of the Twentieth Century*. London: Dorling Kindersley

Muntz, P. 1997 The Historical Narrative. In M. Bentley (ed.), *Companion to Historiography*. London: Routledge, pp. 831–72

Nugent, A. 1992 *The Stage*, 2 April

Parry, J. 2002 in *Revealing MacMillan*. London: Royal Academy of Dance

Percival, J. 1992a *Dance and Dancers*, May, pp. 18–19

—— 1992b *The Times*, 23 March

Postlewait, T. 1992 History, Hermeneutics and Narrativity. In J. G. Reinelt and J. Roach, *Critical Theory and Performance*. Ann Arbor, MI: University of Michigan Press. pp. 356–68

Taylor, J. 1992 *Mail on Sunday*, 22 March

Thorpe, E. 1992 *Evening Standard*, 20 March

Wells, L. 2003 *The Stage*, 8 May

White, H. 1989 New Historicism: A Comment. In H. Aram Veeser (ed.), *The New Historicism*. New York: Routledge, pp. 293–302

Worthen, W. B. 2003 Introduction: Theorising Practice. In W. B.Worthen and P. Holland (eds), *Theorizing Practice: Redefining Theatre History*. Basingstoke: Palgrave Macmillan, pp. 1–7

Headlines

Daily Telegraph, 21 March 1992
Evening Standard, 12 March 1992
Gay Times, May 1992
Independent, 21 March 1992
Independent on Sunday, 22 March 1992
Wolverhampton Express, 13 March 1992

Video and DVD

Jordan, S. and Morris, G. 2005 *Ashton to Stravinsky: A Study of Four Ballets.*
 London; Television Roehampton
The Judas Tree, 1998 on video *Nutcracker Sweeties,* Birmingham Royal Ballet.
 London: Warner Music

3
Unbalancing the Authentic/ Partnering Classicism: Shobana Jeyasingh's Choreography and the *Bharata Natyam* 'Tradition'

Janet O'Shea

> The discovery of a dance language both individual and beautiful is always what choreographers are after but very few have succeeded like Shobana Jeyasingh. Trained in traditional Indian classical dance, but resident in London, she fuses exquisite ancient Asian technique and a totally modern urban British ear for music and eye for design.
>
> (Brown, 2002, p. 6)

Ismene Brown's effusive review raises questions about the perception of South Asian and South Asian-derived dance in Britain today. Even as Shobana Jeyasingh and other choreographers experiment with Indian classical vocabularies and integrate themselves into the mainstream of British dance, an enduring Orientalism inflects the reception of their work. In reviews like Brown's, the classical dance forms that serve as these artists' point of departure remain identified as 'ancient' and 'exquisite', despite the vicissitudes of their histories and the contingent nature of their traditionalism. Irrespective of a long history of modern dance in India, a contemporary aesthetic sensibility still aligns with Britain.[1] Moreover, the review emphasises Jeyasingh's geographic positioning, indicating, perhaps, a mild surprise that the choreographer lives in London, a response that overlooks the global history of *bharata natyam* and the diasporic nature of Indian communities.

I do not present this critique to berate Brown. Reviewing works on a weekly or nightly basis produces its own challenges. A detailed knowledge of the historical and aesthetic specificities of the world's classical dance

forms might be a lot to ask of a dance critic. But when a choreographer like Jeyasingh is so prolific and so articulate about the representation of her own work and about *bharata natyam*'s history, I wonder why we continue to hear about Jeyasingh as though her work were a 'fusion' of otherwise opposites, a place where 'East' and 'West' have met for the first time. I question why we do not hear more of Jeyasingh's work as she presents it: a negotiation of numerous influences, originating not simply from India and Britain, but arising out of the multiplicity of migrations and pathways that make up modern, urban life (Jeyasingh, 1993, p. 8; 2000). I become even more concerned hearing such reviews of Jeyasingh's work when I consider that *bharata natyam* is a highly visible form that has produced a number of contemporary and classical choreographers. Since the late 1990s, the explosion of new choreographies within the South Asian dance field, especially in Britain, has begun to challenge the critical perception that associates India with classicism and Britain with innovation. However, even as viewers and writers recognise the category of contemporary British South Asian dance, they tend to portray 'tradition' as the static foil against which innovative choreographers work.

In this chapter, I challenge this assumption and demonstrate that Jeyasingh's choreography, while distinctive, engages reflexively and dynamically with classical practices that are as much subject to debate as work that defines itself as contemporary. For instance, responding to those who suggest that her work fundamentally alters an otherwise unchanged practice, Jeyasingh maintains that concepts of classicism and tradition define themselves not through an exact replication of their past, but through consensus among performers and viewers (Jeyasingh, 1993, pp. 6–7). She counters the suggestion that her work unsettles a static orthodoxy by arguing that her *oeuvre* interrogates a constructed, not inherently fixed, tradition (Jeyasingh, 1995, p. 193). Jeyasingh's choreographic inquiries and the ways in which she frames them demonstrate that not only contemporary work but also 'tradition' itself is in flux and that a range of different strategies can be deployed in order to engage with it.

Stephanie Jordan argues that too much attention to the cultural and political issues associated with Jeyasingh's work ignores the choreographer's 'abstractionist' concerns (1996, p. 40). Jordan finds that, although Jeyasingh draws out the geometric, spatial and temporal qualities of both her work and the classical form she draws on, analyses of her work tend to focus on 'contextual themes of migrancy and of relation to tradition' (1996, p. 40). I share Jordan's concern that Jeyasingh's choreography,

having escaped the frequently exoticised category of Indian dance, should not become equally fetishised as diasporic, hybrid and global at the expense of attention to form. However, it is not just critics and scholars who affiliate Jeyasingh's work with identity and mobility. Jeyasingh's own commentaries, and increasingly her choreographies, also reflect on the complexities of belonging.[2] But Jeyasingh puts forward more nuanced notions of identity and difference than those viewers who would see her and her choreography as 'Indian'. Jeyasingh highlights her position not as Indian, and frequently not even as British, but as urban and migratory. She insists that she is not alone in this regard: 'Late twentieth-century living…has made Captain Kirks of us all' (1995, p. 192).

Jeyasingh's choreography and writing investigate identity and belonging, but in such a way that she turns the mirror back onto the 'original' subject, the ostensibly neutral category from which her choreography departs. For instance, where critics and viewers highlight Jeyasingh's Indianness, Jeyasingh urges us to look at how India has integrated itself into Britain, as well as vice versa. Where spectators might see hybridity in Jeyasingh's experience as a diasporic subject, Jeyasingh reminds us that we are all hybrid. Although she is celebrated as a choreographer who challenges tradition, both her commentaries and her choreography demonstrate that the classical practice she draws on developed out of contestations between colonialists, Indian social reformers and cultural nationalists (1993, p. 7; 1995, p. 193).

Jordan further argues that we should not simply see Jeyasingh's work in terms of how she 'develops from and "subverts" classic Bharatha Natyam style' (1996, p. 41). Here, I depart from Jordan's critique as I emphasise Jeyasingh's relationship to the classical form, doing so because Jeyasingh deploys the movement vocabulary of *bharata natyam* even while she questions it. Jeyasingh has also, over the course of her career, appeared as both a challenger of tradition and its representative. Her commentaries (1982, 1992, 1990, 1993, 1995, 2000, 2005) investigate the conventions of classical *bharata natyam* while querying the social, cultural and aesthetic meanings of the form. Jeyasingh's choreography simultaneously explores, critiques and fragments classical material. This is more than a 'subversion' of classicism; it is a critical engagement, a deconstruction, a re-evaluation and an historical exploration, sometimes all at once.

With Jordan's critique in mind, I integrate movement description with a consideration of its cultural, aesthetic and political implications.[3] I consider Jeyasingh's work alongside the classical form in which she

trained, not to evaluate the degree to which she overturns it, but to consider how she extracts choreographic elements to fracture and refigure them. Jeyasingh describes this process as 'asking questions of the *adavus*' (personal correspondence 1999). *Adavus* are units of movement that operate as the building blocks of classical *bharata natyam*. They are both the vocabulary on which repertoire rests and the training exercises through which dancers attain technical mastery. In investigating these movement elements, Jeyasingh reflects on the choreographic components of the classical form, but does not see them as determinative. She examines aspects of classicism, pushing and pulling at their edges, tipping them off balance, resting them on their side or inverting them. I thus extend her statement, taking the idea of questioning the *adavus* as a methodology for approaching her choreography. I apply this frame to three of Jeyasingh's choreographies: *Romance ... with Footnotes* (1993), *Phantasmaton* (2002) and *Exit No Exit* (2006).

Shobana Jeyasingh, aesthetic categories and dance forms

Before this, I delineate categories in order to position Jeyasingh's work and indicate the extent to which the classical dance form *bharata natyam* is itself in transition. The term 'traditional' suggests an unbroken, handed-down heritage while 'classical' denotes an adherence to a set of defined principles. The distinction made in English between the two concepts parallels that made in Indian aesthetic theory between *parampara*, oral tradition, and *sastra*, canonical text. In the case of *bharata natyam*, the term traditional has several meanings. 'Traditional' *bharata natyam* can refer exclusively to specific genres of dance items, created within the conventional *margam*, solo concert order, as laid down by the musicians of the Thanjavur court in the nineteenth century. The word 'traditional' also appears in discussions of hereditary dance practitioners (*devadasis* and their mentors, the *nattuvanars*) and their role in propagating the dance form.

Bharata natyam practitioners, as I discuss elsewhere (2006, 2007), have produced a range of choreographic projects as well as commentaries that reflect on the dance form and its origins. In recognition of this diversity, here I use the term 'classical' rather than 'traditional' to refer to performance practices within the realm of the traditional *margam* and those within the arena of new classical work, including ensemble and evening-length pieces that deploy the *bharata natyam* movement vocabulary, incorporate many of its themes and use conventional

musical compositions and instrumentation for its accompaniment. I restrict my use of the term 'traditional' to refer to specific items as they feature in the *bharata natyam* repertoire and to refer to imagery that invokes the *devadasi* past.

While Indian classical dance forms consist of both abstract (*nritta*) and dramatic (*abhinaya*) aspects of performance, the 'story' component of classical Indian dance forms tends to be both emphasised and exoticised, especially internationally.[4] Western analysts understand formalism to be part of their own classical tradition but may have trouble seeing the structural elements of Indian dance forms. As such, Jeyasingh's experiment with form might seem radical to a dance viewer who associates Indian dance with traditionalism, but might seem less so to a spectator who links it with classicism.

Although I explore Jeyasingh's work alongside other inquiries within the *bharata natyam* field, Jeyasingh is usually positioned within the field of British contemporary dance. There are several reasons for this. Jeyasingh works within a western high modernist tradition that emphasises choreographic form over dramatic expression and highlights abstract movement, spatial pathways and the arrangement of dancers in complex groupings. She identifies her project as one of 'creating a new dance language' (1995), in itself a modernist initiative.[5] Her work also intersects with postmodernism in that she draws on a classical form as well as a range of other movement practices, such as the Indian martial art form *kalaripayattu*, ballet and a range of western contemporary dance styles. In addition, her choreography aligns with postmodernism by 'taking the surface seriously' (2000), a feature that Jeyasingh also sees as inherent in classical forms (2005).

In this latter regard, Jeyasingh deconstructs classical aesthetics. I define deconstruction here through Emilyn Claid's (2006) investigation of Derridean categories. Claid discusses choreographic projects that parallel Derrida's exploration of canonical texts within the western literary tradition (2006, p. 143). Claid identifies a parallel between the performer's 'play between' extremes and Derrida's notion of *différance* in which '[t]he meaning of every term only comes into play through its placement in relation to other terms, opening up each and every language term to a displacement of a single truth' (2006, p. 6). Like Derrida's notion of *différance*, Jeyasingh's choreography hinges on the investigation of individual units, attending to their possibilities and seeing where they can split into fractions of themselves to produce other options. However, Derrida's concept applies specifically to the ways in which words produce a multiplicity of meanings. In Jeyasingh's choreography,

each unit of vocabulary or phrase, when broken apart, opens up to produce a multiplicity of new 'terms', that is, new units of movement. Because of her attention to and manipulation of the components of the 'classic text' – the *adavus* of *bharata natyam* – I refer to Jeyasingh's choreography as a deconstruction of a classical movement language.

Delayering and spatialising:
Romance...with Footnotes

Romance...with Footnotes, like the *varnam* of the conventional *bharata natyam* repertoire, alternates lyrical, contemplative sections with explosions of virtuoso footwork.[6] In a *varnam*, a dancer renders dramatic phrases through codified hand gestures (*mudras*), stylised facial expressions and pantomimic bodily gestures to visualise a sung poem. In these sections, *mudras* carry specific linguistic meanings as representatives of words, objects or concepts. The dancer exploits facial expressions to depict emotions and uses her gaze in the role of a particular character either to portray a specific sentiment or to invoke another (imaginary) character on the stage. The *tirmanams* of the traditional *varnam* feature highly technical, clearly articulated phrases of footwork. These sections emphasise the rhythmic and spatial components of movement instead of dramatic interpretation. Although *mudras* accompany footwork, they have no literal meaning and serve to augment the choreography rather than to portray an emotional state or invoke an image. The conventional *varnam* thus relies on tension between lyrical, sustained sections that convey poetic meaning and rhythmic, virtuoso phrases that contain no thematic content.

Romance...with Footnotes retains this contrast not by juxtaposing dramatic and abstract movement but by constructing qualitatively distinct dance elements. Like the solo performer in a *varnam*, Jeyasingh's dancers alternate between lyrical and rhythmic phrases. Although it retains structural similarities to classical choreography, *Romance...with Footnotes* also radically alters both sections of the *varnam*. The dancers in *Romance...* do not directly invoke emotional states, nor do they depict characters. Instead, they maintain an intense seriousness combined with a spirit of exploration throughout the piece. Even the rhapsodic portions of *Romance...* project an overall tone of solemnity, rather than conjuring emotional states. Jeyasingh does not use *mudras* as a linguistic system but treats them as spatial shapings, which extend into full body movements that change levels and initiate contact between dancers. For instance, when one dancer holds her hands at the side of her

face, fingers at a right angle to suggest the playing a flute, she does not smile or sway in time to the imagined music. She holds her pose as another dancer circles her and runs her hands over her taut fingers, emphasising their shape rather than attending to their meaning.

Jeyasingh elaborates on the rhythmic focus of the *tirmanams* by choreographing phrases that travel along divergent spatial pathways, with dancers moving in contrasting directions, a decision that requires delayering the complexity of solo dance.[7] She also exploits the spatial possibilities offered by an ensemble of dancers as performers begin phrases in unison, only to branch off into changing groups of twos and threes, charting different trajectories as they travel through the stage space.

Jeyasingh's use of contact between dancers also points to the modifications she has made to *bharata natyam*'s vocabulary, syntax and thematic content. Classical *bharata natyam* depicts romantic encounters and emotional reactions usually based on themes of love in separation that serve as a metaphor for the human relationship with the divine. The classical form thus dramatises connections between individuals. In contrast, *Romance... with Footnotes* physicalises human interaction, portraying contact that is impersonally cooperative. This touch sometimes nurtures and supports, but it also literally unsettles: the dancers tip, pull and push each other off balance. Here, physical interaction causes a dancer to reorient herself.

Through these choreographic strategies, Jeyasingh relies on *bharata natyam* at the same time that she distances herself from it. The choreography retains a grounded use of weight. An angular relationship between joints characterises the dancers' stances[8] and their body positions hinge around the division of the body into triangles, a feature that Jeyasingh identifies as central to *bharata natyam*.[9] However, Jeyasingh replaces the emotional expression of the classical form with light, briefly sustained contact, contained bodies and immutable facial expressions. Her dancers create an aloof ambiance, attending to both transitional and highly technical movement with the same calm attitude. They partner each other with a similar combination of intense concentration and unemotional bearing.

Performing history/imagining a future: *Phantasmaton*

Phantasmaton extends this deconstruction of the *bharata natyam* language, bringing it into closer negotiation with ballet, several contemporary dance styles and quotidian movement. Low, creeping movements also indicate

an ongoing dialogue with *kalaripayattu*. A filmed image of a classical dancer in traditional costume, makeup and jewellery appears alongside the performers. The film is in grainy black and white, marked by digital artefacts as though it were an old, faded photograph. The dancer is frequently still or moves very little. All these elements give her a ghostly quality. The rest of the stage design has an industrial appearance, featuring a structure made of shale squares and wispy metal branches.

The projected image-dancer walks slowly towards the camera, eventually moving so close that she vanishes. As soon as she is no longer

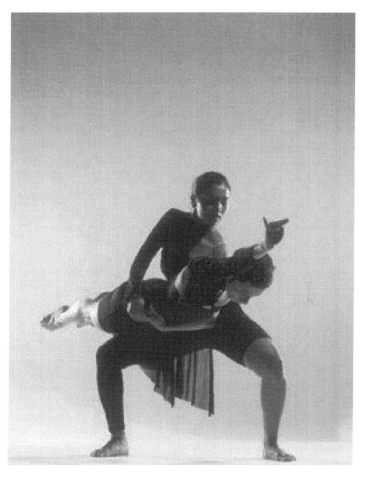

Figure 1 Chris Nash for Shobana Jeyasingh Dance Company in *Phantasmaton*

visible, the pattern repeats: she appears in a full-body shot, walks forward, disappears. Meanwhile, the ensemble of dancers emerges from far stage left. A white rectangle of light isolates them from the rest of the stage. They move in unison, then diverge from one another, first breaking apart in space, then altering their sequences, creating a dense visual pattern, before finally returning to unison. The grouping is tight and their footfall is soft; arms and legs extend fully. Their sudden hip isolations fracture the verticality of the classical vocabulary.

A quintet forms a tight cluster. Sharp stamps – fragments of *adavus* – puncture their phrase. The projected image-dancer turns her head as though to look at the group next to her. The dancers interrupt themselves with a quotidian walk that takes them across the stage,[10] as white noise obscures the image of the projected dancer. The projected figure splits into an abstract image: a series of spots in the shape of an oval. Only when the shape moves from left to right and back again, indicating the *ardhami*, or head and neck movement of a classical Indian dancer, does the shape refer back to the classical dancer's face. The image breaks apart again into white noise.

The visual static spills out onto one of the live dancers. A solo dancer raises a flat, inwardly rotated palm in front of her face and lifts the other hand from behind to touch her forehead, suggesting an iconic image of a woman adjusting her jewellery while gazing into a mirror; a turning in of the feet and drooping of the arms follows. A duet, which references and inverts the classical ballet *pas de deux*, follows: Sowmya Gopalan partners Mavin Khoo through a series of lifts and extensions. She catches Khoo in a swan-dive, tilting him briefly towards the floor, pivoting him into a leg extension, then further into a backbend. Out of this, the pair shifts into a partnering style typical of Jeyasingh's earlier works: extending arms to one another and pulling away, they share responsibility for one another's weight. The dance ends with Khoo, far upstage and behind the structure on which the projection appears, with his arms above his head, his weight on a bent leg, sinking into one hip. A dancer, partially obscured, moves him offstage.

Phantasmaton reworks *bharata natyam* and other movement languages, but retains a connection to the pasts of the forms it explores. The filmed dancer who moves so close that she disappears and whose image shatters into white noise suggests the 'ghosting' of the *devadasi* image. It also suggests the ways in which this past has been applied to classical dance practice at the same time that it is removed and exoticised, made unknowable by the present-day conditions of training and performance.[11] The dancer's slow, methodical movements contrast, in their

dreamlike quality, with the sudden, frenetic and articulate vitality of the dancers onstage.

However, it is not just *bharata natyam* that is subject to this historical layering. Jeyasingh deconstructs ballet alongside *bharata natyam*. Working with the ballet-trained Khoo, she unsettles balletic conventions while retaining some of its aesthetic features. She accomplishes this not only by reversing the expected genders of the dancers – having the powerful Gopalan lift and pivot the slight Khoo – but also by changing the movement dynamics and shapes. Gopalan's partnering, while masterful and smooth, is not exactly effortless. Her stance is frequently grounded and angular. She does not fade into the background to display Khoo; her angles and extensions frame him and offer additional visual texture.

Balletic references also appear in Khoo's solos, not just in the *bourées* by which he traverses the stage and in the elongated extensions of his arms and legs, but also in the repetition of a particular image: Khoo tilts forward from the waist and brings his arms behind him, rippling them like wings. This image invokes the balletic trope of the swan. It suggests the specific intersection of the histories of *bharata natyam* and ballet by conjuring the historic moment at which Rukmini Devi witnessed Anna Pavlova's *Dying Swan* solo. This image suggests the hybrid nature of the modern classical forms. By evincing the encounter between Devi and Pavlova, Jeyasingh indicates the international exchange at the base of the *bharata natyam* revival and signals the colonial conditions that gave *bharata natyam* respectability and popularity. This imagery not only changes perceptions of dance traditions but also deconstructs a sense of time. Instead of moving in a linear sequence from *bharata natyam*'s origins in temple dance to the encounter between Pavlova and Devi to the present-day[12] and into a futurist landscape, Jeyasingh inserts historical references into recently composed phrases and layers the contemporary and futurist design aspects with the crackling black and white image of a 'traditional' dancer.[13] This suggests that history, usually celebrated in classical *bharata natyam*, is itself elusive, impossible to grasp or even to see in its entirety.[14]

Exit/No Exit

Exit/No Exit (2006) continues the fragmentation and exploration of a range of movement vocabularies. The different dance languages align with one another, cut across each other, and collide. *Exit/No Exit*, however, seems to comment less on the intersecting histories of dance forms and more on the ways in which individual experiences interconnect or

fail to connect. In this process, Jeyasingh (re-) incorporates expressivity into choreography.

Rathimalar Govindarajoo[15] sits at a table, alone. A musician sits onstage, clarinet in hand but not yet playing, on a large elevated wooden chair, reminiscent of a lifeguard's platform. Govindarajoo stands and drifts towards centre stage. Her solo alternates between jerky and lyrical movements; rapid twitches shift into a sustained sweep of an arm. Punctuating the phrase with foot strikes to the floor, Govindarajoo extends a hip, flicks her hands before a light, childlike jump and drops to the floor in a *bharata natyam mandi*, or full sit. She grabs a foot and dives into a forward-leaning arabesque extension. A hand works its way into an *allapadma* (open lotus) *mudra,* where fingers extend out from an open palm. The dancer accentuates the vulnerable look of the open palm with a release of breath and an expression of intense longing as it takes her into a deep *mandi* position.

Two dancers – Kamala Devam and Shane Shambu – interrupt the soloist, leaving her to find her way back to the table. The pair pivot and dive over one another, a playful, tumbling quality offsetting their frenzied movement. Devam leaps and Shambu catches her; Devam guides Shambu through turns; Shambu rolls his way over Devam's body; each turns the other's head with their hands.

A trio interrupts the duet. These dancers tilt and extend their torsos, moving into and out of grounded leg positions with rotated legs. Dancers bend forward from the waist, catch their own arms and arch their backs while reaching forward. A foot kicks behind the body, followed by a glance over the shoulder. Devam smiles occasionally, while Govindarajoo, still at the table, stares impassively.

Poses invoke classical *bharata natyam* when a foot crosses over a standing leg, when an arm extends then breaks at the wrist and elbow and when a dancer bounces from a *mandi* to a rotated knee drop. Quotes of *bharata natyam* appear in longer sequences of *adavus* that punctuate a phrase or that end it. A deep bend with an extended leg recalls a *bharata natyam* exercise, an impression that is furthered by tightly angled hands appearing by the side of a dancer's face, a gesture that, in a classical piece, would indicate flute playing.

Movement is fluid and sequential in this piece. Arms scoop, curve and sweep into positions. The movement dynamics are more reminiscent of contemporary dance – especially release techniques – than of *bharata natyam*, ballet or *kalaripayattu*. Yet the architecture of the phrases – their grounded, angular and staccato qualities – suggest another extension of the exercise of 'asking questions of the *adavus*'. This process of questioning departs from the cool remove of Jeyasingh's

earlier pieces and invokes isolation, interruption and, perhaps, longing.[16] A sense of frenzy and disjuncture has overtaken the scientific, investigative qualities of *Romance...with Footnotes* and *Making of Maps*. The device of interruption that Jeyasingh also used in *Phantasmaton* allows her to explore the relationship of individuals and groups, an inquiry that extends to the subsequent piece, *Faultline* (2007), which explores masculinity among Asian youths in present-day Britain.

Imagined homelands

These deconstructive gestures enable Jeyasingh to negotiate 'a pattern of belonging that is multi-dimensional' (Jeyasingh, in Mackrell 2002). Just as Jeyasingh presents her work within the British mainstream contemporary dance milieu, so she also contests an Orientalist worldview that sees Indian dance as mysterious, enigmatic and laden with literal meaning in contrast to the irony, distance and ambiguity of western theatrical dance forms. By mitigating her use of representational *mudras* and avoiding sung poetic text, Jeyasingh highlights the formal qualities of *bharata natyam*, supporting her argument that this dance material can be just as transparent to audiences as European and American dance practices.[17] She asserts that the units of movement in *bharata natyam* constitute an 'objective language' that does not necessarily conjure social, cultural or historical referents.[18] She reminds her viewers that the movement languages she uses as her base, including *bharata natyam*, primarily concern themselves with form and only secondarily with meaning. By presenting choreography that highlights the shape and the structure of movement over emotion and representation, Jeyasingh has levelled the field between western contemporary dance and Indian classical vocabularies.

Having challenged her audiences to see the architecture of the dance, rather than only search for its meaning, Jeyasingh now experiments with expression, including the demonstrative potential of the movement languages she investigates. She does so, however, by pushing her audience to look for multiple levels of meaning and to explore a range of themes themselves, recognising that numerous interpretations might be present at once. This overt layering steers viewers away from the search for a single, literal meaning.[19] The complex visual and mathematic density of Jeyasingh's work contrasts sharply with the easy comprehensibility of much ensemble work within the classical *bharata natyam* sphere, which frequently 'delayers' *bharata natyam* by simplifying it.

In creating this densely textured, dynamic and sometimes frenetic choreography, Jeyasingh upsets conventional assumptions about Indian

dance. Especially in her written commentaries, she challenges two hypo-
thetical sets of viewing positions.[20] The first might expect her work to
convey the timeless, unchanging truths of ancient Indian religion and
philosophy. This spectator would assume that Indian dance always
conveys 'spiritual' meaning and never concerns itself with quotidian
realities. Paradoxically, this observer would ascribe profound wisdom to
Indian dance while simultaneously envisaging the female practitioner
as eroticised and disempowered.[21] This spectator, although perhaps
benign in intention, would assume that Indian dance does not have
access to contemporary aesthetics and would therefore infer that Indian
choreographers could not employ modern and postmodern strategies.

Jeyasingh's choreography unsettles these expectations. To the demand
for 'authenticity' she provides a sense of distance as her dancers pull
each other off balance without interacting dramatically and a sense of
dynamic play as they catch, lift and throw one another. She provides
recurring structures, visual density and mathematical patterns, all of
which themselves are repeatedly interrupted. To the desire to find phil-
osophical meaning elsewhere, in the practices of 'Others', she offers a
modernist abstraction combined with a postmodern layering of themes
that encourages a range of interpretations. To the assumption of inexpli-
cable profundities, Jeyasingh stages an abstraction which dictates that
literal meaning matters less than recurring structures and patterns
created by bodies in space. The dancers' deadpan facial expressions and
their frequent interruption of one another confound assumptions about
the profound, meaningful, but evasive content of Indian dance.

Not only does Jeyasingh contest neocolonial expectations of her
dance, she also unsettles the Orientalist-influenced concerns of diasporic
Indian communities. A hypothetical non-resident Indian (NRI), nostal-
gic for an unchanging, historically rooted homeland that contrasts with
the alienated West, would turn to Indian dance to satisfy a desire for a
pure Indian tradition sealed against influence from western modernity.
He/she would assume that tradition can remain unaltered not only after
colonialism but also in the West. This viewer would use this assump-
tion, not as a criticism of India, but as a means of maintaining Indianness
in diaspora.

Jeyasingh problematises emigrant nostalgia, as expressed through
patronising, practising and viewing classical dance, by suggesting that
'home', an imagined category, represents more the longings of the wist-
ful individual than the traits of the homeland itself (1995). To the
demand for cultural origins, she summons up a diasporic and hybrid
present, fraught with conflict and contradiction. By mapping her blend

of movement languages onto the bodies of her dancers – men and women, South Asian, East Asian, European and North American – she breaks a conventional association of women with tradition, demonstrating that young Indian women and men alike participate in cultural blendings and that hybridity is not unique to the South Asian diaspora. Furthermore, as her dancers lead and follow one another from, for example, *mudra* to floorwork, Jeyasingh seems to suggest that dancers can participate actively in this exchange.

Jeyasingh's choreography thus counters several expectations. She disputes the assumption of 'cultural purity'[22] associated with India, by signalling its amalgamated heritage and the potentials that inhere in the intentional blendings of forms. She subverts the assumption that the histories of dance forms are separate, illustrating that the histories of Britain and India and their dance practices intertwine. She disrupts the classical *bharata natyam* dancer's direct and linear recourse to the past, illustrating the multiple histories of modern *bharata natyam*.

I find Jeyasingh's work exciting because of the specificities of her inquiry. Her honesty about the fragmented and contingent nature of tradition in *bharata natyam* is refreshing, as is her willingness to look not just back or forward but simultaneously in a multiplicity of directions. This impetus lies as much in her willingness to embrace instability within *bharata natyam* as in an interest to engage with the aesthetics of other dance forms.

Notes

1. Not all reviewers take the approach I have critiqued here. Mary Brennan, writing in 1994, emphasised classicism and contemporaneity as aesthetic choices not as cultural categories or as associated with historical periods. Brennan describes Jeyasingh's project as an exploration of the fundamentals of the *bharata natyam* vocabulary in order to open up its possibilities. Keith Watson (2002) identifies Jeyasingh's work as 'multilayered' rather than as fusion. A review from 1993 in the *Asian Times* celebrated Jeyasingh's experiments while placing them in a context of innovation: 'In India, Kumudini Lakhia and Chandralekha have already contemporised Indian dance' (Anon., n.p.).
2. *Surface Tension*, according to Jeyasingh, examines facets of the urban experience. *Exit No Exit* seems to explore a personal identity in which an individual is cut off from a group. *Faultline*, inspired by Gautam Malkani's novel *Londonstani*, explores issues of masculinity among South Asian youth.
3. See Lansdale (this volume) for a further discussion of the integration of interpretation with analysis. Texts that identify the political implications of specific choreographic works or dance practices include Browning (1995), A. Chatterjea (2004), Manning (1993), Novack (1990), and Savigliano (1995).

4. Jeyasingh points out that the use of the hand in Indian dance has been exoticised by Western viewers (Making of Maps video).

5. Jeyasingh resists the term modernist as applied to her work: 'Since work like mine only becomes part of the British narrative well after modernism had given way to post-modernism, this label does not apply. I think what I do is more typical of postcolonial migration. The collision of such eccentric histories within the mainstream British one is typical of what urban contemporary art is about today' (Jeyasingh, in Sanders, 2004, p. 2). While I recognise the postcolonial, diasporic and urban nature of Jeyasingh's inquiry, here I use the terms 'modernist' and 'postmodern' to refer not to artistic periods but to sets of sensibilities that can be present in a single dance work.

6. Sarah Rubidge notes this similarity between the structure of the classical varnam and that of *Romance ... with Footnotes* (1996, p. 40).

7. Jeyasingh refers to this process as follows:
 > [*bharata natyam*] has an immense density of structure but within one body – if one wanted to unpick that structure from the individual body, then one found that in fact one had to compensate by compositional layerings (1995, p. 194).

8. Kapila Vatsyayan (1992) identifies this angularity as central to Indian classical dance forms.

9. Jeyasingh discusses the division of the body into triangles in her commentary on the *Making of Maps* video (1992).

10. Judith Mackrell comments on repetition and interruption in *Phantasmaton*:
 > An accumulation phrase is performed, phrases are broken by the dancers suddenly striding away, and an action in which a dancer is lifted up and carried off the stage is repeated many times (2002, p. 3).

11. Mackrell makes a similar observation about the digital dancer: 'Projected in black and white on to a geometric patchwork of screens, she is a traditional bharata natyam soloist in full make-up and Indian dress – and her flickering, wide-eyed presence haunts the stage upon which her 21st-century descendants experiment with variants on her ancient temple dancing' (Mackrell 2002).

12. Lakshmi Viswanathan's *Banyan Tree* forms a contrasting example. This piece tracks the emergence of dance in the Tamil-speaking region of southern India, following its vicissitudes up to the staging of twentieth-century *bharata natyam*.

13. Mackrell describes this relationship between past and future in *Phantasmaton*:
 > [G]eometric sheets of metal mesh ... [F]uturistic sculptures become opaque screens ... [that] carry the flickering digitalised image of a traditional Bharata Natyam dancer. A ghost from the past, a connection to the future (Mackrell 2002).

14. A statement on the ResCen website offers a similar interpretation of the piece's exploration of the past, integrating this with understanding that focuses on urban life: 'Phantasmaton is inspired by the almost surreal way in which we continue to reinvent ourselves within the accelerating pace of our cities. Our interpretation of the past just (sic) as conditioned by technology as our navigation through the present.' (http://www.robat.scl.net/content/ResCenSite/Shobana_Jeyasingh/phanta.html. Accessed 29 June 2007)

15. In the version of the piece that I saw live in 2006, Govindarajoo played this role. In a subsequent version, Mavin Khoo performed this part. Here, I use Govinidarajoo's name and the feminine pronoun to refer to this 'character'.

16. Luke Jennings provides an alternate interpretation of *Exit/No Exit*, one which aligns more with my view of *Phantasmaton*:

 [I]t is the past, symbolised by the fractured, sea-changed glimpses of Bharata Natyam, which Jeyasingh is really interested in here. It is the past from which there is no exit. (http://observer.guardian.co.uk/review/story/0,,1728895,00.html. Accessed 29 June 2007)

17. Jeyasingh also argues that audiences can understand classical *bharata natyam* without decoding every word and every *mudra*. As such, she compares *bharata natyam* with ballet, which also includes mimed portions that may not be accessible to every audience member (personal correspondence, 1999).

18. The quote comes from Jeyasingh's commentary in the *Making of Maps* video.

19. One of the problems dancers face when performing Indian dance is that audiences assume that the *abhinaya* pieces 'tell a story', that is, they have one, literal meaning. This assumption overlooks the poetic nature of Indian classical dance, in which a multiplicity of meanings is present at once. I have discussed the interest in literal meaning and a concomitant tendency toward providing verbal translations of *bharata natyam* performances in more detail elsewhere (2003).

20. I have reconstructed these paradigmatic viewing positions from two of Jeyasingh's essays, 'Getting Off the Orient Express' (1990) and 'Imagined Homelands' (1995).

21. The Orientalist characterisation of the 'East' as 'timeless' clearly underlies these paradigmatic viewer expectations. Edward Said's (1978) influential analysis outlines the pervasiveness of such images and locates their roots in both colonial and pre-colonial Western discourses of dominance.

22. I borrow this phrase from Priya Srinivasan, who explores intersections between North American modern dance and Indian classical dance.

References

Brennan, M. 1994 Twisting India out on a Limb. *The Glasgow Herald*, 1 May

Brown, I. 2002 Pick of the Week: Shobana Jeyasingh. *The Daily Telegraph*, Saturday, 2 February, p. 6

Browning, B. 1995 *Samba: Resistance in Motion*. Bloomington: Indiana University Press

Chatterjea, A. 2004 *Butting Out: Reading Resistive Choreographies through Works by Jawole Willa Jo Zollar and Chandralekha*. Middletown, CT: Wesleyan University Press

Chatterjee, B. 2002 The Spin Factor. *Pulse* 3 (Autumn), pp. 9–10

Claid, E. 2006 *Yes? No! Maybe…Seductive Ambiguity in Dance*. London and New York: Routledge

Jennings, L. 2006 Step into the Past. *The Observer*, 12 March 2006. http://observer.guardian.co.uk/review/story/0,,1728895,00.html. Accessed 29 June 2007

Jeyasingh, S. 1982 Bharatha Natyam: Understanding Indian Classical Dance. *New Dance* 23, pp. 3–5

Jeyasingh, S. 1990 Getting off the Orient Express. *Dance Theatre Journal* 8, 2, pp. 34–7

—— 1992 What is Dance? *Dance Now*. Spring, pp. 21–2

——1993 Traditions on the Move. Transcript of presentation, open forum, Academy of Indian Dance. 6-9. Appendix comp. and prod. Tina Cockett

—— 1995. Imaginary Homelands: Creating a New Dance Language. In *Border Tensions*. Guildford: Department of Dance Studies, University of Surrey, pp. 191–7

—— 2000 Presentation. University of Surrey.

—— 2005 Presentation. *Negotiating Natyam*. Royal Opera House, London

Jordan, S. 1996 Networking Dances: Home and Away in the Choreography of Shobana Jeyasingh. *New Dance from Old Cultures: Green Mill Papers 1996*. Crusader Hill and Urszula Dawkins (eds), The Australian Dance Council. Braddon ACT.

Mackrell, J. 2002 Phantasmaton. *The Guardian*. 6 February http://www.guardian.co.uk/reviews/story/0,3604,645557,00.html. Accessed 29 June 2007

Manning, S. 1993 *Ecstasy and the Demon: Feminism and Nationalism in the Dances of Mary Wigman*. Berkeley, CA: University of California Press

Novack, C. J. 1990 *Sharing the Dance: Contact Improvisation and American Culture*. Madison, WI: University of Wisconsin Press

O'Shea, J. 2003 At Home in the World? The Bharata Natyam Dancer as Transnational Interpreter. *TDR: The Drama Review* 47, 1, T177, pp. 176–86

—— 2006 Dancing through History and Ethnography: Indian Classical Dance and the Performance of the Past. In T. J. Buckland (ed.), *Dancing from Past to Present: Nation, Culture, Identities*. Madison, Wisconsin: University of Wisconsin Press

—— 2007 *At Home in the World: Bharata Natyam on the Global Stage*. Middletown, CT: Wesleyan University Press

Phantasmaton. ResCen: Centre for Research in the Performing Arts. http://www.robat.scl.net/content/ResCenSite/Shobana_Jeyasingh/phanta.html. Accessed 29 June 2007

'Romance…with Footnotes', a Very Controlled, Elegant Performance 1993. *Asian Times* 23–29 November

Rubidge, S. 1996 *Romance…with Footnotes*. London: Shobana Jeyasingh Dance Company

Said, E. 1979 *Orientalism*. New York: Vintage

Sanders, L. 2004 Choreographer Fact Card: Shobana Jeyasingh. National Resource Centre for Dance

Savigliano, M. E. 1995 *Tango and the Political Economy of Passion*. Boulder, CO: Westview Press

Srinivasan, A. 1983 The Hindu Temple Dancer: Prostitute or Nun? *Cambridge Anthropology* 8, 1, pp. 73–99

—— 1985 Reform and Revival: The Devadasi and Her Dance. *Economic and Political Weekly* 20, 44, pp. 1869–76

Srinivasan, P. 2003 Performing Indian Dance in America: Interrogating Modernity, Tradition, and Cultural Purity. PhD dissertation, Northwestern University

Vatsyayan, K. 1984, reprinted 1992 *Indian Classical Dance* New Delhi: Government of India

Watson, K. 2002 The Green Room: Backstage with…Shobana Jeyasingh. *South Bank Magazine*. April

4
Akram Khan's *ma* (2004): An Essay in Hybridisation and Productive Ambiguity

Lorna Sanders

'A lovely idea lost in a thicket of overblown production' or a 'powerful and resonant piece'?[1] Perhaps underlying these divergent responses to Akram Khan's *ma* (2004) by critics in the UK are limitations to understanding.[2] Contemporary Kathak, the style for which Khan is fêted worldwide, provides difficulties because its complexity is not explicable as *fusion*. Khan's own rejection of the term as inappropriate to his work can be supported in that it suggests an over-simplistic response. To understand Khan's embracing of what he calls the *confusion* of having two physical systems overwritten in his body requires a shift in critical and historical perspectives.

A flavour of the movement in *ma* is discernible in this quotation:

> Kathak's ... stamping feet, its whirring arms, its speed, mesh seamlessly with modern handsprings, barrel rolls and off-centre lurches to forge a mercurial style.
>
> (Gilbert, 2004, n.p)

It is necessary to situate analysis by contextualising *ma*, recognising that 'history does not just provide a background to the study of texts, but forms an essential part of textual meaning' (Loomba, 2005, p. 39). Already expert in Kathak, Khan studied for a degree in dance at De Montfort University and the Northern School of Contemporary Dance.[3] He founded his own company in 2000 with the trio *Rush*.[4] A quintet, *Related Rocks* (2001), followed.[5] The music 'was based on the destruction and construction of a piano, so I immediately thought of Shiva [*sic*] as the creator and destroyer ... we used all the gestures of Shiva ... [it was a]

test run for *Kaash'* (Anon., 2002, p. 4).[6] The starting points for *Kaash* (2002), a full-length work, included the movement qualities traditionally associated with three Hindu gods: Ganesha, symbolised by swinging gestures and three beats; Krishna, playful, darting actions and four beats; and Siva, seven beats and vigorous dynamics *(tandava)*.[7] Khan also takes inspiration from film directors and film (Khan, 2004–5, p. 46) and he used a cinematic flashback structure for *Kaash*.[8] Nitin Sawhney, the composer, added notions of parallel universes and Anish Kapoor's set provided a 'black square painted on gauze that vibrates like a hungry hole, poised to suck in any passing matter' (Mackrell, 2002, n.p). The result was an abstract yet allusive piece:

> [*Kaash*] opens with a lone dancer. He gazes into the void and a woman enters and whispers to him. (Hints of Parvati and Siva perhaps?) A cataclysm of cosmic proportions ensues. The dancers form war-like columns from which they break out, arms slicing with an energy that would split atoms.
>
> (Sanders, 2004, p. 8)

During a break in the tour of *Kaash* Khan made further material for this work. The opportunity to revisit its themes of destruction led to his taking a reworked solo from it as one of the starting points for *ma* (Sanders, 2004). Up to this point his work seemed relatively abstract, but a growing interest in exploring more overt narrative through Contemporary Kathak became evident in *A God of Small Tales* (2004).[9] Khan asked the performers to draw on childhood memories to create movement and stated this dance provided a background experience for *ma* (Sanders, 2004).

Khan acknowledges an essay by Arundhati Roy as an inspiration for *ma*. Although not specific, he seems to be referring to *The Algebra of Infinite Justice* (2002), which explores the social and ecological impacts of the Narmada Valley Project. Roy describes how, with controversial governmental support, a series of dams on one of India's largest river systems resulted in the destruction of natural woodland, the flooding of farms and the displacement of local populations. Khan's 'biggest production to date … [*ma*] ambitiously integrates dance, text and live music' (Anon., 2004b, n.p). He had performed Kathak separately until that point. By its inclusion of the classical form, *ma* highlights its own hybridity.

It is difficult to identify the subtle interplay across the genres in Khan's style using analytical frameworks that treat dances as self-referential

systems which might be fully understood by paying sole attention to internal features. Even where this formalist process is expanded to take account of contextual information, it tends to assume that this assists explanation of the choreographer's intentions embedded in the materiality of the dance or points to influences causally connected to movement choices. It is difficult to elucidate *ma* via these means. Intertextuality, however, accepts plurality as its starting point and so this approach is brought to bear in order to explore how interpretations of the dance might be more appropriately constructed. I am not arguing that all formalist critique is irrelevant, but that Contemporary Kathak is not best served by concomitant notions that genres are homogeneous, unitary practices.

Boundaries which have been broken or crossed cannot be simply reimagined. This strategy leaves interpretational problems unresolved. Analysis of *ma* reveals that although some effects may be traceable to particular origins, all are not. Their significance, answerable in the new context, is not entirely explained by meanings in the old. Khan does not merely relocate movement between Contemporary and Kathak; he transforms it. Writers such as Desmond (1997), for example, point to the complex manner in which movement is reinscripted and not merely transferred between different sites. Recourse to an understanding of genre is necessary in order to frame the work.

Frow, writing within literary and critical studies, sees genre as a dialogic process rather than functioning as determining rules. This is a useful prism through which to view a hybrid style such as Contemporary Kathak since historicity abandons *origin* as the fixing of identity.

> The assumption is that the moment of constitution... establishes... essential characteristics, which then continue to be operative... [but] the form and the function of genres change constantly.
>
> (Frow, 2006, pp. 136–7)

Assessing the dance against its supposed genre (as immutable template) is of limited value. Frow challenges essentialist perspectives that consider genre as operating to segregate works from that which is outside, the *extra-* or *con*textual;

> the edge of the text is a site of dangerous ambivalence which must be negotiated and secured... frames work to... convey information from that adjacent world to the... text. The frame belongs to both domains – both 'inside' and 'outside' – and to neither.
>
> (Frow, 2006, p. 106)

Text is thus performative, working 'upon a set of generic raw materials.' The relationship is one of productive elaboration rather than of derivation (Frow, 2006, p. 24). Stability is displaced and genre, released from a dictatorial role, might be seen more usefully as a sense-making *strategy*. It gives pointers to the kinds of intertextual knowledge that could be appropriate, indicates which reading positions might be available and provides guidance as to 'what … counts as plausible' meaning (p. 103). Not predetermining outcomes, it suggests clues as part of a dynamic interactive process where the reader, in dialogue with the dance, activates their chosen context. This constraint is productive. It reveals a lucrative area of potentialities, 'the unsaid of texts, the information which lies latent' in the background (p. 83).

In summary, boundaries which have been crossed cannot be reconstituted as if their current form fixed them again. Formalist perspectives, however, rely on these strategies. As Loius Arnaud Reid states, these view 'meaning [as] wholly embodied in the aesthetic object' (in Smith, 1971, p. 163) and assume demarked borders are necessary:

> [a dance] is such only by being related to existing works of the same category, and is recognised and appraised by its likeness to and differences from such works. It refers to its own tradition.
>
> (Sparshott, 1995, p. 66)

Interpretive strategies such as these provide partial (in both senses of the term) analyses. For example:

> the dancers … balance in a headstand … he regroups [them] … with quick mercurial steps … but that basic headstand is ugly and inflexible. By repeating it, Khan stops his dance short … other steps reinvent … Kathak. Hands arch, and … upper bodies are flexible, gracefully poised … Khan is strongest when he drops the symbolism and just dances.
>
> (Anderson, 2004, n.p)

By valuing speed and fluidity, with origins traced to Kathak, Anderson is able to exclude other interpretations and dismiss certain actions as unsuitable. Formalist critique such as this tends to assume pre-existing, self-sufficient, regulatory frames of reference. Its sole use encourages a view that unitary outcomes *should* emerge from Khan's *confusion*. When relationships between the aesthetic values typically ascribed to Contemporary dance and Kathak (modernism/classicism, western/eastern,

experimental/traditional) appear to be in tension, as in *ma*, this is assumed a flaw. For example, what are perceived as jarring elements are rejected by Brown without further consideration:

> the choreography, violent and velvety at once, flaunts ... [Khan's] confidence by moving from East to West in a single, fascinating swirl ... poetic and exceptional imaginings are cut by hard driven, dazzlingly lit communal dance sessions. With all lights blazing, the stage resembles a studio, and this feeling of superficial exhibition won't be shaken off.
>
> (Brown, 2004b, n.p)

Frow states that 'the point ... is not to assign [work] to one or more genres, but rather to notice its provocation of the question about what kind of thing this is' (2006, p. 106). Productive ambiguity characterises the kind of thing that *ma* is:

> while his programme notes tell us ... [*ma*] is about issues of land, kinship and belonging, Khan is also investigating what happens when Indian and western styles of storytelling and performance share the stage.
>
> (Mackrell, 2004, n.p)

It is necessary to situate ambiguity within Contemporary Kathak as a positive construct and Derrida's theory on the discursive function of difference is useful here. Signs stand in place of the objects to which they refer, but this implies no *natural* or truth correspondence in the relationship that can be *unequivocally* uncovered. Instead, complex webs of signs produce dispersed meaning which is inherently unstable and temporarily achieved:

> the signified concept is never present in and of itself ... every concept is inscribed in a chain ... within which it refers to ... other concepts, by means of the systematic play of differences. Such a play, *différance*, is thus no longer simply a concept, but rather the possibility of conceptuality.
>
> (Derrida, in Kamuf, 1991, p. 63)[10]

Multiple interpretations are enabled in this nonlinear, open network. Additionally, Derrida's notion of an irreducible *pharmakon* (Greek: poison and cure), in which both meanings of an antithetical term are

present simultaneously, illustrates how ambiguity might be seen as productive *undecidability*. Confusion is not always reconcilable. It is not possible to separate the effects of the subtle interplay across the genres in *ma* when both are present, *pharmakon*-like, in the same movement. Khan is clear that unitary qualities are superseded:

> I put them [contemporary and Kathak] in one place or just let it rest with each other and after a while it starts to kind of, you know, fit in. You know the more time they spend with each other the more it kind of melts into each other ... and occasionally you don't know what is Western.
>
> (Khan, in Khan, 2004b)

Until *ma*, Khan had segregated his performance of traditional Kathak from his Contemporary Kathak work.[11] The inclusion of the classical form in a dance incorporating text highlights issues of hybridity and foregrounds the question of how these genres operate. Khan claims his style is the unintended consequence of learning two physical systems which became overwritten in his muscles (Sanders, 2004). The result is that the originary techniques and their associated value systems are present simultaneously in an *inseparable flux*. This is the confusion to which he refers.[12]

Formalist readings of *ma* are thus destabilised. Essentialising frameworks, which misconstrue or ignore these issues, cannot reasonably offer effective analytical models because they deny those aspects of hybridity which might better elucidate it. At a different level of operation, they remain useful for excavating internal relationships, such as identifying rhythmic components, as long as they are not used as universalising approaches to nullify difference. Intertextuality seems appropriate to apply to Khan's style because 'its very openness ... invites the interaction of sometimes separate worlds' (Adshead-Lansdale, 1999, p. 13). Heterogeneity can now be approached as something positive.

In summary, as outlined earlier, a number of contextual issues seem pertinent to understanding *ma*: the embodiment and background of the performers and collaborators; aspects of childhood and memory; Roy's literature; ecological concerns; the inseparable flux of the genres in Contemporary Kathak; and Khan's film interests and earlier work, in particular that associated with Siva's creation–destruction cycle. The version of *ma* under consideration is a television recording of the world premiere.[13]

I have suggested that ambiguity is productive. This is immediately suggested by the fact that the etymology of the dance's title points to

Figure 2 Akram Khan Dance Company in *ma*. Photograph Damian Chapman

two cultures (Sanders, 2003). Understood both as colloquial English and as a Hindu word with connections to the Sanskrit *mātā* (Skeat, 1983), *ma* means both mother and earth. An illustration in the advertising flyer makes reference to this.

The two metaphors interpenetrate suggesting nurturing and its absence, the soil is tilled for planting and/or it is barren. The juxtaposition of foreground and background suggests the separation of people and territory and, conversely, their identification with it. Khan's choice of lower case letters (*ma*) undermines the authority invested in titles and challenges expectations. These are clues or *metacommunications*, 'aspects of the text which ... stand out as being also, reflexively, about the text and how to use it' (Frow, 2006, p. 115). Here a double-coded set of references sets up the expectation that this might also occur in the dance.

The company's introductory note provides further metacommunications:

> Khan continues his innovative exploration into ... Indian and Western dance and music aesthetics ... Ma [*sic*] will occupy a more earthly environment invaded by ideas of 'Sacred Seeds, Displaced humans, Silent bells, Decaying movement and Burnt music' ... exploring the role of the Kathak dancer as narrator, musician and dancer.
>
> (Khan, 2004a, n.p)

The use of the term *innovative*, the play on expectations with *Silent bells* and the challenge to grammatical rules in the mix of upper/lower case alerts me to Khan's interest in the role of narrative and his re-examination

of the traditional function of the Kathak dancer. It highlights aspects of destruction that might be ascribed to the subject matter (*Decaying, Burnt*); suggests important intertexts such as Roy's literature (*Displaced humans*); and the prominence that capitals provide *Sacred Seeds* points to the significance of this story in *ma*. One of the dancers tells how the gods gave a barren woman the seeds of trees to plant; she nurtures them as if they are children but misunderstands the gift. The interrelationship between people and land is foregrounded. This links to questions Khan proposed as starting points, asking,

> where is earth if it has nobody to nurture it? Where is earth if it has nobody to water it? Where is earth if it has nobody to cry for it?
>
> (Khan, 2004a, n.p)

Having established the area that the generic frame might encompass, the implications entailed for 'effects of reality and truth, authority and plausibility' (Frow, 2006, p. 2) can be borne in mind as speculative while an intertextual analysis is made.

There are many moments in *ma* where ambiguity produces simultaneous, contradictory meanings. In the opening, for example, Mazhar's Sufi singing conjures a devotional atmosphere. In his lament I hear ancient traditions with assured foundations in faith, but suspended upside down he is rootless, hanging by a thread. This mismatch between the ecstatic states Sufism engenders and Mazhar's surreal position dislocates expectations. Does he warn of dangers facing the world or, in flashback filmic treatment like *Kaash*, has it already perished? Does he educate or mourn? Drawing on Siva's sense of cyclical time evades the polarities before/after promoted by western notions of linear chronology.[14]

Different conceptions of time seem important in *ma*. Kermode states that in addition to chronology (*chronos*), Ancient Greek offers two further concepts: *kairoi*, 'decisive moments (in history or in personal history)... [and *aion*] the continuum in which we achieve a kind of immortality by reproducing ourselves' (1971, p. 146). Given Khan's use of autobiography these seem applicable.[15] This gives rise to a notion of *past–present*, indicating overlap of the temporal states rather than a perception of them as oppositional, lying along a simple axis. This finds echoes across *ma*, reinforced by the use of memory and stories. For example, Khan tells of his childhood game of hanging upside down from a tree, in whispered conversations with the earth, but current issues seem to collide in respect of the responses he heard.

ma was made during a tense period. Roy refers to the India/Pakistan border dispute when nuclear conflict seemed possible; the UK remained obsessed with terrorism after the 9/11 attacks on the United States in 2001; and coalition forces invaded Iraq in the second Gulf War in 2003. Khan explains: 'in times like this…there's chaos and the world is in a way for me upside down…as if the world has been pulled from under you' (Khan, in Khan, 2004b, n.p). Although not specific, the turbulent political situation provides reference points and metaphors against which I might also read Mazhar's upended opening position as reflecting global danger; cultural, personal or spiritual dislocation; and/or determined resistance in the face of difficulty. These are not alternatives from which I choose the most appropriate. Contextual aspects provide the possibility for ascribing multiple meanings.

Mazhar's inversion, the first of many such postures in *ma*, also draws my attention to the head as a body part emphasised throughout. For example, at 23.35 minutes into the dance, Ooi grabs continually at Winlock, trying to cover her ears, eyes and mouth. Hearing, seeing, speaking are key senses by which information is received and given. Repeatedly, she pulls away his controlling hands. The gestures begin to interweave, initiating and avoiding coalesce and it becomes unclear as to who is doing the manipulating. At one point, she covers her own ears, briefly leaving him at a loss as to how to proceed. Winlock appears, *ambiguously or with Lyotard's undecidability*, complicit-victim. Later, a desperate struggle occurs, at which time Mazhar, focusing his gaze on them, sings in despair.

I am reminded of western culture's polarities: head and heart; rationality and feeling; order and chaos. These dualities echo Roy's polemic in which political cynicism and communal naivety blur the roles of perpetrator and victim. 'We take care not to dig too deep. We don't really *want* to know the grisly details' (2002, p. 63; original emphasis). Contradictory readings of Ooi's actions are set in motion: abusive authority; the powerlessness of landless peasants; his prevention of Winlock hearing Mazhar's song or forcing her attention to its message, overcoming her obdurateness. Drawing on aspects of their embodiment, I might also ascribe stereotypical gender relationships or suggest that Winlock symbolises mother earth and man's reckless exploitation of it.

Similarly, Rafaelisova at the beginning of *ma* shouts a single *bol* (rhythmical syllable used in Kathak) and, in the ensuing blackout, her cry is echoed by the musician Manjunath, who introduces spoken motifs which recur throughout, *tak-a-thum* (sky and earth). I am reminded that in Hindu mythology the universe was created by sound when Siva beat

his drum. A flaring of green light disorients. The colour is suggestive of ecological issues, but drawing on *Kaash* its bright intensity might be seen as nuclear or cosmic explosion (destruction–creation, past–present). From the opening I am drawn into intertextual strategies that make me flick between conflicting readings. This suggests that the core aesthetic operating within *ma* embraces multiplicity as productive.

The headstand disliked by Anderson, for example, can be read in more positive ways. A long-held recurrence at 10.00 minutes into the dance draws attention to the solid trunk (a double-coded word), the planted quality of the top of the head on the floor and the splayed leg position with the weight teetering on the tips of the toes. Strength and precariousness seem combined. This conjures up the fragility of the ecosystem and/or an ostrich-like capacity to ignore problems. I associate the curved arms with tree branches or perhaps wings, if a similarity to a key moment in Alvin Ailey's *Revelations* (1960) is noticed; a recognition prompted by the fact that Khan's rehearsal director, cited as a collaborator, is from Ailey's company. This intertext allows the infusion of spiritual connotations, notions of human determination, powerlessness and poverty, cross-cultural difference and the worldwide displacement of people over time. Slavery, colonialism and globalisation now collide in the image.

Later, this inverted position accumulates another resonance. Rafaelisova speaks about baobabs. Leafless for much of the year, these trees are the subject of many legends explaining their odd appearance: the devil planting them upside down; a punishment for being envious (Nirvana, 2000).[16] They withstand harsh conditions and all the parts are useful: the fruit and seeds can be eaten or used in medicine; the bark holds water during dry seasons, for example (Anon., 2004a). Although native to West Africa, Arab traders introduced them to India and Sri Lanka. Reputedly living a thousand years, these trees connect me again with notions of past–present, the mythic realm, intertexts of exploitation and survival, nurturing and uprooting. The pose now becomes a metaphor for the complex interrelationship between the ecosystem, world trade and human communities.

Other inverted positions resonate differently. At 55.34 minutes, Farro scuttles along in a one-legged handstand. This surreal, tipped-over position, similar to Mazhar's opening, lends itself to ascriptions of physical discomfort. It is long held during a duet with Rafaelisova in which their hands, alluding to the planting of seeds, tap the floor in seven beat rhythms (associated with Siva) in a form of upside-down

tatkar.[17] Some traditional aspects of Kathak are evident, but I also read an ostrich-like determination to ignore the prevailing conditions, however strange. There are echoes of Roy's literature: people avoid confronting unpleasant facts. Habituated to circumstances, Farro is unquestioning of the pose, an ironic contradiction given the incessant queries with which she bombards Rafaelisova during her telling of the *Sacred Seeds* tale.

Farro's interruptions, set against the timeless realm of the myth, might be read as child-like, humorously irrepressible and naively charming, alleviating the work's overall dark tone (*Decaying, Burnt*). Her insistence on detailed realism might also be seen as insatiably demanding of a confluence between language and reality which cannot be satisfied. This suggests that material which has instructed past generations might have lost its force, or perhaps that the ability of language to carry meaning is problematised. There are other plausible interpretations. Farro might be baobab personified, selfishly wanting what others have, or if I draw on Roy's literature it reminds me that we may be conditioned to stop questioning and that Farro's persistence is laudable. It is possible to ascribe both negative and positive values simultaneously. Rafaelisova competes exasperatedly for her point of view, as the following extract illustrates:

Rafaelisova: Anyway, it doesn't matter. So she took the seeds and she planted them in the earth.
Farro: [*interrupts*] In the garden, because she had a garden?
Rafaelisova: Yes, just next to her house.
Farro: No, not next to her house, no, because next to her house would be her neighbours.
Rafaelisova: No, next to her house is her garden, because there is a house and there is a garden, so it's a garden next to her house.
Farro: So it's inside the house?
Rafaelisova: It cannot be inside because it doesn't make any sense.[18]

Children, of course, often challenge grammatical rules or press logical inference onto metaphorical speech in order to test its limits. The relational words, *next* and *inside*, are the focus of the verbal play in the extract. Each intent on winning the point in this word game, the protagonists pursue conflicting temporal and spatial contexts. Neither uses their first language and the dancers' accents, Slovakian and Spanish, are noticeable. More than a humorous parrying of words seems suggested

by their embodiment: meaning is something to be negotiated and it cannot be guaranteed.

> *Rafaelisova*: You planted them, you took care of them, now they are beautiful trees, so those trees are your children, because what you feel for those trees is the same what mothers feel for their children.
> *Farro*: [*interrupts*] Yes but then, she didn't understand, no?
> *Rafaelisova*: Maybe. [*pause*] Maybe not. Anyway ... [*she walks away*].

As a mirror-image of the woman in the myth, (it began, 'Let me tell you a story'), what is it that I understand? The surface of the tale connects me to messages about ecology, but deeper aspects emphasise issues of language where communication, narration, meaning and translation seem crucial. One of Khan's interests lay in exploring the narrative role of the Kathak dancer.[19] The classical tradition typically (but not exclusively) extols the virtues of Hindu gods or heroes through *nṛitya* elements, so the inclusion of autobiographical text which Khan speaks himself might be read as situating the personal as epic. Embodied as the past–present (Farro's child–adult; Khan's memories; physical metaphors of thousand-year-old baobabs), subjectivity becomes a contemporary locus which takes on the mantle of the mythic, making new stories for twenty-first-century audiences.

Khan's comments on Bausch's *Nelken* (1982) provide insight into his views on narrative.

> [*Nelken*] shattered all the illusions I had built up from the classical world and opened my curiosity towards uncertainty ... she grants us the realisation that the performers' stories are not so far away from our own stories ... I believe the art of storytelling is not embedded in the stories we tell, but in the way we tell them.
>
> (Khan, in Anon., 2005)

Uncertainty is something Khan has embraced, as the ambivalent ending of the *Sacred Seeds* text suggests. In classical Kathak and contemporary dance styles, narrative is differently treated. Khan's engagement with both personal experience and mythic elements allows me to see such distinctions as blurred or in continual flux.

Blurring is evident in a different manner at the beginning of *ma*. Classical and contemporary aspects combine in the movement. Michael spins across the stage, propelled by her flailing arms. Her solo,

both abstract and allusive in effect, echoes and counterpoints the clipped dynamics of the music. Her material seems spliced together, a filmic term deliberately chosen, in phrases of uneven length: recycling, repetition, embellishment and accumulation produce complex visual patterns that replicate the sophistication of Kathak's rhythmic elements. Impetus is generated peripherally from the limbs, a high circular kick leads into a pivot, for example, or it moves outwards from the centre in serpentine trajectories, dissipating and rebounding through the joints, or suddenly arresting. Gestures are correspondingly varied. They slice, ripple, encircle, stroke, flick, swing and pierce the space: arrival is often incisive, with Kathak positions sometimes identifiable.

Kathak pinched fingers, for example, hint at pricking out seedlings, but gestures also cut and slash as if reaping or tying sheaves, and the palms curve around, suggesting globe-like shapes. Michael's female embodiment and actions make links to *ma*'s title but she is also a South African, a country with a colonial past. This provides intertexts suggestive of exploitation and more positively with the peaceful overthrow of apartheid. Khan (2004a) highlights the varied backgrounds of his dancers, so diverse agency is clearly important. It provides a reading against which their performance of the hybrid movement style of *ma*, to which all have contributed, can be cast as productive. Michael is joined by Ooi in a hyper-fast duo. Metaphors of destruction now invade the phrases; for example, energy flow becomes *tandava*-like with the vigorous qualities associated with Siva in *Kaash*.

The use of non-literal approaches to allude to narrative is typical of certain forms of Contemporary dance and of Kathak where *nṛtya* aspects are not mime. There are numerous examples in *ma*. At 7.56 minutes into the dance, a smooth, rolling action keeps the crown of the head in contact with the floor. At 27.50 minutes it is performed in a series of spasms by a trio of women. Febrile qualities, stiff contractions of the torso and limbs now suggest variously that they might be in the throes of childbirth; that the floor is too hot to touch (*Burnt*) as they flex away from it, or is no longer able to nurture them (*Decaying*). They appear rootless, panic-stricken, incapacitated.

This trio and its spasms contrasts with earlier material at 11.46 minutes introduced by Lachky, where fluid dynamics give the appearance of easy sliding on a liquid-covered surface. Yet his forays also hint at Roy's drowned lands, and his breadth of travel and lifted head could be read as possessive: a metaphor for the peasants' dependence on their farms or the builders of dams taking ownership.

These descriptions make it clear that assigning aspects to one genre or another is problematic. Contemporary and Kathak both send energy outwards from the centre of the body towards its extremities; share action content across gender; have close structural relationships between music and movement; and value abstraction and allusive qualities.[20] Hybridisation gives rise to a rich range of interpretations when both sets of aesthetic judgments are seen to operate simultaneously instead of conjuring their separateness.

A significant moment in this respect is a solo by Khan. His demeanour gradually changes from Contemporary Kathak to the classical form. The precise moment that the transformation is completed cannot be pinpointed. The fading of one persona and emergence of the other illustrates the ineffectiveness of applying originary criteria to differentiate between them. An autobiographical text follows, when he relates childhood memories. His aim of exploring a fluid concept of narrative, presenting a story then telling it, and vice versa, means that the movement to which this spoken text corresponds remains ambiguous.

Once contiguity of text and movement is displaced the resultant ambiguity might be seen as *dispersed* narrative: the borrowing of Derridean notions of deferred signification outlined earlier provides a strategy for viewing this as productive, not muddled. Each episode refers back and forth in the chain of events; confirming, developing, juxtaposing or contradicting in a system of refraction which disrupts linearity and multiplies possible meanings. This encourages me to reappraise how I arrive at interpretations and to be alert to which correspondences and intertexts I draw on. The structure of *ma* produces a complex network of interconnections where the elements, like the genres, are also held in continual flux.

This reinforces my sense of agency in respect of interpretation and resituates notions of narrative: ambiguity provides multiple possibilities. When Khan, for example, says 'Let me tell you a story', an understanding of the traditional role of a Kathak dancer invites me to see his subsequent hand gestures as *nrtya* aspects. Yet his movement is tentative. I read this as indicating loss of certainty and, given his nonlinear structure, he could also be prefiguring later episodes. The mysterious quality is reinforced by his juxtaposition with a duo. Winlock, eyes closed, is nudged forwards by Ooi. There is something unsettling about them, dehumanised by lack of hand contact, Ooi speaks incessantly into her ear. They may be unconnected to Khan's tale; his protagonists; his intended listeners; or perhaps Khan is the subject of Ooi's whispers. Khan does not much single himself out. The fact that he does so here

seems significant. This resituates the narrative role of the Kathak dancer and indicates some of the new means at Khan's disposal to explore/extend the range of the tradition.

The metaphors collide in the closing moments of *ma*; heads down, planted like a row of baobabs or engrossed in whispered dialogues with the earth, the performers are felled by a drum beat. They shift and jerk, their feet slipping as if they cannot gain purchase on the ground: it has been pulled from under them, if I refer to Khan's earlier remark. Rootless, disconnected from the music and thrown out of their natural habitat: are they dancers who cannot coordinate movement; aspects of Roy's drowned lands; or the victims/perpetrators of the cataclysm that is yet to, or already has, engulfed the world?

The sense of past–present is reiterated; *ma* begins and ends with singing. The lights fade on the twitching dancers whose juxtaposition with the tones of Louis Armstrong's *It's a Wonderful World* seems strongly ironic. If I draw on Kermode's notion of *kairos*, the fullness of time, it suggests a portentous quality. Resolution is not provided: are they dying, has the cataclysm happened, are they victims or blameworthy, what is the place of tradition and what kind of stories might be told in the twenty first century?

In conclusion, the inseparable flux within Khan's Contemporary Kathak style cannot be reduced to points of origin or adequately interpreted by essentialising accounts that attempt to adjudicate between contradictory value systems. Ambiguity is not a failing in *ma*; its double-coded character can be seen as a positive attribute. Intertextuality is a useful method for exploring hybridity. By actively seeking out *difference*, instead of considering it disruptive to a holistic, universal, self-referential enterprise, intertextuality embraces contradiction and contextual complexity. It reveals its own ideology and constructions, avoiding closing down, overdetermining or recolonising the emergent boundaries of the work.

Notes

1. Brown (2004a, n.p.) and Burt (2004, n.p.), respectively.
2. *ma*: Riccardo Nova (music); Mikki Kuntu (lighting); illur malus islandus (set); Hanif Kureishi (text); Tony Aaron Wood, Kei Ito (costumes); Faheem Mazar (vocals), B C Manjunath (Mridinga/percussion); Natalie Rozario (cello); Ictus Ensemble (recorded music). Dancers: Eulalia Ayguarde Farro, Akram Khan, Anton Lachky, Moya Michael, Inn Pang Ooi, Nikoleta Rafaelisova, Shannel Winlock. Premiere: 28 May 2004, Victoria Theatre, Singapore Arts Festival.

3. Khan's Kathak guru was Sri Pratap Pawar. For his degree he studied ballet, Graham, Cunningham, Alexander, release-based techniques, contact improvisation and physical theatre (Sanders, 2004).
4. Andy Cowton (music); Michael Hulls (lighting). Dancers: Akram Khan, Moya Michael, Gwyn Emberton (later Inn Pang Ooi). UK premiere: 5 October, Midland Arts Centre, Birmingham. World premiere: work in progress, 20 July 2000, Rosas Performing Space, PARTS choreographic project, Brussels. Dancers: Akram Khan, Rachel Morrow, Gemma Higgingbotham, Moya Michael, Igor Chichko; Ann Joseph (lighting).
5. Commissioned by the London Sinfonietta: Magnus Lindberg (music); Aideen Malone (lighting); Saeunn Huld (costumes). Dancers: Akram Khan, Rachel Krische, Moya Michael, Inn Pang Ooi, Shanell Winlock. Premiered 9 December, Queen Elizabeth Hall, London.
6. *Kaash: Hindu, what if.* Nitin Sawhney (music); Anish Kapoor (design); Aideen Malone (lighting). Dancers: Akram Khan, Rachel Krische, Moya Michael, Inn Pang Ooi, Shanell Winlock. Premiered 28 March 2002, Exit Festival Maison des Arts, Cretiel, France.
7. Siva is creator and destroyer. *Tandava* is the vigorous dance style associated with him.
8. Khan is also a professional actor. As a teenager he toured in Sir Peter Brooks' version of *The Mahabharata*. Khan refers to himself as director, a filmic term, and not choreographer, because the dancers play a large part in the collaborative process.
9. Commissioned by the Royal Festival Hall Education Unit for a group of mature women performers. Hanif Kureishi (text); Faheem Mazhar, Philip Sheppard (music).
10. See in particular Derrida (1976, 1978).
11. For example, *Third catalogue* (2005), premiered 12 April, Purcell Room, Royal Festival Hall, London. It included: sections from previous Kathak performances, *Polaroid Feet* (2001) and *Ronin* (2003) choreographed by Gauri Sharma Tripati, the latter piece preceded by the actor Christopher Simpson reciting text by Kureishi; *Chakravyuh*, choreographed by Kumudini Lakhia based on the myth of the warrior Abhimanya; and *Unplugged*, improvisations in Tintal cycle. Text, cello and set design by illur malus islandus indicate non-traditional sensibilities to the presentation but critics were not disposed to state that this disqualified the programme from classification as a Classical Kathak recital.
12. Formalist critique typically ignores notions that each technique within his style is already multiple. Kathak is a hybrid of Muslim and Hindu sources. Contemporary dance values eclecticism. Neither genre should be considered unitary in any simple sense.
13. Video recording, loaned by Akram Khan Company: gala performance, Singapore Arts Festival. Producer: Josephine Gan, for Arts Central, Mediacorp TV. Small changes were made to *ma* as the tour progressed but are not referred to. I do not suggest that the première is the substantive version, merely that recording enables multiple viewings.
14. Siva destroys and creates in a cyclical process. There is no beginning or end; they are interdependent (Khokar, 1988).

15. Kermode (1971) maintains that drama represents *kairos*. Frow (2006, p. 113) refers to *kairos* as 'a time out of time', further illustrating that linear chronology is not essential to understanding either the world or performances.
16. 'The baobab was among the first trees to appear...next came the...palm tree. When the baobab saw the palm tree, it cried out that it wanted to be taller. Then the beautiful flame tree appeared...and the baobab was envious for flower blossoms. When the baobab saw the magnificent fig tree, it prayed for fruit as well. The gods became angry...pulled it up by its roots, then replanted it upside down to keep it quiet' (Nirvana, 2000, n.p).
17. *Tatkar* is a feature of *nṛtta* (the abstract aspect of movement). The feet slap the floor in complex rhythmical patterns.
18. Text provided by the Akram Khan Company.
19. *Nṛtya* is the expressive aspect of Kathak. It carries narrative meaning in the *gaths* (storytelling episodes).
20. In Kathak, hand gestures have a dual function. Used as abstract *nṛtta* elements and to convey the fundamentals of the stories in *nṛtya*, dancers do not learn the names of the *hastas* because the whole body is deemed to be expressive (Anon., 1963).

References

Adshead-Lansdale, J. (ed.) 1999 *Dancing Texts: Intertextuality in Interpretation*. London: Dance Books
Anderson, Z. 2004 *Ma*, Royal Festival Hall, London, 1 December. *www.enjoyment.independent.co.uk*. Accessed 3 December 2004
Anon. 1963 *Classical and Folk Dances of India*. Bombay: Marg Publications
Anon. 2002 Akram Rocks on, *Pulse* 1 Spring, p. 4
Anon. 2004a The Baobab, www.manrecap.com/baobab. Accessed 4 November 2005
Anon. 2004b Company Advertising Flyer for South Bank Centre performances, London, 30 November–5 December
Anon. 2005 Pina Bausch theatre programme. Sadler's Wells, 10–20 February
Brown, I. 2004a Edinburgh reports: party spirit and Brussels spoil the mystery. www.telegraph.co.uk. Filed 23 August 2004; accessed 3 December 2004
Brown, I. 2004b Superior style, superficial impact. www.telegraph.co.uk. Filed 2 December 2004; accessed December 2004
Burt, R. 2004 Akram Khan Dance Company, *ma*, Warwick Arts Centre, Coventry, 26 October 2004 www.criticaldance.com: Ballet and Modern Dance Forum. Filed 12 November 2004; accessed 27 January 2005
Derrida, J. 1976 *Of Grammatology* Trans. Gayatri Spivak. Baltimore, MD and London: Johns Hopkins University Press
Derrida, J. 1978 *Writing and Difference*. Trans. and introduction Alan Bass London: Routledge & Kegan Paul
Desmond, J. (ed.) 1997 *Meaning in Motion*. Durham, NC and London: Duke University Press
Frow, J. 2006 *Genre*. London and New York: Routledge

Gilbert, J. 2004 Top of the world, *ma* (Well, pretty close at least). *Independent on Sunday* 5 December. www.independent.co.uk. Accessed 3 December 2004

Kamuf, P. (ed.) 1991 *A Derrida Reader: Between the Blinds*. New York and Chichester: Columbia University Press

Kermode, F. 1971 *Modern Essays*. London: Fontana

Khan, A. 2004a material on company website www.akramkhancompany.net. Accessed 3 February 2005

Khan, A. 2004b Video of Akram Khan Company in *ma*. Gala performance for the Singapore Arts Festival. Producer: Josephine Gan for Arts Central Mediacorp TV12 Singapore Pie Ltd. Video loaned to author by Akram Khan Dance Company

Khan, A. 2004–5 Turning points. *outhbank* December–January, p. 46

Khokar, M. 1988 *The Splendours of Indian Dance*. New Delhi: Himalayan Books

Loomba, A. 2005 *Colonialism/Postcolonialism*. London and New York: Routledge

Mackrell, J. 2002 Kaash *The Guardian* 13 May. www.guardian.co.uk. Accessed 19 November 2002

Mackrell, J. 2004 Akram Khan Company, Monday, 23 August. www.guardian.co.uk. Accessed 3 December 2004

Nirvana, H. 2000 Baobab www.blueplanetbiomes.org/baobab. Accessed 4 November 2005

Roy, A. 2002 *The Algebra of Infinite Justice*. London: Flamingo

Sanders, L. 2003 Choreographers Today: Akram Khan. *Dancing Times* May, pp. 17–23

Sanders, L. 2004 *Akram Khan's Rush: Creative Insights*. Alton: Dance Books

Skeat, W. 1983 *Concise Etymological Dictionary of the English Language*. Oxford University Press

Smith, R. A. (ed.) 1971 *Aesthetics and Problems of Education*. Chicago and London: University of Illinois Press

Sparshott, F. 1995 *A Measured Pace: Toward a Philosophical Understanding of the Arts of Dance*. Toronto, Buffalo and London: University of Toronto Press

5
Elusive Narratives: Mats Ek

Giannandrea Poesio

Revisionism and theatre dance

It is nearly 30 years since the adjective 'revisionist' started to be used in journalistic writing to refer to performances that challenge the allegedly sacrosanct tenets of ballet tradition. Although it is difficult to determine when the term was first used, the earliest documentary evidence is found in an article published in 1982 in the *Progrès de Lyon* (Anon., 1982, p. 6), in a review of the 'postmodern' (Sirvin, 1984, p. 79) version of *Swan Lake* by Andy Degroat, performed at the Festival of Aix-en-Provence. Whether the critic of a French daily had deliberately set a semantic trend immediately taken up by his international fellow writers is difficult to determine. What is certain is that Degroat's provocative *Swan Lake* was not the sole example of a flourishing radical choreographic trend at that time. A few weeks earlier, on 6 July, the Cullberg Ballet had premièred in Stockholm Mats Ek's *Giselle*, a work that prompted then, and still prompts today, various epithets in the international press, 'revisionist' being the most frequent one.

The adjective was initially used in a derogatory way, by analogy to the connotation it has had within political circles ever since Eduard Bernstein (1850–1932) proposed his rethinking of Marxism – something that became synonymous with political ambiguity and an inability to formulate new ideas. For the reviewers, therefore, 'revisionist' dance works were creations that lacked inventiveness and originality, were parasitic on pre-existing artistic materials, and thus came across as gratuitously outrageous takes on allegedly untouchable landmarks in our culture.

Those critics, however, had not considered that the term had multiple uses and meanings, and not exclusively derogatory ones. 'Fictional

revisionism', for instance, began to be used in the early 1970s to group narrative works, whether written, filmed or performed live, that drew on a fairly radical reworking of existing plots or an equally provocative subjective interpretation of those same plots' meta-narratives. This was the case with Tom Stoppard's *Rosencrantz and Guilderstern are Dead* (1967), a play in which the tragedy of Hamlet is revisited and retold from the point of view of two secondary Shakespearean characters. Similarly, in Andrew Lloyd Webber and Tim Rice's musical *Jesus Christ Superstar* (1971) the story of Judas' betrayal of Christ is narrated from a provocatively different angle. More recently, among the most popular examples of fictional revisionism are Gregory Maguire's novel *Wicked: The Life and Times of the Wicked Witch of the West* (1995), a reappraisal of the quintessentially villainous Wicked Witch of the West in L. Frank Baum's *The Wonderful Wizard of Oz* (1900) and Jonathan Larson's acclaimed musical *Rent* (1996), based on a contemporary reinterpretation of both the main plot and several sub-narratives of Giacomo Puccini's *La Bohème* (1896).The influence of poststructuralism is evident in each case, whether overtly and directly, as in the case of the earlier works, or in a more complex and multifaceted manner, which takes into account the more recent developments of poststructuralist theory, together with its related critiques, as in the case of the later creations.

It is not surprising, therefore, that the fluid ambiguity of the term 'revisionist' led to its often confused and contradictory use. Paradoxically, it was in the name of that ambiguity that many adopted the idea to define and classify a choreographic genre that was elusive and could not easily sit comfortably in categories such as 're-staging', 're-reading', 're-creation', 'reinterpretation' or 'revisiting'. Nevertheless, a quick internet search provides substantial evidence of the problematic dichotomy relating to the definition within performing arts culture. Some works are called 'revisionist' as if they belong to a specific movement; others are dubbed 'revisionist' in a critical, derogatory way.

As far as the former is concerned, neither a history nor the fundamentals of a hypothetical 'revisionist' choreographic movement have ever been investigated, acknowledged and explained. Yet, as this chapter sets out to demonstrate, it was Mats Ek's distinctive approach to ballet narratives that was the origin of the tenets of what has become a well-established trend.

Long before Ek's *Giselle* took the dance world by storm in 1982, other dance artists had experimented with formulae similar to those of 'fictional revisionism'. Although in drama history the urge to re-present

the classics in a new and frequently provocative way can be traced back to the early 1960s, it was only in the mid-1970s that the often bold return to ballet masterworks became symptomatic of an historically recognisable choreographic exploration in Europe, as demonstrated by Roland Petit's *Coppelia* (1975) and John Neumeier's *Illusions, like Swan Lake* (1976) and *The Sleeping Beauty* (1976).

In the case of Petit's *Coppelia*, the choreographic medium remained almost exclusively the ballet idiom, even though sporadic interpolations of dance vocabularies and styles other than the classical punctuated the performance. The distinctiveness of the French choreographer's personal reading, therefore, resulted mostly from the interpolation of humorous episodes and ornamental solutions, through which Petit quoted from his own artistically multifaceted background – as evident in the Fred Astaire-like dance sequence Coppelius performs with the doll. At the same time, the narrative remained faithful to the 1870 libretto, even though the action had been transposed from the traditional fairy-tale Galician village to a late nineteenth-century operetta-like community.

Neumeier, on the other hand, in both *Illusions* and *The Sleeping Beauty*, went far beyond the interpolation of mere ornamental solutions, although he too remained faithful to parts of the traditional texts regarded as too famous to be tampered with. In his take on *Swan Lake*, aptly re-titled *Illusions, like Swan Lake*, therefore, the choreography of what is conventionally referred to as Act 2 remains the one most people believe to be closest to the original, although it takes the form of a performance attended by the swan-obsessed King Ludwig of Bavaria, the protagonist of Neumeier's reading. Similarly, some of the most famous variations and solos from the standard versions of *The Sleeping Beauty* are preserved in his psychoanalytical reading of the 1890 classic, and as such become part of a court ballet the young blue jeans-clad protagonist himself is watching, either because of a magic spell or from drug-induced hallucinations.

Like Petit, Neumeier did not move away radically from the ballet syntax, nor did he subvert any well-affirmed balletic rule, convention or parameter. Petit and Neumeier are thus dance makers who were, and remain, at their best when operating with the ballet medium and within ballet traditions, whether they be nineteenth- or twentieth-century ones. Their creations, therefore, remain intriguing but never audacious transliterations.

It is not surprising, then, despite familiarity with those works and with the wealth of similar ' re-readings', that the 1975 *Coppelia* and the

two 'revisited' Tchaikovsky's classics had inevitably spawned at international level, the dance world was unprepared for as radical a work as Ek's *Giselle*. It was greeted by some as the long-awaited turning point of an art that was becoming stale and by others as blasphemy.

Performing narratives: Ek's approach

Although it is difficult to assess how much influence dance makers such as Petit and Neumeier might have had on Ek, there is little doubt that his *Giselle* and, a few years later, *Swan Lake* (1987) and *Sleeping Beauty* (1996) represent a dramatic and abrupt change (development sounds too gentle) of those formulae and, at the same time, a radical move away from them. Ek after all was never a 'ballet' maker, even though ballet was part of his background. And it is his complex and multifaceted artistic persona that allows him to interact with balletic canons, precepts and narratives in a vibrantly diverse mode – diverse, that is from those underscoring the 'revisiting' discussed above. His approach to the ballet classics thus transcended the parameters of a more or less provocative *mise en scène*, by taking into consideration the performativity of three layers of the dance text: the dramatic narrative, the musical narrative and the dance narrative.

Dramatic narratives

A provocative dramaturgic revision of ballet's storylines is arguably one of the most distinctive traits of Ek's treatment of the classics. Indeed, his ballet-based works are born of an initial investigation into the possibilities offered by the existing narratives. For Ek, fairy tales, such as the ones ballet librettos are based on, are like 'small pretty houses with the sign "mine field" written on the door' (in D'Adamo, 2002, p. 141). The intentional or inadvertent opening of that door thus leads to conflagration, a sort of micro Big Bang with an unpredictable aftermath. The consequences and the possibilities that follow are myriad and ever-changing, displacing certainties and expectations. Such elusiveness contrasts with the theories expounded about fairy tales by the followers of Vladimir Propp, the Russian structuralist who posited the existence of just one, recurring basic structure for every fairy tale, with and within which different variations, stemming from diverse cultural contexts, interact to generate the variations characteristic of each lore. For Ek, fairy tales indeed have common denominators – princesses and princes, magicians and witches, good and evil – but at the same time 'each ... has something all its own, a dark point where something inexplicable

happens' (in Gauert, 1999, p. 18). Elsewhere, Ek referred to that 'dark point' as a 'mysterious door one must open to find out what is hidden behind it' (in Jensen, 2002, p. 36). The door, 'like the ones Alice finds at the bottom of the burrow', leads to a path that is different each time and thus offers alternative narrative options (Poesio, 2002). A 'door' can be a particular character, whether primary or secondary, a location, a prop, a twist in the plot, a theatrical convention or an existing metaphor in the libretto of the classic considered.

Ek's narrative paths are clearly underscored by the synergy of multiple influences, which are reflected in his work as both puppeteer and director, in his exposure to different modern and postmodern performance practices and his knowledge of drama, literary and critical theories. These synergetic combinations, however, are tapped into irregularly, forming *ad hoc* clusters of informing strata for the options he selects each time. Not unlike the paths of options mentioned above, these clusters too can never be arranged in a clearly defined and recognisable molecular structure. As such, they reveal the uniquely diverse narrative angles that characterise each of the three ballet classics Ek has dealt with. As such they also provide unique variety in the treatment of Ek's signature themes, those political, social, psychological, cultural, artistic and personal issues that form and inform both his artistic persona and his *oeuvre*.

The theme of motherhood, for instance, recurs in many of his productions. In *Giselle* it is interwoven with issues of otherness, diversity and class. Because of her mental state, the eponymous heroine is denied motherhood and thus a place in the rigidly constructed society of which she is a member. Her mental state worsens when her dreams of becoming a mother and of moving away from the social environment that both protects and marginalises her are suddenly shattered. Denied motherhood becomes sexual hunger – exemplified by the typical Italian gesture for 'eating' – once the heroine is segregated, together with others sharing her destiny, in an asylum.

In *Swan Lake* the drama of Prince Siegfried is filtered through a combined Freudian and Stanislavskian reading of the 1895 ballet's male protagonist, whose character is reminiscent of Shakespeare's Hamlet. Not unlike Shakespeare's hero, Ek's tormented prince suffers from a strained and morbid relationship with his mother, and it is only by running away from her – both mentally and physically – that he finds both the object of his romantic desires, Odette, and that of his more carnal urges, Odile. Both are equally suffering from a constraining relationship with a parental figure. And although the former is the one he will marry, the latter is the one he will follow immediately after the bridal procession.

Finally, in *Sleeping Beauty*, the angst and fears related to giving birth and raising a child amid the horrors and dangers of contemporary society provide the narrative background to a modern interpretation of the 100-year sleep, seen as the consequence of heroin addiction – the hypodermic here takes the place of the spindle. In spite of an apparently happy ending, the princess will eventually give birth to a black egg, the result of her interaction with her former lover and drug dealer, the male equivalent of the wicked fairy Carabosse.

In each instance Ek's dramaturgic introspection neither betrays nor moves drastically from the standard plot of the ballet classics, for the basic structural elements, as well as the main motifs of the old stories, are unchanged. In *Giselle*, the female protagonist is as 'diverse' as the heroine in the traditional version of the ballet. The latter does not participate in the activities of her fellow peasants because she has a weak heart. Ek's Giselle is kept away from the everyday social cycle of her village because of her mental state. Similarly, in both versions, her beloved Albrecht belongs to a higher social class and in each version he pays the price for his superficial behaviour through a cathartic experience.

In *Swan Lake* the Ekian, sexually confused, Hamlet-like prince escapes the burden and constraints of his royal duties by daydreaming – his kingdom is surely as rotten as that of Denmark – in the same way that the male protagonist of the 1895 work escapes his duties by going hunting at midnight on the shores of an enchanted lake. Both remain unmoved by the parading of potential brides/beautiful women from different regions of the world; both succumb to Odile's sexual allure.

Despite being stripped of all the court splendour that characterises both the 1890 ballet and the seventeenth-century fairy tale, Ek's *Sleeping Beauty* still depicts the drama of a young family and of an adolescent coming to terms with the facts of life. Indeed, this work is rife with narrative detours and interpolations, such as a lengthy dance for a gathering of grandmothers and a cookery class, but all the salient narrative elements of the original tale remain untouched and in place.

In each instance it is as if Ek wanted to show what happens before and after opening the door of the explosive little house. The 'before' in this sense is our knowledge, no matter how detailed, of the traditional plot, whereas the 'after' is the path taken by Ek himself. Such an evident link between the traditional version of the ballet classic and his own interpretation is matched and even reinforced by his use of the ballet score.

Musical narratives

In Ek's hands, music that has often been regarded as being of little or no importance, as in the case of Adolphe Adam's 1841 score for *Giselle*,

becomes a vital component of every dance work. It is well known that most of nineteenth-century ballet music, from the Romantic era onward, was intended as *musique parlante* or 'speaking music' (Smith, 2000). Scores like those by Adam and Pyotr Ilyich Tchaikovsky, therefore, provided characters with distinctive voices, described and evoked a number of actions – laughing, quarrelling, fighting, conversing, threatening, spinning, etc. – and enhanced salient sections in the action with appropriate atmospheric moods. It was, in other words, 'story-telling' music, which carried a number of identifiable narratives embedded in its notes. Unlike many of his contemporaries, and against the general bias towards nineteenth-century ballet music, Ek has taken full advantage of these extra narrative layers when operating on ballet classics. Both his understanding and appreciation of the score's story-telling potential are manifest in his two different, though complementary approaches to ballet music: a rediscovery of the score's original features and a constant awareness of the narratives subsequently generated by the score's own performance tradition.

The reappraisal of what the original score might have been like provides Ek with an insight into the music's intended dramaturgic layout, which in turn adds to his investigation of the work's original narrative. He thus refutes, at first, the ballet's standard or traditional performance score – the one commonly used for contemporary performances. In his *Giselle* the use of the conductor Richard Bonynge's 1981 philological recording is a fitting example. Passages that have long been removed from the traditionally performed version of the ballet are reinstated and used by Ek to add dramaturgic depths to his reading of the story. This is the case, for example, in the so-called 'daisy scene' in the ballet's first act. By reinstating the customary cut Ek restores a narrative passage that allows him to shed light on the psychological make-up of the two protagonists. Interestingly, his reading of the often omitted *cantabile* section, in which Ek's Giselle and Albrecht engage in a subtle game of child-like sexual discovery, matches the ballet's long-lost corresponding mime passage, in which the two protagonists engage a in moment of subtle Romantic sensuality.

Similarly, in his *Swan Lake*, what is traditionally known as Act 3's 'black swan *pas de deux*' is found in Act 1, where Tchaikovsky intended it to be, as a duet between the prince and one of the young female guests at his birthday party. By restoring the *pas de deux* to its original location – and by using, later, the music originally intended for the black swan episode – Ek provides the viewer with insight into the prince's drama and creates, as discussed below, a pivotal dramaturgic situation on which rest the ensuing developments of his plot.

Yet, the original score's narrative is not the sole element of attraction for Ek. The music of *Giselle*, *Swan Lake* and *Sleeping Beauty* survives as a tangled web of interpolations and interventions which were added to and removed, at different points of time, from the original compositions onwards. The continuous shifting, the omission and, paradoxically, the addition of music have all contributed to the enduring popularity of each score and have bestowed iconic status on some sections, whether they be original or not. As such they have become commonly shared signifiers characterised by a multilayered encrustation of narratives accumulated through the lifespan of the work. Ek, interested in the multiple possibilities offered by each of those encrusted narratives, engages with them in an often playful game of references to which the viewer is invited, but never compelled, to take part.

The black swan duet is a fitting example, for the actions performed to that shifted section are linked to the narrative that the same music has acquired over time, becoming synonymous with seduction music, to which Odile entices the prince and makes him forget Odette in Act 3 of the traditional ballet. In Ek's version, sexual sultriness is indeed what characterises both the waltz that opens the duet and its frenzied final *coda* – traditionally used for the ballerina's 32 *fouettés en tournant*. The latter matches the end of the musical crescendo with the depiction of sexual intercourse that Ek's prince forces his mother and her favourite courtier into. Particular attention is thus paid to the narrative meanings that music is traditionally associated with – for the *fouettées* have often been regarded as a metaphorical representation of sexual climax in traditional ballet. And it is in line with these associations that Ek plays with the music, inverting the order of the two numbers, so that the conclusive duet's section, the *coda*, occurs before the opening waltz. This waltz, originally composed as the *entrée* or initial section of the *pas de deux*, is used to introduce the viewer to a series of significant dramaturgic episodes that generate as reactions to the queen's willingness to have intercourse with a courtier. The seductive waltz with which Odile entices the prince in the traditional ballet is thus provocatively used as a post-coital episode in which psychological and dramatic tensions complement and contrast the notion of 'seduction' traditionally associated with that music.

A fairly radical, subjective intervention in the ballet's original music occurs in *Sleeping Beauty* too. By developing further the canons first introduced in his musical reading of *Swan Lake*, here Ek makes cuts and changes to the original score, in the name of the narrative affinities that the various musical numbers have with his dramaturgic concept.

Once again, music numbers that carry a multiplicity of meanings, because of performance tradition or popular associations, are carefully handled and manipulated in what becomes an intriguing game of references. For instance, the duet that marks the first encounter between the male counterpart of the wicked fairy Carabosse and Princess Aurora in Ek's work is set to the music of the duet originally intended for Puss in Boots and the White Cat from the Act 3 *divertissement* of the 1890 ballet. It is worth noting that the same music had been used as the wicked fairy's unsettling and eerie *leitmotif* in Walt Disney's *The Sleeping Beauty*; its use in relation to an episode involving the Ekian male Carabosse might thus be read as a potential reference to the Disney film and, in particular, to its popularisation of Tchaikovsky's score.

The subtle game of references to narratives embedded in the score or associated with it is not the sole way Ek delves into music's story-telling. Among the contemporary dance and performance makers who have reworked ballet classics, Ek was arguably the first and, for some time, the only choreographer to have given serious consideration to the way music composed expressively for the ballet medium – and often commissioned by the choreographer – 'tells, suggests, and somehow dictates' specific dance movements (Poesio, 2002). The music qualities of 'telling', 'suggesting' and 'dictating' movements can be seen as forming yet another narrative layer which adds considerably to the characteristics of the nineteenth-century *musique parlante* and which has significant repercussions for Ek's chorographic composition.

Choreographic narratives

Ek has also been the first to replace ballet vocabulary with a choreographic idiom that draws on modern and postmodern solutions. Hence the sensation first caused by his *Giselle*. Still, not unlike his dramaturgic options and interventions in the available scores, his choreographic treatment of ballet classics is informed and underscored by a well-considered interaction between existing texts – whether the original version of the work or the standard one performed worldwide – and the one generated by his subjective reading of the same. Such interaction is particularly evident in the way his choreography refers constantly, in the case of *Giselle*, *Swan Lake* and *Sleeping Beauty*, to both distinctive solutions from the traditional version and the ballet's standard choreographic layout.

The captivating use of classical signs in a non-classical context is symptomatic of such interaction, as demonstrated, among other instances, by the *arabesque* motifs and the use of equivalents of a *developpé à la seconde*

in *Swan Lake*, or by the fairies' movements in *Sleeping Beauty*, derived from an amusing adaptation of the 1890 choreography Marius Petipa created to portray the qualities of their gifts. In each instance there is a striking similarity between the choreographic signifiers and their corresponding signified in both the traditional and the new versions. The flight of Ek's swans, both male and female, Giselle's naïve and child-like excited skipping and hopping, and Princess Aurora's coming of age are all rendered by movements that, despite intrinsic stylistic and technical differences, have a great deal in common with their balletic counterparts.

The use of recognisable signs imported from existing balletic contexts, however, is never purely referential. Ek refutes the theatrical sterility of citations, opting for choreographic signifiers that echo the Derridean notion of 'traces'. As such, the inclusion of imported classical signs in his choreography generates an allusion, namely a signifier that 'points beyond itself' and 'does not designate ties to individual ownership' (Orr, 2003, p. 139). Ek is thus free to intervene in and manipulate those signs, creating movements and steps that stand to the alluded text as choreographic synonyms, not unlike literary ones. These too refer to but do not reproduce entirely faithfully. The discreet ambiguity of their shadings and nuances, characteristic of synonyms in every language, adds to the ingenious elusiveness of Ek's dance narrative. In his *Swan Lake*, Odette's repeated *developpés à la seconde* do not convey the submissive abandon the romantic ballet's heroine is conventionally expected to portray. Despite following a very similar dynamic pattern of its balletic equivalent, the Ekian movement is presented in a variety of forms that displace the traditional associations with the balletic step and elicit a variety of readings, moving from a martial art-like act of self-protection to a somewhat fetishistic act that culminates with Odette's bare foot on the face of an ecstatically worshipping prince. Both the reiteration and the variation of the movement within the same scene enhance the complex dramaturgic palette of the main female character, in contrast to the two-dimensional ballet heroine, and the whole scene. Pruned of its stereotypical and stereotyped romantic palpitations Ek's duet becomes a choreographic Freudian essay on issues of sought and denied affection, rejection and sexuality, in line with a not so idealised view of modern-day relationships.

Another thought-provoking example of Ek's allusive manipulation of distinctive choreographic features is found in his *Sleeping Beauty* and especially in the Rose Adagio, the well-known Act 1 *pas d'action* – a term that refers to a dance section in which the dramatic action develops and

is narrated by pure dancing and not, as customary in the nineteenth century, by a mime scene. The section is regarded by many as the touch-stone for the ballerina's skills, for in the ballet's traditional version Princess Aurora performs long-held balances throughout the adagio, while surrounded and partnered by four aristocratic suitors. In Ek's work, the handshake with which the first of only three male stereotypes greets Aurora on her first outing with the family is clearly reminiscent of the more formal gesture performed by each of the four princes in the ballet to support the ballerina before her balancing on *pointe*. Yet, the feet of Ek's Aurora never leave the ground, nor does she engage in daring bal-ancing feats. Her suitors do most of the dancing, in contrast to their balletic counterparts who have little or nothing to do. Her spinning too refers to the turning the ballerina performs centre stage, but in Ek's instance, the spinning motion becomes an ecstatic, alienating act, which eventually deters the suitors, who leave the stage scorning the young girl and abusing her verbally. Dazzled and puzzled by what one might assume is her first encounter with desiring and desirable exponents of the opposite sex, Ek's Aurora remains passively alone in an anti-climactic ending in contrast to the explosive crescendo of its theatrical and applause-provoking balletic antecedent. It is the scorn and the verbal abuse of her would-be suitors that generate the crisis which will drive the young girl into the arms of the drug dealer, whereas in the 1890 bal-let the *pas d'action* does not have any further narrative development.

Interestingly, Ek's choreographic synonymy extends beyond expres-sive and/or narrative ballet solutions, as demonstrated by his adaptation of Giselle's popular Act 1 solo. Unlike any other narrative and expres-sive sections from nineteenth-century ballet classics, the solo in ques-tion is one of the many showcases choreographers created to let stars show off their technical skills. As such it is not meant to be expressive or narrative. It is also interesting to note that, according to some his-torical sources, this solo, allegedly set to music by Ludwig Minkus, was interpolated long after the ballet's premiere in 1841 (Poesio, 1994). As a bravura number, it reaches its climax in its second half, when the bal-lerina crosses the stage diagonally from back to front with a series of little hops *en pointe* on one foot. In some versions of the ballet's tradi-tional staging, this is performed by the protagonist in front of and at the request of her hitherto unknown rival, Princess Bathilde; in other equally popular stagings the number is part of the winemaking celebra-tions Giselle's fellow peasants engage in. Ek opts for the former, but he assigns the execution of the solo to Hilarion, Giselle's unrequited lover and warden. The opening sequence of movements assigned to the male

dancer presents several similarities with the steps traditionally performed by the ballerina: long-held extensions of the legs, balances and turns *en attitude* occur almost in unison with the sustained *arabesques*, balances and *tours en attitude* of the classical version. Not unlike the ballerina, Ek's male interpreter then moves backstage where he starts a diagonal of crouching hops on both legs towards the aristocratic onlookers. His hops, performed with his back to the audience, soon become intentionally irreverent, as a hand drops, cupped at first, in between his legs, while the man keeps hopping. A multiplicity of socially 'unacceptable' notions can be read into that movement: a phallus dropping out, defecation or even a variation of the 'up yours' gesture. Therefore, the meaningless bravura solo becomes a rather abrasive political statement, which develops from and expands on the discreet socio-political discourses covert in the 1841 ballet.

Not unlike *Giselle*'s Act 1 solo, other bravura numbers or ornamental dances have been turned by Ek into dramaturgically salient narrative episodes. This is the case of the Russian and the Spanish character dances, from the traditional Act 3 of *Swan Lake* or the popular dance of the cygnets from Act 2 of the same ballet. Ek's cygnets are a nightmarishly comic representation of the three jesters that serve the prince, who appear in his dream of freedom and love – the equivalent of the first lake-side scene in the traditional ballet – as Donald Duck's nephews. Their comic dance serves a number of dramaturgic purposes: it breaks the magic of the moment, thus creating one of those typically incongruent episodes both dreams and nightmares are often made of; it indicates that the ongoing action is but a projection of the prince's mind; it ridicules and caricatures the dream creatures the prince has just encountered, and, finally, it detracts intentionally from the romanticism of the ensuing love duet – something modern audiences can hardly believe in – by introducing it in a slapstick way: one jester performs copulating acts with a phallic stage prop, while atmospheric mist is generated by another jester's flatulence. Similarly, both the Russian and the Spanish dances, traditionally presented as part of a purely ornamental *divertissement*, become narrative episodes depicting the various stages of the prince's quest for the ideal woman. Russian women are thus presented as a flirtatious flock guarded by a barking man, while the Spanish female is the willing victim of ridiculously macho bullfighters.

The majority of choreographic synonyms in Ek's treatment of ballet classics take place in strict correlation with the music. As reported earlier, the choreographer believes that, in the case of each of the three classics he dealt with, the function of the music goes far beyond being

a mere accompaniment to the steps, for it suggest and even 'dictates' the steps themselves. Indeed, this interdependence between music and dance signs is a distinctive feature of Ek's choreography. As such, it is also the feature that has elicited the harshest criticism from those who interpret this sort of music's abiding process as lack of inventiveness. However, an in-depth analysis of the various occurrences of choreographic synonymy indicates that correlation between dance and music too is subjected to that process of manipulation discussed earlier. Ek's game of allusions and synonyms invests the use of music-generating choreographic chiaroscuros. It is within this game of vivid contrasts and subtle shadings that expected and expectable classic signs are contrasted and interwoven with non-classic solutions that contrast the 'dictating' music, thus developing with a myriad of unpredictable twists its embedded choreographic narratives.

Displacing cultural heritage

If it is agreed that Ek is the first historical exponent of choreographic revisionism, then the performance-making processes analysed above can be regarded as a distinctive feature of that artistic movement. Indeed, a comparative analysis with the creations of other choreographic revisionists who started to tackle ballet classics after the 1982 *Giselle* reveals that, regardless of different approaches and solutions, there are numerous commonalities between Ek's creative procedures and those adopted by his contemporaries and followers. The inter- and intra-textual interpretation of the dramaturgic layout which draws on a pre-existing, well-defined narrative, the choreographic synonymy, the pondered subjective manipulation of allusions and, finally, an equally subjective, though never irreverent or radical interaction with the ballet's score, quoted respectfully and in its entirety, are the symbiotically inseparable fundamentals of choreographic revisionism. As such they occur, almost identically, in Maguy Marin's *Cinderella* (1985) and *Coppélia* (1993), Mark Morris's *The Hard Nut*, based on *The Nutcracker* (1991), and Matthew Bourne's *Nutcracker!* (1993 and 2002), *Highland Fling* (1994) – based on *La Sylphide* of 1832 – and *Swan Lake* (1995), to mention but a few of the best known works that have been labelled 'revisionist'.

Although the discourses that inform and characterise each of the titles mentioned above require separate studies, it appears that their common denominator is a postmodern approach that challenges and questions the givens of western dance culture and tradition. Whether

Marin, Bourne and Morris can be considered postmodern dance makers, however, is beyond the scope of this chapter. What is certain is that postmodernism underscores Ek's treatment of the ballet classics. It is, however, a late postmodernism filtered through the developments, experiences and practices of avant-garde theatre and dance in continental Europe – a significant historical filter, for both European avant-garde and postmodernism of the late twentieth century differ considerably from the postmodern and avant-garde modes that developed in the United States from the early 1960s onwards.

Not unlike other European performance makers – and other North European ones in particular – Ek's challenges to theatre dance culture and tradition do not stem from a total refusal of spectacle, conventions and tradition. His postmodern and poststructuralist challenges derive from working with and within spectacle, conventions and tradition, as revealed by his predilection for narrative works – and not necessarily pre-existing classics. Instead of stripping performances of the parameters bestowed on theatre-making by centuries of theatre traditions, including avant-garde ones, he intervenes on those parameters to create new, antithetical ones, as demonstrated by the analyses of the narrative layers in his treatment of nineteenth-century ballets.

His intention is primarily to reconsider critically cultural dogmas and artistic monoliths in the name of a lively reappraisal of an existing cultural heritage he considers still worth knowing and exploring. For Ek, cultural heritage is both an 'inexhaustible source of inspiration' (Poesio, 2002) and, at the same time, 'an immense container, which I like to break, reassemble and re-fill with my own ideas' (Ek, in Jensen, 2002, p. 35). Cultural heritage, therefore, is something that is vibrant and not dead, something that allows us to operate endlessly on old archetypes and metaphors simply because far too often 'we have forgotten … what they stand for' (Ek, in Jensen, 2002, p. 35).

The use of terms such as ' breaking', 'reassembling' and 'refilling' leaves little doubt as to the kind of theories that underpin Ek's approach to the ballet classics. His 'breaking', moreover, is never gratuitously destructive; his aim is simply to 'remove what has become stale and obvious', to discover the 'new interpretative options that are on offer' for 'the public's and my own benefit' (Ek, in Jensen, 2002, p. 35). His 'reassembling' too is never too radical, for in the end it entails putting pieces of a pre-existing artefact together again, even though in line with his own taste and not with sterile notions of choreographic and narrative philology. Likewise, his 'refilling' the reconstituted container with his ideas moves from a number of considerations that take into account

those 'interpretative options' offered by cultural heritage. Drawing on his experience as a drama director, Ek's handles the narratives and meta-narratives of cultural heritage through a somewhat magnified and subjectively adapted application of Konstantin Stanislavsky's 'magic if' formula. Instead of focusing on the possible reactions the characters might experience in relation to given situations and contexts – a fundamental of Stanislavskian belief – Ek transfers the game of possibilities to the whole plot and applies the 'what if?' to the possible developments of the whole work's narratives and the meta-narratives. The outcome of this magnified and subjectively manipulated Stanislavskian approach is a new text that nests in, and at the same time moves from, the old one. Although the process presents an undeniable affinity with the narrative modes favoured by 'fictional revisionism', the final outcome is far more fluid and engagingly elusive than Stoppard's *Rosencrantz and Guildenstern are Dead* or McGuire's *Wicked*.

Ek elicits the public's active participation by displacing existing knowledge and biases towards the work that is being treated and by inviting viewers to engage individually with the outcome of his displacement. His 'interpretative options', therefore, are interspersed with a number of prominently visible closed doors, left intentionally there to stimulate the curiosity of each audience member.

The intentional musical 'feminisation' of male characters achieved by using soft-toned phrases, chords and tonalities for the actions of male roles or sections that had been originally intended for the a female dancer (as in the case of the solo from *Giselle*), the equally intentional attacks to the long-unchallenged prominence and centrality of the ballerina (evident in the more prince-oriented *Swan Lake*) and the removal of any courtly splendour and fairy-tale magic from *Sleeping Beauty*, provoke myriad issues and questions, empowering each viewer to identify, construct and follow subjective narrative paths either within or outside Ek's proposed plot. By intervening in the ballet classic and proposing the outcome of his intervention, Ek thus offers a narrative that is text and commentary at the same time. And, as a commentary, it is thus received and interpreted differently by each member of his audience, generating that stimulatingly unsettling narrative elusiveness that characterises his works.

When considered from this angle, the Ekian *Giselle*, *Swan Lake* and *Sleeping Beauty* are similar to Banksy's interventions on paintings by Monet, Van Gogh and Leonardo. A controversial, elusive and provocative figure within the visual arts, in 2006 Banksy turned an empty shop in London into an art gallery, in which he proposed revisionist versions

of known masterworks. Monet's *Water Lilies* had a supermarket trolley sinking in the pond, Van Gogh's *Sunflowers* were wilting next to a pot of plant food and the face of Leonardo's *Mona Lisa* had been replaced by Banksy's iconic smiley. The improvised gallery, moreover, was populated by live rats, whose presence added to the artist's critique of how art is proposed and preserved in modern society. The sinking trolley, the plant food and the smiley have the same function as Ek's farting cygnets, the giant eggs the female peasants roll in his *Giselle* and the grubby bourgeois household in which live Aurora's parents in his *Sleeping Beauty*. They provoke and elicit debate, inviting viewers to reconsider the still lively potential of a cultural heritage that has long been laying lifeless thanks to debatable beliefs and sterile conventions.

Indeed, the cultural heritage Ek is interested in – theatre dance – is one that can only come to life, and thus survive, when and if its tenets and contents are subjected to appropriate adjustments to the passing of time and to the changing of views, as clearly demonstrated by performance history itself. It is, in other words, a matter of revitalising that heritage through the inputs generated by a particular 'vision', namely creative and original thinking. Any new approach to works that are part of that heritage becomes thus a 're-vision', or the addition of a different vision prompted by specific cultural, social and artistic circumstances. In this sense 'choreographic revisionism' is everything but sterile regurgitation.

References

Anon. 1982 Le Lac de Cygnes. *Progrès de Lyon*, 30 July, p. 6

D'Adamo, A. 2002 *Mats Ek*. Palermo: Epos

Gauert, J. 1999 *Sleeping Beauty*. ArtHaus Musik DVD

Jensen, G. 2002 Intervista a Mats Ek. In G. Ottolini (ed.), *Reggio Emilia Danza 2002*. Reggio Emilia: Edizioni del Teatro Municipale Valli

Orr, M. 2003 *Intertextuality: Debates and Contexts*. Cambridge: Polity Press

Poesio, G. 1994 'Giselle' in *Dancing Times*, pp. 688–97.

——— 2002 Interview with Mats Ek, live recording, 16 May 2002, Teatro Romolo Valli, Reggio Emilia Danza

Sirvin, R. 1984 *Le Lac de Cygnes*. L'Avant-Scène. Ballet Danse Giann

Smith, M. 2000 *Opera and Ballet in the Age of Giselle*. Princeton, NJ: Princeton University Press

6

On the Premises of French Contemporary Dance: Concepts, Collectivity and 'Trojan Horses' in the Work of Jérôme Bel and Loïc Touzé

Toni D'Amelio

The French choreographers Jérôme Bel and Loïc Touzé have recently shown work at prestigious Parisian venues: the Théâtre de la Ville and Centre George Pompidou, respectively. As I read a critique of Bel's performance by Tim Etchells, the director of the British-based experimental performance ensemble Forced Entertainment, it became clear to me how culturally specific these works are, and that some contextualisation by someone 'on the premises' may be in order. A resident of France for the better part of 20 years, I would like to offer this.

Under consideration: Jérôme Bel's *The Show Must Go On* and Loïc Touzé's *Love*, which he choreographed with Latifa Laâbissi and six dancers. Why these works? Because they are representative of the larger historical movement in French dance: the shift from a modernist aesthetic to a postmodern one. They also allow me to trace a return from a moment in French dance history marked by a rejection of dance gesture (Bel) to its partial recuperation (Touzé).

Let me start by situating the reader in the context of current French dance production, whose activism for the last half-decade has consisted in its non-action; in *not* dancing. Labelled 'la non-danse' by the French press, this choreographic trend has been observed to have replaced dance gesture with concepts. What I shall add to this observation, and, through particular focus on *The Show Must Go On* and *Love*, suggest is characteristic of French dance now, is an omnipresent tension between

high and low culture. Strangely, in these 'conceptual' works, there reigns an atmosphere verging on the infantile, the regressive and sometimes the just plain silly. Bel's piece consists in an unlikely cast of amateur and professional dancers standing around listening to, mouthing and vaguely undulating to pop songs. Touzé's is a series of scenes including mimed death thralls, mock boxing-matches, slapstick tap numbers and interludes in which the dancers, on all fours, pretend to be lions. That the audience stays – and stays awake – to watch these works is the incredible wager Bel and Touzé win, by which means I shall consider.

Premises/*Prémisses*

Linguistics has taught us that a particular philosophy is implicit in each language. Yet languages and cultures can sometimes be ostensibly so similar that their differences evade detection. This is especially true of the French and English languages whose many *faux amis*, words which may be written the same and pronounced similarly, cunningly mask diverse meanings. Often this diversity is one that evolved over time, after the French word entered the English language (perhaps with the Norman conquest). What I suggest is interesting here is that the diverse ways a common seed has grown reveal the direction to which each culture tends to turn: that the pair of almost-homonyms premise/*prémisse* offers insight into the signature turnings of English and French cultures. Formed by two other words, which translate as 'put before', the French *prémisse* has a predominantly philosophical register: a proposition (which begins a process of reasoning); a principle (from which is drawn a conclusion); a fact or event (from which issues a consequence). The English 'premise' keeps this meaning as a first sense. But it grows more pragmatic than its French homologue, taking on a second sense that is physical: a locale or a place. Something may be made on the premises; miscreants may escorted off them. In this consideration of French contemporary dance, the word 'premise' helps underline how the focus of Bel's and Touzé's work moves from the particular to the general, from an example to the rule that governs them. Bel writes:

> Mon projet artistique est de travailler les structures théâtrales, ayant la certitude que si le théâtre existe encore c'est qu'il est représentatif de structures psychiques, sociales, et politiques de la société. Il doit y

avoir des parallèles entre la structure théâtrale et la structure de la cité, l'histoire du théâtre et l'histoire de l'humanité.

(quoted in Sigmund)

[My artistic project is to manipulate theatrical structures, in the certitude that if the theatre still exists it is because it is representative of society's psychic, social and political structures. There must be parallels between the structure of the theatre and that of the city, between the history of theatre and the history of humanity.]

(translation of this and other quotes by D'Amelio)

Bel's statement shows how his drift is directed from the specific, practical instance to larger abstract questions, a habit of mind that can be recognised as particularly French. Whereas my own mental proclivity, as a native English speaker despite my long French residency, leads me to consider how these choreographers depend on the physical to contemplate the metaphysical. The proxemics, demographics and economics of the French dance scene shape how the dance performance is made and seen. As the word 'premise' oscillates back and forth between its physical and conceptual facets, it encapsulates my larger argument that thought and action mutually engender one another. Ways of thinking become attitudes that predispose the dancing body to move in certain ways; ways of thinking also have an immediate currency and influence as they construct discourse on dance. But over time, attitudes become sedimented in a more permanent way in a culture's infrastructures, institutions and in the actual premises of buildings. These more durable structures which condition how dancing bodies can work and produce art are precisely so obvious – so monumental and seemingly inviolable – that like Poe's purloined letter, they escape notice. Length restrictions make it impractical here to trace the connections between the different timings of cultural sedimentation in satisfactory detail. Yet to break this analytical habit of overlooking the overarching context of cultural institutions, I shall briefly identify them as the horizon of possibility within which individual instances of artistic production emerge.

At the Théâtre de la Ville: the premises of reception

In 1967 a refurbished and radically modernized Théâtre Sarah Bernhardt opened its doors as the Théâtre de la Ville. Ever since then, but especially

since 1985, when its directorship was assumed by Gérard Violette, the theatre has discovered and developed contemporary choreographers, been recognized as the principal theatre for contemporary dance in France and wielded an important influence in establishing dance trends internationally. British dance-goers visiting Paris may therefore be shocked, if they attend a performance at the Théâtre de la Ville, to find themselves part of an audience which behaves as if watching *The Rocky Horror Picture Show*. British audiences are respectful: never have I heard any catcalls or seen anyone walk out of a mainstream theatre. At Bel's *The Show Must Go On*, which premiered there in January 2001, the audience lit their lighters, hooted, clapped and sang along with the soundtrack, not to mention yelling their objections. Far more disconcerting for the performers was the evening a disgruntled audience member actually joined their number, having climbed on stage from the orchestra pit to exhibit what he thought was a more valid evening of dance to the audience. Yet while reaction to Bel's *Show* was extreme, it is traditional for audiences at this venue to 'vote' with their reception of it, and not only with their feet. *Danser*'s Daniel Conrad observes:

> Le paysage chorégraphique français, comme n'importe quel autre milieu, n'aime rien tant qu'on le montre, qu'on lui tende un miroir dans lequel il puisse contempler sa propre puissance et voir célébrées ou moquées ses vanités.

> [The French choreographic scene, like no other milieu, likes nothing better than that [the performance] shows it to itself, that the performance holds out a mirror to it in which it can contemplate its own power and see its vanities celebrated or mocked.]

In the same house, Anne Teresa DeKeersmaeker's 2006 production was treated to loud hisses and a massive walkout; the 2007 revival of Pina Bausch's *Bandoneon* created a scandal. Chicken or egg: does this habit of joining in the process of performance spring from the French language, in which one says '*assister un spectacle*', or did language assume this form because it accounts for this attitude?

As I read Etchells' critique of Bel's *Show*, in *Dance Theatre Journal*, it occurred to me that while correctly identifying the relevant elements and details, he had trouble assembling them into a clear picture, because he had interpreted them through a mode of perception and paradigms of understanding that emerge out of the climate of feeling of his own country of production. Etchells writes: '[Bel] understands that theatre is

a frame (game) constructed so that people can look at other people' (Etchells, 2004, p. 12). Close attention to Etchells' metaphors reveals that he figures theatre as a sort of window ('frame') through which the spectator may travel in imagination to experience an enjoyable fictive world ('game'): it affords a view of that which is not the self, but 'other'. But the premise Etchells assumes as universal cannot be transported happily to France, as the testimony of the French press corroborates. From the above quote and others, we understand rather that the audience sees *itself* – and not the other – in the performance; *Le Monde*'s Rosita Boisseau (2001) observes, 'Jérôme Bel pose le public face à lui-même' (Jérôme Bel places the public in front of itself); *Le Devoir*'s Denis Lord inverts this with '*Le Show* est dans la salle'. These dance critics are suggesting that the paradigm of performance–audience relations in contemporary dance in France is more mirror than window; they simultaneously identify a cultural curiosity: at this venue, dancers dance for other dancers, and not for the general public.

A first reason why France's theatres tend to assemble proportionately more artists in their audiences is that art is heavily subsidised by the state. In the case of Théâtre de la Ville, as might be expected from its name, subsidisation comes from the city of Paris, whose generosity allows the theatre to price its tickets so that they are affordable for almost everyone. While those in London paid up to £48 (€ 68) to see Pina Bausch's 2005 performance at Sadler's Wells, those who watch her offering in Paris in 2008 may pay as little as £12 (€17). A second reason more dancers may attend performances is that French dancers themselves enjoy greater economic stability relative to those working in other European countries. This is in part because of '*l'intermittance*', a status peculiar to France, which gives special unemployment benefits to performing artists. There is recognition at the political level in France that the performing arts professions are intrinsically sporadic, consisting in contributing to projects that are neither continuous nor spaced out at regular intervals. Part of a disappearing heritage of France's once-dominant socialism, the economic infrastructure of *intermittance* allows performers to count on a certain proportion of their salary between projects, providing them with a measure of artistic freedom not enjoyed elsewhere.

La 'non-danse'

Another spectacular disregard for premises, this time relating to the medium of dance, comes as Etchells quickly glosses over the absence of

dance gesture in Bel's choreography. He writes: 'trained as a choreographer, Bel seems to have invented something that might better be described as conceptual time-based sculpture' (Etchells, 2004, p. 12). Unlike the choreographers who became prominent in the 1980s and 1990s, the originality of whose artistic vision resided in their having been trained in disciplines other than dance (Jean-Claude Gallotta, Karine Sapporta, Alain Platel) Bel, and perhaps even more so Touzé, have had their perceptions and identities moulded through training received at France's most selective and prestigious dance schools during the impressionable years of childhood. The absence of dance gesture in their works is not a case of merely wanting to find 'something else'. Rather, it constitutes an excision of a fundamental part of themselves. Bel came out of the National School for Contemporary Dance at Angers, and worked afterwards with the most sought-after contemporary companies in France of that time (Angelin Preljocaj, Bouvier/Obadia, Daniel Larrieu, Philippe Decouflé). Dance gesture still inhabits him, something I witnessed during a conference at the Dance Festival in Kalamata, Greece in 2002. Separated from his audience by a conference table, Bel broke out repeatedly in polymorphous arm movements in illustration of what he does *not* want in his work, in a striking contrast to the pithiness of his style of verbal communication. In the case of Loïc Touzé, his inscription by academic dance training is not merely a matter of my observation, but rather corroborated by his own testimony. In the filmed interview *Entretien avec Loïc Touzé*, conducted by two dance scholars, Christophe Wavelet and Isabelle Launay, Touzé refers repeatedly to the muscular and perceptual habits engrained in him at the Paris Opera as something to be deconstructed.

An ideological reason impels Bel and Touzé to reject dance gesture: they believe it has a certain powerful and negative effect on the public. Formalist dance has elaborated an aesthetics of physical exploit which exerts a 'fascination hynotique' on the public, from which Bel seeks to deliver it, according to *Danser*'s Nathalie Dray (2000). Touzè avows a similar distrust of 'beautiful' movement in an interview about *Love*, describing it as 'médusante' (Medusa-ising) (Jacquet and Piron, 2004, p.148). Bel and Touzé seem to imagine the spectator, riding on the crest of an empathetic wave created by the performer, rendered so passive by the experience that it is as if his/her own power to act were temporarily paralysed. The project that Bel and Touzé hope to accomplish by eradicating dance gesture from their works is to make the audience into active agents. Bel, reading *Mythologies,* seizes on Roland Barthes' two spectator–performer paradigms: 'bouillir' (the actor's emotions come to

a boil: there is combustion and expansion towards the audience), and 'vénusté' (Venus-like, the actor engenders the public's desire) deciding emphatically in favour of the latter:

> Ce phénomène me semble beaucoup plus intéressant...par le seul fait que la vénusté décrit un mouvement du spectateur vers l'acteur et non l'inverse...Le spectateur doit payer non pas pour consommer quelque chose, mais pour travailler à définir son désir'
>
> (quoted in Alphant and Léger, p. 68)

[This phenomenon seems to me much more interesting...if only because it describes a movement of the spectator towards the actor and not the inverse...the spectator has to pay, not in order to consume something, but rather to work to define his desire.]

For Bel, the performance–audience relationship is also one of duty (rather than the pleasure implied by Etchells' 'game'): 'Je demande au spectateurs de prendre leur responsibilités. De devenir actifs, reflexifs, de faire leur 'job': comme j'essaie de faire le mien' (quoted in Angel, 2001) (I ask the public to shoulder their responsibility. To become active, to do their 'job' as I try to do mine). Yet the condition of the audience's engaging in this activity is that it has to be there, and to be paying attention. This was the problem that confronted Bel, when his reading of Barthes' *Le Degré Zero* resulted in a piece (*Nom donné par l'auteur*) so 'terrifying' (Bel's own adjective) that spectators left in droves when they did not fall asleep, or try to obstruct the ongoing performance by hurling insults. The question of how to unsettle the audience, yet keep them still in their seats (both occupying them and silent), is the problem both choreographers solve by employing the same formalist-engrained expertise, at an organisational level, that they reject at the level of gesture.

The premises of the collective: Loïc Touzé

A massive futurist structure built in Pantin in 1972, one of Paris's historically socialist suburbs, is today home to the Centre National de la Danse, an umbrella organisation that supports dance in diverse ways. Purpose-renovated in 1997–2004, it houses the Centre's different activities: the elaboration of choreography; the training of professional dancers; the education of prospective dance teachers; research in dance. It is here that I consult the video of the Wavelet and Launay interview of

Touzé (which was also produced by the Centre). In the interview Touzé attributes his artistic orientation to his early life as part of a clannish 'famille nombreuse'. In the best tradition of French post-'68 activism, the whole family took part in political activity, with the children getting up early near election time to put up a candidate's posters. Touzé affirms having been marked by the feeling of belonging to a collectivity, and to reproduce these relations in his own interactions. In school he was part of a circle of same-age children who got in and out of scrapes together. By contrast, Touzé portrays his entrance to the dance world as the rupture of a utopic community. Accompanying his sister to dance class, Touzé had been discovered to have enormous natural talent and was encouraged to remain. But when Touzé's gang found out, they would have nothing further to do with him. Yet while he was ostracised by one group, he became part of another, since having auditioned for and been accepted by the Paris Opéra school, he soon found himself among another group of children of his age.

Membership in the new group was disappointing, since Touzé soon realised that its individual members' unique common desire was to stand out from it. So competitive was the atmosphere at the Opéra that one's entire concentration was given over to remaining there, and to succeed by climbing up through its echelons. To obtain success everything extraneous to dance had to be excised from life. Touzé goes so far as to liken his time at the Opéra to the incarceration undergone by one of his brothers during the same period. Travelling to visit his sibling in the outskirts of Paris, Touzé saw certain parallels between their situations: both were being held as elements to be disciplined in a collective on the margins of society. Yet Touzé saw that his own bondage, in contrast to his brother's situation, was self-constructed: that it was formed out of his belief that the Opéra's machinery of elitism, for which separation from the world was a prerequisite, was the sole process capable of making him a viable artist. In an act of imagination and courage, Touzé confronted Nureyev with his desire to leave the main company and join the Groupe de Recherche Chorégraphique (GRC), then headed by Carolyn Carlson. Opposed in this by Nureyev, Touzé's reaction was again to identify himself with a collective: the dancers' union at the Opéra, without whose help Touzé speculates he might not have been able to impose his decision. Once in the GRC, Touzé was on track, working towards the goal that still motivates him: 'de faire que la vie s'engouffre plus dans la danse' (to allow life to intrude more into dance).

The premises of concepts: Jérôme Bel

Bel's choreographic beginnings are a tale with two versions. The version Bel recounted orally to the conference crowd at Kalamata stressed physical influences: after working as Découlfé's assistant for the opening ceremony of the Albertville Winter Olympics, Bel found himself with the wherewithal to closet himself in his small Paris apartment for long enough to produce *Nom donné par l'auteur* (1992). By contrast, the version which appeared in print, as part of Marianne Alphant and Nathalie Léger's exhibit *R/B Roland Barthes* (presented at the Pompidou Centre, November 2002–March 2003), not surprisingly emphasised philosophical influences. Bel describes his encounter with Barthes' work in the following terms:

> Étant peu cultivé et n'ayant pas fait d'études supérieures, c'est avec un peu d'apprehénsion que j'ai commencé à lire les *Eléments de semiologie* – par curiosité et grâce à l'ouverture d'une bibliothèque municipal dans ma rue.
>
> (Alphant, 2002)

> [Being little cultivated, and not having had a University education, it was with some apprehension that I began to read *Elements of Semiology* – out of curiosity and because of the happy chance that a public library had opened up on my street.]

One may wonder whether a budding Anglo-Saxon choreographer could find him/herself in the same readerly position. Leaving aside questions of the individual's personal culture, let us consider the shared background that constitutes France's attitudes towards the activity of reflection. Bel stresses that he has not benefited from higher studies, but in order to take his *baccalaureate*, he would have had more exposure to philosophy than most Anglo-Saxons with the same level of education, since a condition of French national education is that it requires a year of philosophy in the graduating class. But as my method in this essay has attempted to demonstrate, production and reception are two sides of a single coin, and, turned around, Bel's claim to authority (through his inspiration by Barthes) becomes the matter of his acclaim by others. We should reflect that it is in 1992 that Bel is applying literary theory to dance. Once we have done so it becomes clear that whether this could occur in the Anglo-Saxon world is no longer a relevant question, since

if it did, it would not be heeded by those constructing dance discourse. Bel is free to take up reflection on dance because the premises, so to speak, are under-populated. Unlike in the Anglo-Saxon university system, where dance has been a discipline since the 1930s, dance has had a very recent presence in French academe. Dance is a department in its own right at only three *facultés*, and only now has a first generation of scholars been able to obtain a doctorate from within the discipline.

Watching *The Show*

In *The Show*, not only does Bel refuse to choreograph dance movement, he also stages that refusal as a drama. For he first heightens the audience's expectations, by having the song *Tonight* (*West Side Story*; 5.43), broadcast into the darkened house when the public has found their places. Teasing the audience further, Bel brings up the house lights slowly to the strains of *Let the Sun Shine* (*Hair*; 6.06).

Le Figaro's René Sirvin observed, '[il] joue sur les mots et avec les nerfs des spectateurs'; I would like to add that he does so simultaneously. Punningly leaving the audience to wait (*dans l'attente*) heightens expectations (*leurs attentes*). Eleven minutes and 49 seconds into the performance, the audience finally sees the stage – which is empty. It can also dimly make out the back of a seated figure in the first row of the house behind a table, upon which are a CD player and stack of CDs. This figure, an avatar for the choreographer, controls the dancer's actions, for the songs he selects and loads one by one into the CD player dictate a literal acting-out of their lyrics. As the eponymous refrain of The Beatles' *Come Together* is heard, 20-odd professional and amateur dancers mill out of the wings, coming to stand in a flattened semi-circle facing the audience, in an arrangement which promotes the spectator's equal view on each, like a recalcitrant student body assembled for a class photo. But the snapshot the audience takes – and takes over again and again during the 4 minutes, 10 seconds of the song – is at odds with the picture's frame. This emphatically banal group, of diverse ages and sizes, dressed as Etchells has it in 'dysfunctional Gap', in trainers and carrying back-packs, appears within the proscenium arch of a centre-city mainstream theatre.

The audience is in agreement when it hears the refrain of the next song, David Bowie's *Let's Dance*, for after 15 minutes no dance has yet been seen. Yet it becomes uneasy with its own wish to see dancing when the performers react to the refrain as though it were a command. With 'instant absurd commitment' they break into frantic gyrations that stop as though

'a switch had been thrown back' as soon as the lyric does, as if responding to the puppet-master of the audience's desires (Etchells, 2004).

Over the next three songs Bel shows the dancers' immediate and unthinking response to external imperatives as linked to their identity as dancers. Throughout the 3 minutes, 50 seconds of Reel 2 Real's *I Like to Move It,* each dancer invents an exuberant signature gesture, which he/she repeats as though trapped in his/her own narcissism. The next song, Lionel Riche's *Ballerina Girl,* banishes the men from the stage and foregrounds the more amateur of the female members of the cast as they endeavour earnestly, but flounder in their attempts to dance according to the forms of classical ballet. At the mercy of their own desire to please, the dancers contort themselves to fit into ballet's restrictive mould.

The next song explores the darker aspects of the dancer's reification. The women exit the stage, leaving it empty. The lights go out except for a spotlight illuminating a sole small circle centre-stage. Leaving his station behind the table, the disk jockey/choreographer climbs up on the stage, penetrates the small circumference of light, and once there disco dances passionlessly to Tina Turner's *Private Dancer.* In theatre, soliloquy bares the innermost thoughts of a protagonist; the solo form is dance's translation of this, but the movement Bel puts to *Private Dancer* is utterly consensual. Soliloquy consists in that privileged moment in which the audience learns the truth – that which the protagonist would not otherwise disclose were he/she not unaware of being overheard. Bel's staging shows the performer completely conscious of, even actively manipulating, the devices that constitute him as the centre of attention. The spotlight shining on the disk jockey, recognised as doubling the intense interest the audience is directing at the dancing figure, is an effect the disk jockey himself has cued. Far from revealing the truth, this gaze is perceived to be a distorting glare: a fantasy whose projection obscures true seeing. What is seen is not the truth because it is done in order to be seen, in order to please. What is given to view will always be mediated in advance by the artist's knowledge of the audience's expectations: a cold calculation in concert with the semi-prostitution of Turner's lap dancer. The public's expectations are foreseeable. Literally in the light of them, the performer adjusts his/her performance to be that fantasy.

Ideological premises

Consider the title of Bel's piece. A favoured theme of what has also been called 'dominant theatre' has consisted in glorifying the reification of its own workers, a reification which it re-casts, heroically, as

professionalism – by dint of which jingle? Of a plethora of examples, ones that spring immediately to mind are the musical-theatre's *Forty-Second Street, That's Entertainment, A Chorus Line.* In film, we may count *The Red Shoes, Turning Point, Company.* By contrast, Bel is not celebrating the fact that it is possible to earn a living by dancing, but questioning the validity of the exchange: money for entertainment.

It is very French of Bel to conceive of this as something open to critique. Despite France's ostensible status as a modern capitalist power, economics are not the only factor at work in France, especially as it concerns the world of culture. Tellingly, it was to his North American public that Bel thought it necessary to insist: 'aller au théâtre c'est un acte risqué, pas un achat' (quoted in Brody, 2001) (going to the theatre is a risky business, not a shopping trip). As I have said above, to understand these attitudes one has to look back in time to France's socialist political history. While massive support by the state has the positive effect of giving a certain economic stability and thus artistic freedom to the dance world, the other side of the coin is the necessity to remain in the state's good graces. For the state not only funds choreographers but also the theatres where choreography is shown, and thus controls both the means of production and of distribution. A young experimental artist such as Touzé, who declares that he cannot be said to have an audience, is particularly dependent on the state's benevolence, and during the Wavelet and Launay interview Touzé remarks that his awareness of his dependence is reinforcement of his attempt to make art address the public. The way in which funding is applied for and distributed may also be fostering the conceptual turn of French contemporary dance. Civil servants looking over a choreographer's grant application may not know how to 'read' choreography, but they may have read Barthes, for example, and this is shared culture on which aspiring choreographers can call. Neither does dance scholarship escape this circle of mutually constituting influences. A document such as the Wavelet and Launay interview is an example of how scholarly activity is not only about increasing knowledge (as though knowledge could exist separate from the world in the proverbial ivory tower). Rather, it also acts to legitimise a choreographer's artistic project by training attention on it, and furthers a choreographer's visibility by multiplying his/her points of contact with a public.

Back at *The Show*

The French preoccupation with the question of the artist's relation to a larger world can be seen in how Bel moves from focusing on the people

on stage to 'pan out' to take in the audience. In the next three songs the disk jockey plays, and, in the staging he imagines for them, Bel shows that his actors/dances are part of a larger collective of human beings and the way they are moved by that basic humanity. Desire for social inscription impels the bodies on stage to move in unison to the set steps and gestures of *La Macarena*. Emotional needs displace them across the stage and into a momentary embrace with one partner after another to Nick Cave's *Into My Arms*. Our final movement, into the grave, is enacted to The Beatles' *Yellow Submarine*, as one by one the cast climb down and disappear into a rectangular aperture that opens up centre stage.

Having broadened his focus to include dancers in the wider human-ity, Bel can then suggest that wider humanity, the audience, can also be considered a performer: 'All the World's a Stage', as it were. Pink house lights come up making the audience-members easily visible to one another, as Edith Piaf's *La Vie En Rose* is heard. Not content with having evened out the differences between the performers and their audience, and having thus levelled the gaze they exchange, Bel goes yet further. The Police's *Every Breath You Take* and George Michael's *I Want Your Sex* invert the mechanism of gazing, and this time the public is the object of the gaze. The dancers move in a line towards the edge of the stage and each fixes an audience member with an unambiguous glance of invitation.

During the next few minutes no song is played to the audience, but the dancers, having donned walkmans, stand alone and equidistant from one another, nodding to inaudible music, each in his/her own private world. As each dancer hears the refrain of the song they are listening to, he or she sings along with it, so that the public hears bursts of song snippets which fall incongruously into the silence. First we hear what we see, as the first dancer intones, tautologically, 'I'm still stand-ing', while subsequent performers progressively break out in statements that are less verifiable: 'I am a woman in love', 'I'm too sexy'. Etchells (2004) notes that here *The Show* is at its most polemical, with the danc-ers 'locked in an exaggeratedly private relation with something that remains outside of our grasp'. Yet the point is that what is outside is already inside. These songs, coming from the other, form our interiority to the extent that we remember them. In the German-language *Tanzdrama*, Kästner (2000) quotes Bel saying:

Jeder denkt, er sei einzigartig. Aber das stimmt nicht. Die Vorstellung von einer authentischen kreation ist Schwindel. Meine Geschichte,

und damit meine Arbeit, besteht aus allen Tanzperformances die ich in meinem Leben gesehen habe, ... das ist Geschichte.

(Kästner, 2000)

[Everyone thinks he is unique. But that is wrong. The ideal of authentic creation itself is deceit. My stories, and therefore my work, are composed out of all the dance performances I have ever seen in my life ... that is history.]

The reception Bel enjoyed throughout continental Europe points to the complicity it seems to evoke among a community of non-native English-speakers. During the question-and-answer session with the public at Kalamata, one young Greek dancer took advantage of the microphone to let Bel know that 'she had known exactly what he felt': by which she meant a feeling of being overwhelmed by a foreign culture. By contrast, what (English-speaker) Etchells did not see, while observing that the dancers automatically executed each song's orders, is the cultural strangeness of the fact that in *The Show*, French dancers are obeying commands in English. Of the 18 songs, only one is French, *La Vie en Rose*, which is the carrier of such nostalgia that the present generation cannot identify with it. *The Show* is also commenting on the inability of French culture to renew itself, to sing its own song. Sensitised to questions of preserving the purity of the French language by the former socialist Minister of Culture (and staunch supporter of contemporary dance), Jacques Lang's famous embargo on Franglais, French audiences witness the takeover of their compatriots by Anglo-Saxon pop culture. They too are included in this takeover, they realise, when their memories supply the bulk of the song that is not heard aloud. 'Je est un autre'.

Visual premises

In 1969, President Georges Pompidou conceived the idea of an arts centre as a place for both the production and consumption of modern art. In 1977 the structure that bears his name was completed, whose signature feature of external, caterpillar-shaped glass escalators, appear to inch geometrically up its sides. The building houses several institutions: the museum of contemporary art, a library and a centre for research in music. It has a performance space that offers a season of experimental dance performances, which tend to be more linked conceptual trends in the plastic arts. It was here that *Love* by Loïc Touzé and Latifa Laâbissi was shown in 2003.

Entering the theatre the audience sees a luminous blue box placed on the stage to create a raised restricted space of about 4 × 6 metres. Floating at the back wall of the space is the projected negative image, tinted blue, of a forest: nature made art and artificial by the stage. The dancers – three men and three women – are dressed alike in blue tee-shirt and shorts. They stand off to the side of the elevated dais during the intervals between the small scenes of which the piece is composed.

The piece starts as the entire cast climbs on the stage in silence. Once there the six dancers turn their faces to the audience, where they are seen, like the photograph of the forest scene, to be denatured, made into art by the stage setting. Overexposed in the blue glare, they appear under menace: patients about to undergo surgery, deer caught in headlights. Disconcertingly, both the men and women sport bright-red lipstick. The fixed gaze of the dancers makes the atmosphere of danger, of precarious stillness, mount. Then the seemingly interminable moment is broken, as, without warning, the dancers erupt violently in improvised simulations of sudden death. This is both frightening and comic, grotesque and infantile, with popping eyes, clutchings at the throat, extreme grimaces, with no music to palliate our empathetic swallowing: but only the sound of chokes, gasps and the last rattle. As if to insist 'this is fiction', once 'dead' the dancers get up, stand facing front with their bodies strictly oriented once more to the audience, and sidle out crab-wise along the front of the stage to its edge, where one by one they jump off the stage/gallows, and out of the space of representation.

The code of entrance and exit is repeated at each scene, and by these devices Touzé and Laâbissi keep before the public the fact that they are watching a performance. The position of looking is potentially a sadistic one, we learn in the next scene through witnessing a punching match that the dancers perform with closed eyes. Yet the fascinating/reifying effects of specularisation that are enacted in some of *Love*'s scenes are maintained in counter-tension by their alternation with others in which the dancer's gaze refuses fixation. Nature is juxtaposed with culture as in the next scene the dancers pretend to be zoo animals, blissfully unconcerned by those staring at them outside their 'cages'. Even as they turn their heads to the front, their gaze, as though glazed, turned inside themselves, remains unaware of being watched. Simulating some larger member of the cat family, the dancers stalk around on all fours, stretch, yawn, scratch, plunk down to sit on a haunch, and pile up on one another to nap inside the blue box-cage.

Love's spectacle of spectacularity and its opposite use, devices it obscures to invert the usual effect these have on an audience. Tap dancing does

not necessarily restrict itself to a strict vocabulary of bobbing up and down, as we may all agree, remembering Fred Astaire films. In *Love*, however, the dancing sequence that follows that of the 'lions' presents the movement as exclusively two-dimensional. The dancers' frontally oriented bodies remain equidistant from one another and stuck in one attitude, like the silhouettes of cut-out paper dolls that a child jiggles up and down. By contrast, it must be objectively admitted that the choreographic possibilities of crawling are inherently limited. Yet the lion-dancers remained fascinating to watch. Here a myriad of variations on a ripple in the dancers' spines were on view, as the dancers, highly skilled improvisers, prowled around, seemingly artlessly. Their skilled intelligence showed infinite ways that the body collects relaxation in one area and muscular tonus in another. It staged surprises in the way intention enters and leaves the body – with the speed of light or the slowness of fading disinterest. It gave repeated renewed pleasure in seeing the way contact – of flank or paw or belly – creates shapes in the 'animals', touching and being touched.

After the tap dancing, there follow: the death scene (repeated twice); a scene of single combat, one in which a sole dancer fights four others; and a scene in which a dancer, studded with knives, picks a flower. Repetition here does not function as it does in the work of Pina Bausch, where it exacerbates, or exhausts, the meanings of the object seen. Rather, *Love*'s staging of repetition is reflexive: it forces the audience to change its way of looking. A movement always has a trajectory of intention, and part of our reptilian brain is programmed to anticipate movement in order to see where it is destined so that we can save our skins if need be. Nature structures gaze to move faster than the moving object, in order that we meet up with it where it *will* be. The art in *Love* lies in its uncoiling of nature's mechanism of looking, which it does by presenting the audience with movement whose innocuousness they have just been made sure of. Liberated from the imperative of anticipation, the audience can now focus on the actual moment of a movement's unfolding, and experiences a mode of looking that is strangely altered, in which sensitivity is heightened. Awareness of this new mode of looking is measured most acutely when the 'lion' scene repeats, with the difference that this second time, the dancers are nude. What the scene now ostensibly discloses is a group of sexualised nude bodies combining in animalistic positions – factors which might normally arouse a reifying gaze. Yet the exaggerated effects of specularity *Love* has staged until that point have saturated, exhausted and finally altered this kind of specularity. Watching the nude 'lion' scene in *Love* becomes an uncanny self-observation that one is looking differently at skin and flesh.

Beware of Greeks bearing gifts

In her critique of *The Show*, *Tanssi*'s Katja Werner brings back questions of high and popular culture with the following insight: 'high culture, if examined more deeply, often proves a Trojan horse, a vehicle for the enemy' (Werner, 2001, p. 21). Curiously, the same image crops up as Touzé discusses his desire with Claire Jacquet and François Piron to get the audience immediately on board in *Love*. While 'éthiquement douteuse' (ethically suspect), Touzé allows himself to do this because: 'je comptais bien me servir de cette beauté comme cheval de Troie' (I planned on using this beauty as a Trojan horse). What the dangerous gift of myth figures in these two instances is that the relationship between form and content is no longer isomorphic. In their training as dancers, Bel and Touzé did not only obtain an ability to lift their legs, jump and turn. They also acquired an acute sensitivity to rhythms, sequences and duration, and a mastery of the semiotics of spacing and proxemics. This ability to configure moments of rightness in time and in space is the choreographic skill they use, to *pretend* to give the audience what it wants. Under cover of which, they manage to deliver something else to the public: perhaps the realisation that it no longer wants what it thought it did.

A deceptive offering – Trojan horse – is what is presented in *Love*'s nude 'lion' scene, where the choreography literally unwraps the dancers to reveal a gift which takes the public by surprise. Its generosity consists in having imparted an experience that has changed perception – altered the very premises of the audience's watching. The stage set which seems to flatten the dancing body while itself metamorphising into gallows, film-set, ring, forest or cage are illusions which emerge instead, out of the agency of the dancing body. For it has been the dancers' splendid ability to control, diffuse, modify the body's muscular tonus and directionality that has made these effects. The way the body acts, acts on the premises and reconfigures them.

In Bel's case, the Trojan horse appears as *The Show* rolls out popular culture onto the premises of high art. Ostensibly an invasion of this space and a takeover by it, it is actually a triumph of formalism, through whose rigorous grammar a magnificent work has been created that even manages to recuperate the banal material it structures. It resides too in how, while representing the individual as alienated and isolated, it actually gives the public an opportunity for communion. As the public collectively recalls shared memories, the premises of liberté, égalité and, most especially, fratérnité, are strengthened.

References

Alphant, M. 2003 Compangnie R.B.: Entretien avec Jérôme Bel. Exhibit notes *R/B Roland Barthes*, Centre Pompidou. November 2002–March.

Angel, P. 2001 *Tetu*. January

Bel, J. 2002 Conference communication. Kalamata Dance Festival

Boisseau, R. 2001 *Le Monde*, January

Brody, S. 2001 *La Presse*. Montréal, Canada. 20 September

Conrad, D. 2001 *Danser*. Paris

Dray, N. 2000 Dancer in the Dark. *Danser*. December, pp. 86–8

Etchells, T. 2004 More and More Clever Watching More and More Stupid: Some Thoughts around Rules, Games, and *The Show Must Go On'*. *Dance Theatre Journal*. 20, March, pp. 10–20

Jacquet, C. and Piron, F. 2004 A Propos de Love: Entretien avec Loïc Touzé, Latifa Laâbissi, and Jocelyn Cottencin. *Trouble* 4, Spring–Summer, 7

Kästner, I. 2000 'Der Semiotiker'. *Tanzdrama* 56, December

Lord, D. 2001 *Le Devoir*, 15 September

Sigmund, G. 2003 Hall of Fame. *Tanz Aktuell*, Summer

Sirvan, R. 2001 *Le Figaro*, 7 January .

Wavelet, C. and Launay, I. Filmed interview. *Loïc Touzé*. Paris: Centre National de Danse

Werner, K. 2001 Tansii

7
Chasing Voices: Ian Spink's Dancing *Fugue* (1988)

Janet Lansdale

Pinpointing an historical moment in the move towards abstraction, Deborah Jowitt (1983) writes not of form or material content, but of mood, in a review of *26 Solos* (1978), by the Australian/British choreographer Ian Spink – a work shown in the first season of the then new company Second Stride. She describes vividly the works of Richard Alston and Siobhan Davies (Spinks' partners in the venture) in terms of 'lovely' movement – for example, 'the dancers seem to be musing with their bodies', the style is 'overwhelmingly gentle', the movement is full of 'gently surprising shifts' (1978, p. 16) – all ways of talking about an abstract concern with movement that borders on the minimalist. But when she speaks of Spink's work she says:

> in this piece the numbness and the repetitiveness, along with the oddities, create an atmosphere of sadness and emptiness, even though we laugh. These women seem to have been widowed of their own bodies and transformed into genteel shells.
>
> (Jowitt, 1983, p. 17)

Something more than gentle musing is going on here and it stimulates this essay in which I address a paradox in supposedly abstract work that it reveals; the drive to abstraction, tugged back and simultaneously underpinned, or in some sense undermined, by expressivity in movement.

Theoretical problems

This paradox might be posed broadly in terms of the binary oppositions of structuralist and poststructuralist methods in analysis and, indeed, worldviews of the arts. As Krauss argues, the oppositional terms of

modernism, namely of originality and repetition, are 'bound together in a kind of aesthetic economy, interdependent and usually sustaining' (2002, p. 160) rather than in a hierarchical relationship where one term is valued and the other discredited, i.e. the repetition or copy or reduplication of an 'original'. It is this binding together that is of interest here. Posed more narrowly, I investigate the complex interaction between danced, musical and spoken repetitive forms, which can create both abstraction and narrative, and demonstrate originality arising from repetition, in Spink's *Fugue* (1988).

Similarly bound together are the idea of abstraction and human significance despite an attractive illusion that form and content can be distinguished, one from the other, that some styles focus on one and not the other, and even that one has more value than the other. This supposedly Greenbergian divorce between form, line, texture and meaning is challenged by recognising that meaning lies within a specific form, not apart from it (Best, 1992).[1] De Man's essay, titled *the Dead End of Formalist Criticism* (1983), reflects on the strengths this divorce nonetheless effects, in refining techniques of analysis, while its weaknesses lead to analysis that is ahistorical. While both Greenberg's and Barthes' notions of form are capable of reflecting the choreographer's or writer's experience, criticism has often emphasised a view of structure as inherent in the work rather than productive of meaning. Early in the twentieth century this almost scientific elucidation of the text appeared to guarantee the construction of a truth about the work, a position later challenged by the many ambiguities and multiplicities in the practice of reading texts (De Man, 1983, p. 236). As De Man states, 'the promise … of a convergence between logical positivism and literary criticism, has failed to materialize' (1983, p. 241).

The relationship thus made problematic between analytic strategies of a formalist or structuralist nature (which might be adequate to the analysis of form) and those of an interpretive or poststructuralist nature (which might be adequate to the analysis of meaning) has been of longstanding interest to critics and scholars in the arts. I have argued in the past that analysing movements and their juxtapositions, which we tend to think of as a straightforward matter of description of what is there, are themselves more a matter of interpretation than fact (Adshead, 1988). Individual movements do not unequivocally belong only to a specific dance or even to a specific style, but have an affiliation not only to everyday life but also to pre-existing dance styles. The choice of descriptive terminology used to examine the movement closely, and implicitly, its underlying analytic framework, is therefore not a straightforward one; it

is a matter of how one *chooses* to see the movement. Nor is it innocent. The very choice of a particular language is an interpretive act, often with politically charged overtones, based on consideration of the style of the work and the critic or analyst's personal preferences (Adshead-Lansdale, 1994).

Copeland points up the incoherence of dissociating form from meaning by linking Pina Bausch's minimalism to an *intensification* of meaning, and Yvonne Rainer's formalist minimalism with *objectification*. Repetition in Bausch's work is not there to clarify or to 'deflect the attention from meaning to form' but to intensify meaning (1990, p. 4). Rainer, he argues, uses repetition to *drain* the movement of 'content' and of worldly associations, an echo returning of the first statement in this essay, of 'women being widowed of their bodies' in Spink's work.

Copeland, now discussing formalism, a construct which itself is often reliant on extensive repetition, emphasises the possibility of freedom that it brings, unburdened by representational purposes. The 'cooling and distancing effect of repetition', strangely, can *reinforce* expression (1990, p. 5). Self-restraint is an important idea here and he refers to Rainer's use of repetition as a formal strategy, which in her own terms 'can serve to enforce the discreetness of a movement' (Rainer, 1966, 1974, p. 68). It is indicative that in the famous Chart from 'A Quasi Survey of Some 'Minimalist' Tendencies in the Quantitatively Minimal Dance Activity Midst the Plethora', she lists elements of 'objects' and 'dances', which she then 'eliminates', in order to find 'substitutes'. She eliminates such classic devices as attention to complexity and detail, variety, in rhythm, shape and dynamics, and replaces them with what she calls unitary forms, factory fabrication, an equality of parts, repetition and task-like activity. This is a notion of repetition without the underlying aesthetic assumptions of either classic ballet or modern dance. And, crucially for my purposes here, she points to the difference in *energy investment* as marking one thing out from another, a visible thread in Spink's *Fugue*. Writing in 1966 she asks:

> in *Trio A* where there is no consistent consecutive repetition, can the simultaneity of three identical sequences be called repetition? Or can the consistency of energy tone be called repetition? Or does repetition apply only to successive specific actions?
>
> (Rainer, 1966, 1974, p. 68)

An example of direct relevance to my purposes can be found in Macaulay, like Jowitt, writing on Second Stride in their early days, who

indicates that what Spink's *Canta* means 'is to be found in the constantly developing vocabulary of steps, groupings, rhythm, and phrasing and therein lies its beauty and its reward' (1982, n.p.), that is, deep within the movements themselves.

Nonetheless, and despite its problems, we need some conception of form, or organisation, in order to trace the events of a work through time. Since dance plays with the medium of time (and space), this in turn exposes the significance of changes in the movement from moment to moment, and challenges us to find ways of making them visible.

Revisiting repetition

Perhaps the most significant device that allows the spectator to perceive structure, and indeed meaning, is repetition. Through history the idea of repetition has been dominant in both the making of dances and in much writing about them. It is obvious, in part, because the body itself, being symmetrical, invites repetition of what is done on one side, on the other. It is obvious, likewise, that the visual display has long invited divisions of space that encourage repetition, particularly in classical and high modernist forms. Most obviously we make sense of the progression of dance through time by comparing what is happening now with what has just happened, expecting to find some relationship to what is happening now. We recall events some minutes ago that bear similarity to the event of the moment; we observe similarity and difference at many levels in this process. This classical set of expectations which modern dancers make equally good use of has been challenged, notably in Merce Cunningham's dispersal of focus and in the work of many subsequent postmodern choreographers, to which I return later. I argue, however, that repetition does not disappear or cease to be significant in the mid-twentieth century, but that it reinvents itself.

Repetition can serve the deeper purpose, it is commonly suggested, of creating distinctive aesthetic qualities that in turn are seen to promote harmony and unity – an equality of form often produced through the symmetry of pattern (see, for example, Sparshott, 1963). Since dance is unlike a painting, which remains stationary in front of the viewer, repetition also serves a pragmatic purpose in showing again and re-emphasising what otherwise would be fleeting. It is one of the intriguing complexities of dance that it is both a time-based art, much like music, and a visual art, sharing constructs with painting and sculpture. Dance, furthermore, is compounded by its dramatic and narrative qualities, to become a quintessential collaborative and interdisciplinary

art, requiring a collaborative and interdisciplinary form of analysis to address it.

Terms such as 'form', structure', 'organisation' and 'system' abound in the dominant structuralist dictum, often only loosely distinguished from each other and typically described as embodying 'a set of *relations* among *elements* shaped by a *historical* situation' (Lentricchia and McLaughlin, 1995, p. 25; emphasis in the original). 'Form', the term generally used by philosophers and critics, is replaced by 'structure' in the 1930s and 1940s under the pressure of Ferdinand de Saussure's linguistic analysis, which focuses on how meaning is made possible within specific historical moments rather than on the meanings of individual movements or words.

What, then, is repetition and how might it be used in the twenty-first century in the analysis of dance?

Postmodern repetition

I offer a reinterpretation of accepted positions on repetition making reference to postmodern works based on musical ideas by the North American choreographers Twyla Tharp, Trisha Brown and Lucinda Childs. These are interesting in both their diversity and similarity, and provide an historical and analytical context to underpin a subsequent, more detailed study of Spink's *Fugue* (1988). In making *Fugue* Spink took inspiration from Bach's eighteenth-century *The Art of Fugue* and worked with his contemporary, the playwright Caryl Churchill, on a newly created, spoken text. Together with Terry Braun they produced a filmed, danced fugue – hence my reference earlier to the quintessentially collaborative and interdisciplinary nature of dance.

On the surface there could be few more severe, formalist/structuralist devices based on repetition than the fugue and it is unusual for twentieth-century dance makers to approach it. It has a long history in the creation of highly complex musical works, epitomised in Bach's *Art of Fugue*. By convention, a musical fugue opens with a passage in which a theme or subject is announced by a number of voices or parts in turn. It is usually unadorned in this first exposition. A fugue is structured around a fixed number of melodic strands carried by a set number of 'voices'. Voices enter at different pitches. A counter-subject will then accompany the subject and the interplay between subject and counter-subject forms the main point of interest. The fugue enshrines the essence of counterpoint in the interweaving of melodies; indeed ever-more complex structures were devised in its heyday. Bach's *The Art of Fugue*, a work written

over several years in the 1740s, is often referred to as the highpoint of classical fugue writing. An important element of fugue it is reliance on repetition, either directly or in modified form, with inversion, augmentation and retrograde motion.

Discourse within the art forms of music, painting and literature, and within academic disciplines such as literary theory and psychoanalysis, has, in recent years, extended this theoretical construct beyond its musical connotations in interesting ways. Clearly, there is something of substance still in this elaborated concept of repetition in that it continues to challenge artists and viewers despite changing constructs and artefacts of the twentieth century. Wassily Kandinsky (1866–1944), like other early twentieth-century European painters, stripped away extraneous detail to create paintings that were seen as inherently abstract, yet based in emotional and spiritual responses to other arts. Kandinsky's *Fugue* (1914), it has been suggested, 'is a visual equivalent to a musical fugue, with its overlapping, repeated motifs and themes at different pitches'.[2]

Beyond the visual arts, Douglas Hofstadter's extraordinary book *An Eternal Braid* (1979) is, as the subtitle states, 'a metaphorical fugue on minds and machines in the spirit of Lewis Carroll', which reads Gödel's mathematics and Escher's drawings through a series of dialogues based on Bach's *Musical Offering* but as a computer scientist might construct them. In his account of the fugue, its rule-bound initial statement of themes gives way, as the work proceeds, to a state without any rules. Self-reference and the interplay between many levels inform equally Hofstadter's analysis of each of these figures and disciplines.

Indeed, doubt about the fixed nature of this form can be found within the discourse of music itself. The fugue can be described as a 'procedure', or even a 'texture', rather than a strict form (Sadie, 1995, p. 9). This characterisation and the sense of a fugal *treatment*, found more widely across the arts, is the one I develop here. A fugue becomes an idea, a concept, of flight as embodied, and of a text as a chase between voices, which can be interpreted in a metaphorical or poetic sense as much as in a structural one. In this way the close relationship between structural and interpretive modes of analysis is made evident.

Some danced fugues

Twyla Tharp provides a stark and formal dance example in *Fugue* (1970). She uses Bach's *Musical Offering* as a starting point but not as an accompaniment. She structures the piece as 20 variations on a 20-count

theme, an idea taken from this musical work, although her dance proceeds without music. Rigorous, mathematically-based early works by Tharp reach their peak in *The Fugue*'s percussive phrases performed by three women in boots dancing on a floor amplified by microphones.[3] Tharp (1982) talks about this work as an almost 'invisible dance' and refers to its 'pure economy' and to its being 'nearly pure concept'. Despite this last statement the dance never loses a fierce sense of materiality.

Each variation follows the same pattern, three dancers representing a notional bass, alto and soprano voice. Each variation is derived from the initial phrase, using techniques of reversing, inverting, re-sequencing phrases, and changing their moments of dynamic emphasis as forms of development (Tharp, 1992, pp. 133–6). Rarely do such exact descriptions exist as Tharp herself constructs:

> the fugue phrase has four counts revolving clockwise, four counter clockwise, two counts travelling backward stage right front, two moving backward on the upstage front and arcing around the corner...beats thirteen, fourteen and fifteen move forward on the upstage front, lowering to a kneeling position...nineteen steps back, and twenty, the only circular movement in the theme, sweeps open and drops heavily to punctuate the end of the phrase.
>
> (Tharp, 1992, p. 133)

Interestingly, though, according to Tharp, each phrase is based on natural imagery, e.g. 'twisting around waxy blackberry bushes' (1992, p. 134), used as starting points for these strictly formal ideas within dance. In other words, its form is not devoid of content, structure from idea.

Lucinda Childs, the American postmodern dance artist who worked with the Judson Dance Theatre in the early 1960s, talks of 'movement segments' and 'phrase segments', but uses additive techniques much as Trisha Brown describes in her early work (Livet, 1978, p. 66). In *Calico Mingling* (1973) a kind of postmodern systems music, and a fugal structure, begin to appear:

> four dancers complete four repetitions of a three and a half minute phrase which consists of forwards and backwards walking on parallel lines or on circular and semi-circular loops. Every phrase segment is completed in six paces and the entire dance consists of 1,140 paces.
>
> (Livet, 1978, p. 66)

Child's interest in systems 'which perpetuate the same material, yet continually present the same material in new ways' (Livet, 1978, p. 66) can also be seen in *Radial Courses* (1976) and *Transverse Exchanges* (1976), the first dealing with overlapping circles and the second with parallel lines. It is not irrelevant that her collaboration with Robert Wilson and Philip Glass began in 1975 with her solo in *Einstein on the Beach* in which she continued to explore small, gestural movements alongside minimal stepping patterns. In later works (for example, *Four Elements*, made for Rambert Dance Company), she maintains her interest in tight and angular moves. Her obsession with the precision of repetition is seen in the use of canonic structures where two dancers act as one voice working with another two-stranded voice (Childs, 1999). Childs' notion of repetition, as described by Banes, differs from that of most modern dance choreographers in attempting to restore 'an underlying order' while offering 'the derangement of a set of moves' (1987, p. 140), making 'a world of detail come alive' (1987, p. 145).

Trisha Brown, more celebrated for accumulation techniques than the use of musical forms, departed for new fields in the creation of *M.O.* in 1995, to Bach's *Musical Offering*. Her choreographic play with this 13-part musical composition allows the dance its own, independent existence.[4] The level of analysis required would not surprise her spectators even where, as here, it is in a form quite different from the simultaneous telling of stories and the highly complex sequencing of movement of her earlier work, such as *Accumulation* (1971) and *Primary Accumulation* (1972).[5] In these works, Brown applied structures and gave instructions to performers alongside the use of improvisation. The result, however, resonated for Banes with 'sexuality, vulnerability, laziness' (1987, p. 85). Whereas she regards these qualities as 'by-products', I would argue that they are intrinsic qualities of the work, not separate from it. The formal restraint of the music seems to function in a similar way in *M.O.* to the restraint of the story form of Brown's earlier works, and in turn produces recognisable yet distinctive qualities. The programme for Brown's 1996 visit to the UK describes each movement as distinctive, in the way they range from strict adherence to the structure to metaphoric interpretation. She sometimes employs dancers almost literally as voices in a musical fugue. Her

> goal was to find in the choreography a corresponding density that would generate a multiplicity of possibilities while maintaining at the same time the pure, essential beauty of the compositions. As if the body would listen and the spirit engage in dialogue with the music.
>
> (n.p.)

She refers to a 'geometrical' and 'sculptural' response to Bach. Although she worked closely with the music in making this work she is not a slave to it, but aims to create a 'third music', which moves beyond both the music and the movement. Jowitt recalls from an interview that Brown creates patterns that function by 'shadowing but not quite shadowing' each other (Brown, 1996). It is apparent that fragments, rather than whole phrases, overlap, making a distinctive fugal equivalent, not always matching musical phrases and pauses.

Such examples deal with questions of repetition in a fugal form, and in consequence can be said to share a subject matter, yet each is different since the treatment of the theme is markedly diverse. None, however, uses fugue form simply, or solely, as a structuring device as is even more clearly the case in Spink's *Fugue*. I focus on how attention to detailed repetition within the form of the fugue can collide with a highly emotional narrative of death and bereavement in a verbal text, only to be enshrined in a rich movement texture which complicates, rather than clarifies, each element.

The case in point: Ian Spink *Fugue* (1988)

Jowitt picks up on Spink's similarity to his colleagues, Richard Alston and Siobhan Davies, co-founders of Second Stride, in his creation of short movement phrases (for example, in *26 Solos* (1978)), which have a 'smooth, full, slow, mildness' (1983, p. 16), but she also marks his differences, notably as revealed in his vocabulary, of 'everyday gestures... orchestrated into a bizarre and dreamlike drama' (1983, p. 16); his use of old wooden chairs and tables evoking for Jowitt a 'funeral parlour' rich in qualities of 'numbness and repetitiveness', an apt prefiguring of the *Fugue* under discussion here.[6]

Spink was also unlike either of his partners in his consistent emphasis on theatrical images, gestural movement and the use of text. The interplay of texts drawn from myth, religion, historical characters and fantasies has dominated his subject matter in many works, such as *Further and Further into Night* (1984), based on Alfred Hitchcock's 'Notorious'; *Weighing the Heart* (1987), based on fragments of plots from Ancient Egypt, the Bible and other sources, and *Heaven Ablaze in his Breast* (1990), based on Hoffman's 'Sandman'.[7] A similar intermixing of music, song and speech with movement, typically characterised his treatment of these themes. These are not subject matters that would seem to align themselves easily with fugal treatments, although his interest in this field, as well as in the dramatic, is apparent from his early work. Spink

first explored the fugue form in *Some Fugues* in 1980, although it is his later work, *Fugue* (1988), which uses Bach's *The Art of Fugue*, that is of particular interest for my purposes here.[8]

Caryl Churchill, whose text accompanies Spink's *Fugue*, was apparently fascinated by 'the potential of writing dialogue that was fugal', again a rather unusual approach (Cave, 1995, p. 297). The two artists came to this form through a process of collaboration with an interest in how a musical structure might be used for a play. The result was a written and verbal fugue, added to a musical fugue, to which Spink adds a danced fugue and, together with Terry Braun, created a filmed fugue.[9]

Spink's own account of *Fugue*, which Mackrell records in an interview, identifies its themes as

> the death of an older man, a father, the mother telling her daughters about it and daughters telling their husbands and boyfriends. That whole section in itself is very fugal in that we see the same words and actions being repeated, with slight variations, as everyone tells each other the news.
>
> (1988, p. 28)

However, further themes focus on the reaction to the death, as Jordan indicates, announcing that the subject matter 'concerns a man's death, his bereaved family and their process of coming to terms with his death' (1992, p. 204). These themes are pursued through a narrative structure showing the father's death, the funeral and post-funeral party. The film is organised in eight scenes.[10]

The return of the repressed: a psychoanalytic fugue

To make the link between fugue and such poignant narrative subject matter requires an understanding of the end of life, a deeply psychological, as well as physical, matter, which might be informed by a consideration of how repetition, clearly dominant in this piece, works in the light of psychoanalytic theorising. It is tempting to adopt the view that, if the unconscious can be seen as a non-verbal phenomenon, it can escape cultural indoctrination by language and thus its manifestation through other means might be more significant. Jacques Lacan, together with other theorists, however, stresses the relational character of the unconscious in being 'structured like a language' (1977, p. 20).

Whereas Copeland argues, in the poststructuralist tradition, that 'the unconscious is viewed as both a *verbal* and a *political* entity: culturally-conditioned, historically-determined, penetrated by, and in large part *constituted* by language (1990, p. 6; emphasis in the original), Spink, in turn, diverges from abstract modernism in meeting head on the seductions of language in *Fugue*.

The relevance of psychoanalysis to this fugue is clear, through the complex levels of repetition of both language and movement in this work. Sigmund Freud, in a series of meta-psychological writings dating from 1919, brings several of his earlier ideas into relation, attributing the character of an instinct, of a deeply intimate kind, to the 'compulsion to repeat' (1984, p. 272). This trait, which 'emerges in the treatment of neurotics' (1984, p. 289), is 'ascribed to the unconscious repressed' (1984, p. 290). What is 're-membered' can be distinguished by this means from what is 'repeated'.

This is painfully elaborated in the fugal motif of the opening scene of *Fugue* where the story is passed from mother to children and their partners. She says: *'he had just got out of the bath. I thought I heard him call. I came out of the kitchen. He was already falling down the stairs.'* In its retelling, the phrases come in different orders, sometimes in fragments and with distinct nuances and dynamic emphasis. No two iterations are the same. Each is accompanied by body movement, which ranges from the slump of the body of the daughter to a boyfriend's violent disarrangement of a tie. The text recurs during the funeral tea. An air of deep unease and anxiety accompanies each version.

Psychoanalysis asks why we would want to repeat such essentially unpleasurable experiences, to which Freud replies that 'there really does exist in the mind a compulsion to repeat which overrides the pleasure principle' (1984, p. 293). This may, however, be matched by instincts which 'push forward towards progress and the production of new forms' (1984, p. 309). It is evident that Spink shows individuals as obliged to 'repeat the repressed material' arising from their trauma, but whether this is 'as a contemporary experience' or as 'remembering it as something belonging to the past' is an interesting point (Freud, 1984, p. 288). The former is regarded as a less healthy response than the latter in its perpetuation of regression, while the latter allows the individual to move on.

Another manifestation lies in the transference of the verbal fugue into a musical fugue in Scene 7, where each daughter/partner plays a part of the fugal text. In Scene 8, this formal fugue becomes a danced fugue where relationships between the children and their partners are

played out with danced phrases splintering and re-forming between the four dancers. Towards the end of *Fugue*, where the family prepares the father's body and burns it on a pyre, the rather formal representation of the cremation is remembered. Each makes this death their own in a distinctive and intimate fashion.

Ideas of repression are sometimes related to traumatic dreams in which the individual attempts to 'master' the event retrospectively. Indeed in Spink's *Fugue* there are several dream-like states, the first evoked in happy flashbacks to childhood seaside holidays, then in the sinister events depicting the violence of the father, smashing the child's model aeroplane, and later, plaintively, in echoes of him playing the piano. In Scene 4 the children, now grown-up, dance out a scene of competitive sibling rivalry and cruelty but it, too, takes on a dream-like quality.

Fugue states are part of a group of dissociative disorders, which, in the heyday of psychoanalysis, were grouped under the rubric of hysteria – a term that is no longer used in psychiatric diagnosis. So-called dissociative fugue is characterized by

> sudden, unexpected travel away from home … with inability to recall some or all of one's past. This is accompanied by confusion about personal identity, or even the assumption of a new identity.[11]

It is relevant to Spink's *Fugue* that the manifestation of repetition and difference invites the question not of what is repeated but of what the significance of this repetition is. Since there is no explanation for the father's absence, as described in Scene 5, it aligns itself with this notion. He loses his memory, and although he returns knowing who he is, it is as a different person.

Dissociative fugue is often associated with a sudden traumatic event, such as combat death or rape. Single episodes are most common, and may last from hours to months. Typically, during the fugue itself, the individual is completely or nearly completely forgetful of his/her past lives and associations, though he may retain basic skills or interests. There are usually personality changes when the person recovers.

An important analytical shift is evident in a claim made for specific concepts located in culturally specific forms. Snead (1984) claims that repetition is a basic formal property of Black culture marking significant difference from White European culture, which can be characterised by linearity and teleology. However (as an anti-postcolonial point), it is also clear that this is not peculiar to Black culture, since many

trends in postmodernism have dealt with seemingly endless repetition. One can also challenge Snead's assumption that contemporary culture is still bedevilled by these notions of continuity, growth and progress. The assumption that White European culture does not allow surprises or accidents, while perhaps true of classical forms, cannot be argued convincingly, or globally, for late twentieth-century forms, for example, of postmodern dance-theatre.

Furthermore, this Deleuzian notion of repetition, itself a western construct, does not lead to an attempt to resolve difference and to achieve psychic equilibrium through understanding as Freud might have wished. Freud's worldview is, therefore, not entirely satisfactory since the indeterminacies of *Fugue* impress the spectator rather more than its drive to resolution. A Deleuzian perspective, which springs from the desire for connection, a life that 'strives to preserve and enhance itself', is more convincing than one based on lack or repetition of the Oedipal myth for this analysis (Colebrook, 2002, pp. 91, 144).

The endlessly repetitive yet differentiated Deleuzian fugue

Endless repetition, particularly that associated with systems music and dance of the minimalist style, causes mixed reactions, from respecting and enjoying the complexity and intrigue achieved with minimal methods, to extreme boredom. In Spink's *Fugue* the repetition of the story invites such a range of response. Heidegger (1995) who is acknowledged in the underlying texts of Deleuze's philosophies. asks whether contemporary man has become profoundly bored with himself. He articulates two forms of boredom, found in structural moments of 'being left empty' and being 'held in limbo' (1955, p. 133). Significantly for my purposes, he characterises certain types of 'passing the time' that accompanies boredom, distinguishing between boredom derived from one's own being and boredom induced from the outside (1955, p. 133). The rituals surrounding death are performed in Spink's film in a strangely absentminded manner, strangely detached from the experience, and strangely fixed, with little movement – hence the relevance of the second of these ideas.

In Krauss's terms, and those of many other theorists of the postmodern, splintering and increasing complexity is inevitable. The boundaries between the elements of the work and its framing dissolve, creating, in this instance, a link to a Deleuzian chaos (Williams, 2003, p. 59). Spink uses techniques of flashbacks, repetition with variation, rearrangement

of fragments, fading of view and shortening of phrases. We never quite know where we are in the narrative sequence. He overlaps movement, text and filmed images to create shifting and subtle moods. These moods, at their most extreme, are of anger and tenderness, but mainly of less clearly defined emotions. In Deleuzian terms 'repeating the past does not mean parroting its effect, but repeating the force and difference of time' to show their 'fractured or machine-like quality' (Colebrook, 2002, p. 118). This is deterritorialisation leading to meaningless, dislocated words and movements.

Productively, however, for Attali, repetition takes on new significance as provoking a crisis and, painfully, one without resolution. Crisis is seen

> no longer [as] a breakdown, a rupture, as in representation, but a decrease in the efficiency of the production of demand, an excess of repetition. *Metaphorically it is like cancer, while the crisis of representation is like cardiac arrest.*
>
> (Attali, 2002, p. 127)

This idea of a fruitless and inefficient reworking of ideas is striking here. It is possible to see the father's apparent cardiac arrest as a crisis of representation, breaking free of underlying and constantly repeated family narratives that reflect a largely painful history.

Is this what Spink shows us in this family's moment of crisis? In other contexts an excess of repetition might be associated more positively with unceasing creativity as the early postmodernists Trisha Brown, Lucinda Childs and Yvonne Rainer demonstrate. The analogy with cancer offers a different parallel, this time with the destructive multiplication of ideas, which seems to relate back to the Freudian perspective of how far these experiences are re-experienced continuously, or repeated in memory. Linked to later theory, Deleuze's reference to cruelty 'with respect to the situation that is destroyed and forgotten when another is affirmed' has an unpleasant resonance (Williams, 2003, p. 30) in *Fugue*. In either case the fugue serves as a structural device integrated with, indeed inseparable from, the emotional and spiritual significances that it embodies.

Conclusion

Krauss (2002) argues that it is the return of the previously unvalued terms within modernism of the copy, of reproduction and of repetition that is significant in this new thinking. Art, which plays with the

possibilities of the multiple, leads to irreducible plurality without there being an original. Certainly we are left reflecting on what, if anything, allows us to think that there was an original event in *Fugue*. We see a film, apparently of the father falling down stairs, but it is grainy, vague and rather indistinct, forcing the spectator to ask in what sense it is 'real'. Did it happen? Deleuze's distinctions between real and actual and of virtual intensities are difficult to grasp in this context.[12] Metaphorically they are attractive, but as philosophical argument less easy to follow, and in practical application to analysis of Spink's *Fugue*, problematic. More convincing as the film evolves, perhaps, is the Deleuzian concept of 'nomadic distribution … to go beyond and undo an emergent order' (Williams, 2003, p. 65).

Spink's creation of this disturbing lack of certainty is rooted in the quality of difference inherent in repetition. The endless cutting back to the beginning results in a sense of deferral (following Snead, 1984, p. 67). There is uncertainty about the real and the virtual that is also key to understanding. Williams, writing on Deleuze's attitude to death, focuses on what he terms 'two central principles of connecting and forgetting' (2003, p. 10). In consequence, he argues that

> there is interplay between an actual death, which we flee and see as 'accidental' and 'violent' because it cuts our existence as an actual thing, and a series of small deaths and rebirths that dissolve the self.
>
> (Williams, 2003, p. 10)

These small deaths and rebirths allow us to become something else, to express greater 'intensities' (2003, p. 10) that is, to connect while also insisting on forgetting specific attachments. It seems to me that Spink's film can be seen in this light in so far as he seems to flee the actual event (as shown in the film) and to focus through many and varied repetitions on the small deaths of the participants and their rebirths. Their repetitions create new connections, forgetting others, to convey new intensities, and thus create difference. This seems a significant insight arising from Deleuze's linking of these ideas to increased abstraction, illusion and irony. The dissolution of the self marks new territory.

It might be argued that Spink shows the immediate aftermath of the shock of death but later, as the repetitions ensue, emotion comes to be remembered rather than felt again, in Freudian terms, but it is also abstracted, given an air of illusion. In the danced sections each character

is given new layers of expression, challenging any fixed sense of identity. At the end I suggest that this poignant work shows humanity as silenced, stilled, in the face of death.

The danced layer of Spink's *Fugue* works with repetition and reiteration of danced material, interwoven with musical and literary material to create a traumatic, repressed family history. The 'fugue' and 'dancing' both stand here in a metaphorical and literal relationship, illuminating critical questions of repetition, abstraction and structure in dance analysis.

Notes

1. Authors such as Krauss (2002) have maintained that this is in fact a distortion of Greenberg's theories and practices of criticism.
2. The source for this quotation is the description in the Guide to Room 7 at the 2006 exhibition *Kandinsky: The Path to Abstraction* at the Tate Modern, London.
3. As Richard Cave reminded me, Tharp has also staged *Fugue* for three men and with a mixed gender group.
4. Brown used the sections Ricercare 3, Crab Canon, Violon I Unisono, Per Motem, Augmentation, Per Tonus, Fuga Canonica, Perpetus, Canon Mirror, Canon a 2, Canon a 4, Trio Sonata, Ricercare 6 placed in her own order.
5. Banes (1987, pp. 82–3) gives a detailed description of these pieces illustrating the increasing density and complexity of the tasks Brown set herself.
6. Ian Spink, a one-time member of the Australian Ballet and of the Sydney Dance Company (1969–74), formed his own group in the UK in 1978, with a much less traditional focus than the dance of the time had in Australia. A founder member of Second Stride with Siobhan Davies and Richard Alston, in 1982, he was nonetheless distinctive in this trio.
7. See Garraghan (1999) for a reading of Spink's work.
8. Ian Spink *Fugue* (1988).

Choreography/co-direction:	Ian Spink
Play	Caryl Churchill
Music:	Contrapunctus from The Art of Fugue
	J. S. Bach
Design	Antony McDonald
Film:	Terry Braun
Dance on Four	Channel 4 26th June 1988

9. Their first collaboration was for *A Mouthful of Birds* (1986) for Joint Stock Theatre Company based on improvisational methods. Spink, in interview with Cave describes his working processes and the multilayered quality of his collaborations (1995, p. 294), fully aware that they 'tend to walk the razor edge between keeping control of the whole thing and losing it' (1995, p. 294). He raises himself the 'traumatic' nature of making such dynamic work. His interest in making work 'that hasn't solved itself' and that 'presents a series of problems that might be solved, ideally, in any number of different

ways' leaves even the finished product open-ended or, in some critics' terms, obscure (1995, p. 295).

10. Scene 1 shows the mother informing the family of the father's death. Her children spread the news. Scene 2 shows the funeral and cremation. Scene 3 is the funeral tea interspersed with flashbacks to a beach holiday. Scene 4 continues the tea but this time incorporating flashbacks of the father destroying the son's model aeroplane. Scene 5 closes the tea with flashbacks of the father's six-month absence. Scene 6 shows the guests departing, the bathing of the baby with flashbacks to the father in the bath and a sequence in which the family search for him. Scene 7 is a piano-playing scene and following this the family shroud the father and burn him on a pyre. Scene 8 is a danced interaction for the children.

11. Ask the expert (website).

12. Williams (2003, p. 27) outlines these difficulties and other complexities of Deleuze's theories, particularly as expressed in his *Difference and Repetition*. His notion of a simulacrum entails conceiving of something in 'a repeated series than cannot be traced back to an origin of the series' (Williams, 2003, p. 27).

References

Adshead, J. (ed.) 1988 *Dance Analysis: Theory and Practice*. London: Dance Books

Adshead-Lansdale, J. 1994 Dance Analysis in Performance. *Dance Research* 12, 2, pp. 15–20

—— (ed.) 1999 *Dancing Texts: Intertextuality in Interpretation*. London: Dance Books

—— 2000 Narratives and Metanarratives in Dance Analysis. In G. Berghaus (ed.), *New Approaches to Theatre Studies and Performance Analysis Theatron* 23 Tubingen: Niemayer Verlag, pp. 189–203

Attali, J. 2002 *Noise: The Political Economy of Music*. Trans. B. Massumi. Minneapolis: University of Minneapolis Press.

Banes, S. 1987 *Terpsichore in Sneakers*. Boston, MA: Houghton Mifflin

—— 1993 *Democracy's Body. Judson Dance Theatre, 1962–1964*. Durham, NC and London: Duke University Press

Best, D. 1992 *The Rationality of Feeling: Understanding the Arts in Education*. London: Falmer Press

Brown, T. 1996 *Just Dancing Around*. Channel 4

Cave, R. A. 1995 Collaborations. Ian Spink Second Stride in discussion with Richard Allen Cave Border. *Tensions* Proceedings of the 5th Study of Dance Conference, University of Surrey, Guildford, pp. 293–303

Cave, R. 2004 Ian Spink: Texts and Contexts. *Contemporary Theatre Review* 14, 3, pp. 63–72

Childs, L. 1999 *Four Elements*, Dancemakers. Channel 4

Colebrook, C. 2002 *Gilles Deleuze*. London: Routledge

Copeland, R. 1990 In Defence of Formalism. *Dance Theatre Journal* 7, 4, pp. 4–7, 39, 37.

De Man, P. 1983 *Blindness and Insight. Essays in the Rhetoric of Criticism*, 2nd edition. Minneapolis: University of Minnesota

Freud, S. 1984 *On Metapsychology: The Theory of Psychoanalysis*. Harmondsworth: Penguin Books

Garraghan, D. 1999 Too Many Cooks Mix the Metaphors: Marin and Spink, and the Sandman Link. In J. Adshead (ed.), *Dancing Texts: Intertextuality in Interpretation*, pp. 148–76

Heidegger, M. 1995 *The Fundamental Concepts of Metaphysics: World, Finitude, Solitude*. Trans. McNeill and Walker. Bloomington: Indiana University Press

Hofstadter, D. R. 1979 *Gödel, Escher, Bach: An Eternal Golden Braid*. Hassocks: Harvester Press

Jordan, S. 1992 *Striding Out*. London: Dance Books, pp. 182–206

Jowitt, D. 1983 On a Sound Footing. *Dance and Dancers*, January, pp. 16–17

Krauss, R. 2002 *The Originality of the Avant-Garde and Other Modernist Myths* Cambridge, MA and London: MIT Press

Lacan, J. 1977 *The Four Fundamental Concepts of Psychoanalysis*. London: Penguin Books

Lentricchia, F. and Mc Laughlin, T. 1995 *Critical Terms for Literary Study*. Chicago and London: Chicago University Press

Livet, A. 1978 *Contemporary Dance*. New York: Abbeville

Macaulay, A. 1982 Second Stride. *Arts Guardian*, 9 June

Mackrell, J. 1988 Fugue. *Dance Theatre Journal* 6, 1, pp. 28–31

Rainer, Y. 1966 A Quasi Survey of Some 'Minimalist' Tendencies in the Quantitatively Minimal Dance Activity Midst the Plethora, or An Analysis of *Trio A*. Reprinted 1974 in *Work 1961–75*, pp. 63–94

Rubidge, S. 1985 Ian Spink Dance. *Theatre Journal* 3, 3, pp. 8–11

——— 1987 Weighing Spink's Heart Dance, *Theatre Journal* 2, pp. 10–13

Sadie, S. (ed.) 1995 *Grove Dictionary of Music and Musicians* 7, pp. 9–21

Snead, J. A. 1984 Repetition as a Figure of Black Culture. In *Black Literature and Literary Theory*, ed. H. L. Gates Jr. New York Methuen

Sparshott, F. E. 1963 *The Structure of Aesthetics*. London: Routledge & Kegan Paul

Spink, I. www.australia dancing.org. Accessed July 2007

Tharp, T. 1982 *Twyla Tharp Dance Scrapbook*. Video. Twyla Tharp Enterprises

——— 1992 *Push Comes to Shove. An Autobiography*. New York: Bantam

Williams, J. 2003 *Gilles Deleuze's Difference and Repetition. A Critical Introduction and Guide*. Edinburgh: Edinburgh University Press

8

Jonathan Burrows and Matteo Fargion's *Both Sitting Duet* (2002): A Discursive Choreomusical Collaboration

Daniela Perazzo Domm

Jonathan Burrows' artistic research has contributed significantly to the reformulation of Western European contemporary choreography and has challenged conventions of genres, languages and techniques. Since the late 1980s international dance critics have praised his inventive and creative work, his 'highly original use of movement' (Percival, 1992, p. 32), his fresh approach to composition (Mackrell, 1987), his 'controlled, understated' (Percival, 1988, n.p.) and 'uncompromising' (Crisp, 1996, p. 15) performances and the humour and 'obliqueness' (Dunning, 2004, n.p.) of his unconventional and charmingly enigmatic pieces. Yet the scholarship to date is meagre and fragmentary, lacking detailed analysis of the themes, qualities and methods underlying his dances.

Burrows' dance embodies a delicate balance between rigour and lightness, seriousness and wit, detachment and intimacy. Despite their deadpan inscrutability, his performances have conceptual depth, whilst also evoking human empathy. I argue that they touch on profound human feelings and conditions without referring to them directly, awakening the spectators' sensitivity without exposing their processes and intentions, and I discuss how the complex interplay of references and qualities in his work can generate an innovative form of communication, at once intellectually intriguing and discreetly emotional.

Burrows' *Both Sitting Duet* (2002) was created in collaboration with the Italian composer Matteo Fargion. It is a work of 45 minutes, which they performed together, mostly seated on two chairs, facing the audience. The choreography is made of rhythmic patterns of

movements, mainly focused on hands, fingers and arms, and occasion-
ally on legs and head, which replicate and vary gestures and small
actions. Only towards the end of the piece do the movements expand,
to involve legs, feet and mouths: the two performers stand up, noisily
stamp their feet and shout rhythmic vocalisations. The performance
space, usually a studio theatre with frontal seating, presents simplified
setting and lighting, and the work is performed without music. The
mood of the show is light and humorous, and the response of audiences
and critics has been reported as extremely warm and positive, with
occasional expressions of puzzlement and disagreement.

Throughout his choreographic career, Burrows has explored ordi-
nary gestures, corporeal vestiges of interpersonal conduct, details of
movement and small actions originating from individual parts of the
body, interruptions of rhythm and variations of speed, devising rules
to break the conventions of codified movements and escape the clichés
acquired through dance training and socially constructed bodily rou-
tines. In the early *Hymns* (1988), the movement vocabulary juxtaposes
dance movements drawn from ballet, contact improvisation and folk
dancing with pedestrian gestures carrying references to the religious
context of the musical accompaniment and to memories of childhood
behaviour. While *Very* (1992) investigates the fragmentariness of the
human condition between inclusion and isolation through gestures
of intimacy and remoteness, affection and violence, *Hands* (1995), a
cameo piece for the camera which can be considered as the antecedent
of *Both Sitting Duet*, consists solely of a few simple hand movements
composed into phrases of varying sequences and speed. In *Blue Yellow*
(1995), the well-known video choreography for Sylvie Guillem, the
dance plays with clearly defined spatial, corporeal and visual interrup-
tions and intersections. In *The Stop Quartet* (1996), the different ele-
ments composing the piece – movement, music and lighting – are
treated as layers that can obstruct or complete, conceal or reveal each
other. *Weak Dance Strong Questions* (2001), devised with the theatre
director Jan Ritsema, challenges the conventions of dance by interro-
gating the principles and effects of movement.

In this respect, *Both Sitting Duet* demonstrates the most radical
rethinking of the traditional components and structure of a dance
piece. The simplification of its movement patterns and scenic elements,
the refusal of virtuosity in the execution of the dance, and the absence
of musical accompaniment or sound system, are among the character-
istics of this work that account for a certain degree of nakedness. André
Lepecki (1999) has described this quality as reductionist, a questioning

attitude towards the principles of dance that he recognises as a thread connecting many European choreographic experiments of the last decade.

A crucial feature of *Both Sitting Duet* is that it presents a radical and innovative approach to the relationship between dance and music. Since the late 1980s, the composer Fargion has created the musical accompaniment to most of Burrows' choreographic pieces – a mutual exchange in which the two artists' creativity has been fed by their parallel experiments with issues such as the relationship between movement/sound and stillness/silence, the structure of layers and holes that shapes the correlation between dance and music in a choreographic piece, and the juxtaposition with pedestrian, mundane elements in both movement and sound. In *Dull Morning* (1989), Fargion's slow and sparse score for string and wind instruments and piano complements the gloomy and contemplative mood of the choreography; the staccato notes of a piece for two pianos accompany the jerky steps and fragmented movements of Burrows' solo in *Stoics* (1991); the composite scores of *Very* and *Our* (1994), juxtaposing music with text, sounds or silence, explore similar relationships to those between dance, pedestrian gestures and stillness in the choreography; *Hands*, a composition for string quartet emphasises the contrapuntal dynamics of the movements of the right and of the left hand; in *The Stop Quartet*, a densely layered choreography combining different qualities and tempos of movement with moments of immobility is intertwined with a score of piano notes, sounds and silences written by Fargion and Kevin Volans; in *Singing* (1998, revived in 2003) the lyricism of a piece for soprano, tenor and fortepiano enhances the continuity of concentration of the performance by Burrows and Lynne Bristow through proxemic and contrapuntal variations.

Both Sitting Duet takes Burrows' collaboration with Fargion to a level where the final piece is no longer a choreography danced to a score written *ad hoc* by the composer, but becomes an 'equal' partnership (Burrows, 2002, p. 28) where both artists take to the stage to perform, side by side, what has been described as a 'musical choreography' (De Kunst, 2003, n.p.) – a movement composition based on a musical score to which the two artists contribute equally, each by employing his own expertise. The dance, created through a dialogue with a pre-existing musical score, plays with the disappearance of the music in an unconventional way, thus raising questions about the possibilities of interaction between these two art forms. The score is converted to movement by transposing each acoustic and rhythmic combination

into a particular physical pattern. As a result, music is absent to the sense it normally appeals to, the sense of hearing, but present in sight. The variations of rhythm, emphasis and colour of the 'disappeared' musical accompaniment are recreated in the dance through the exploration of the various combinations of movements of different types, qualities and intensities and by the interplay of simultaneous, alternate and overlapping modes of gestural execution by the two artists.

Because of its non-referential and non-representational approach, the duet can be described as a piece *about* dance and music. Nevertheless, it can be argued that the self-reflective quality of the piece is what generates its potential for signification thus granting the work a degree of openness that allows for the production of new meanings. The relationship between music and dance in *Both Sitting Duet* is constructed around their shared fluid condition of presence and absence, whereby the disappearance of the music makes way for the appearance of the dance, which in turns allows the rhythmic and acoustic qualities of the musical text to return in a different form. In a performative embodiment of the Derridean notion that 'nothing...is ever simply present or absent' (Derrida, 1981, p. 26), the interplay of the music and the dance can be said to generate a 'movement of play' in which the language of choreography becomes the 'field of infinite substitutions' (Derrida, 1978, p. 289). The centrality of the one and the subordination of the other are questioned, reversed and reinterpreted in the light of their mutual 'supplementarity', where signification arises from the difference between linguistic modes and between signifiers and signifieds.

Choreography such as Burrows', drawing on different dance genres and blending pedestrian elements with dance material with no hierarchical distinction, requires an analytical method that allows the researcher to consider all movement on equal terms, independently of formal conventions. Consequently, a detailed description of all bodily motions has been carried out, with reference to relevant indications of time, qualities of movement and rhythmic elements. The language used describes movements in general terms, without adopting a codified dance vocabulary. However, specialised terminology is employed when a particular figure is perceived as having a clear reference to a particular dance form, whether as a metalinguistic comment or as a direct quotation. Moreover, pedestrian movements resembling specific actions and gestures are placed in relation to the everyday contexts they are perceived to be associated with. Because of its fluidity, a general terminology allows the researcher to construct an account of the movement material without imposing tight stylistic interpretations, an advantage that appears of particular value

where dance strives to break down boundaries between genres and feeds on collaborations with other artistic disciplines.

Intertwining musical gestures

With the house lights still on, Burrows and Fargion walk into the performance space and sit on the two chairs placed in the middle, slightly turned towards each other. On the floor in front of them lie two open notebooks. The two men, both in their forties, wear ordinary clothes – jeans, a shirt or tee-shirt and boots. After a short pause, just enough to adjust their position on the chairs and focus their concentration, they begin the execution of their choreography. From the first minute, the performative elements (lights, silence, ordinary clothes, middle-aged performers, seated position, pausing, back-stage-like actions) deny expectations conventionally associated with a dance duet with regard to scenic elements, age of the dancers and the kinetic dimension of the piece.

The choreography opens with gestural phrases performed alternately and repeated six or seven times: Fargion rubs the back of his hands on his thighs, from hips to knees, and then bluntly brings his hands to his ears, as if to stop them, but without touching them; Burrows starts with his hands resting on his knees, gestures towards the right, with his hands joining and the middle fingers touching, then reaches down for the floor with his right hand. After approximately 20 seconds, Burrows picks up Fargion's phrase and both performers repeat it four times in unison and five times alternately, before Burrows goes back to his first pattern. After just over a minute, a new phrase is introduced, which they repeat successively, Burrows leading: the right hand reaches for the left hand, slides on its palm then up to the forearm and down again to rejoin the left hand and over, ending with only the fingers touching. About 30 seconds later, they synchronise their movements and continue in unison, with a pattern that looks like a smaller version of the previous one, where the movement stops at the hands, without going over the wrists and up to the forearms. The next few minutes are a combination of repetitions of patterns already performed, with variations of the speed, rhythm, succession, duration, energy, size, quality and details of the movements.

The structural and compositional characteristics of the whole choreography can be deduced from the opening section. Steady, regular rhythms are often interrupted by pauses or changes of speed; synchronised actions are followed by alternate or overlapping execution; long

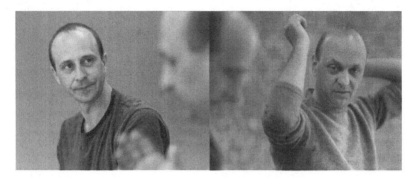

Figure 3 Jonathan Burrows and Matteo Fargion in *Both Sitting Duet*. Photograph
Herman Sorge Loos

sequences of repetitions are interspersed with short, unexpected new
phrases; movements are now vigorous now soft, now big now small; pre-
cise, almost pedantic gestures alternate with a relaxed, casual attitude.
Although the choreography is performed in silence, the performance
has a distinctive acoustic dimension. Sounds are produced by move-
ment itself – the clapping and smacking of hands, their rubbing and
brushing on the rough material of the trousers, the knocking of knuck-
les on the soles of the shoes – and the performers' breathing can be
heard after sequences of fast and frantic gesturing. If these swishing
and smacking sounds, together with the vocal outbursts emitted by the
two performers towards the end, are the main elements of the sound-
scape of the piece, the musicality of this work is nevertheless to be
ascribed mainly to its complex rhythmic arrangement.

The musical composition that the two performers execute in gestural
'transcription' is the 1982 violin and piano piece *For John Cage* by the
American composer Morton Feldman.[1] This score served as a basis for
the construction of the movement phrases, whose gestures and patterns
are recorded in the form of personal annotations in the notebooks lying
at the performers' feet: numeric sequences and words in Burrows' and
notes in Fargion's. These notebooks are referred to throughout the piece
and the performers occasionally interrupt a movement sequence to
turn a page. On another level, however, the simple movements of the
choreography are constructed from culturally transmitted, corporeal,
behaviour and, in evoking body language, gestures and signs, they carry
significance in themselves. They encompass, consist of and refer to
traces which suggest that meaning is to be found beyond the formal

boundaries of the text, in the 'play of differences', 'the spacing by means of which elements are related to each other' (Derrida, 1981, p. 27). At the heart of the piece's underlying concept is an exploration of relations and *différances*: between dance movement and everyday movement, between meaningful gestures and empty gestures, and, above all, between the modes of dance and those of music.

For John Cage is a delicate composition of quiet sounds that plays with the repetition of notes and their length (Feldman, 1999, note accompanying the CD). It is an ongoing dialogue between the violin and the piano, constructed around reproductions of sequences of sonorities and variations of their rhythm, emphasis and colour. As with most of Feldman's late works, this piece is arranged in patterns, a compositional tool that the composer became fascinated with in his mature years, inspired by Jasper Johns' crosshatch paintings of the 1970s and, especially, by Central Asian nomadic rugs (Bernard, 2002; Johnson, 2002).[2] In both types of visual work, the inevitable occurrence of change in reiteration seems to put into question compositional ideas such as symmetry, development and hierarchy. Indeed, Feldman has talked about 'disproportionate' or 'crippled symmetry' and about 'balance between movement and stasis' (cited in Friedman, 2000, pp. 134, 138). This interest in the textural quality of the material signals a correspondence with Burrows' and Fargion's compositional methods, in which the application of alternation and variation to arrangement and patterning plays a crucial role.

Feldman has described his music as being 'between categories' (in Bernard, 2002, p. 179) and indeed in his compositions dichotomous qualities seem to coexist: closure/openness, duration/timelessness (Bernard, 2002); simplicity/complexity, uniformity/difference (Johnson, 2002); unpredictability/sameness, continuity/discontinuity (Sabbe, 1996); order/disorder, self-similarity/surprise (York, 1996). Hence, in *For John Cage*, despite the lack of linear development in the composition, the score is static only to a certain extent, since the reproduction of patterns always implies a degree of change.[3] Feldman has been quoted as saying about *For John Cage* that 'it's a little piece for violin and piano, but it doesn't quit' (Feldman, 1999, note accompanying the CD, n.p.). This observation seems to acknowledge the unrelenting, almost obsessive, quality of the work – a score made of little, unpretentious elements that keep replicating each other in a seemingly identical way, which nevertheless does not lose our attention. Burrows' choreography often presents similar attributes in its use of raw, simple elements arranged in repetitive patterns, and, besides *Both Sitting Duet*, works such as *The Stop Quartet*,

Altogether (1998) and the recent *The Quiet Dance* (2006) display clarity and coherence of structure alongside a meticulous shaping of the details and layering of the parts. The choreographer himself has talked of an 'obsession', when referring to the motives behind his and Fargion's choice of this score as the 'template' on which to construct the duet:

> we ... decided to look for something that we could place between us as a starting point. ... We looked at texts, movies, music and concepts. In the end we found nothing and we decided that we would ... work for a week and see what happened. On the first day, Matteo walked in and he said, 'I've found the thing that we were looking for and it's so obvious that we couldn't see it.' He pulled out the score of a piece of music by Morton Feldman, ... which Matteo and I had both been obsessed with about seven or eight years ago.
>
> (Burrows, 2002, p. 28)[4]

The same kind of surprising predictability can be found in *Both Sitting Duet*. The patterns of gestures that constitute the choreography create a fabric of movement that is at the same time recurring and varied, repeated and different. Moreover, in the piece, as in the musical score, the element of change and uncertainty is given both by the modulation of the various dimensions of the movement, such as speed, energy and tone, and by the interplay of similitude/dissimilitude, unity/discord between the two performers.

Pattern and change

A first substantial contribution on *Both Sitting Duet* was published in 2005 by Valerie Briginshaw, who analyses its structural dynamics in the light of Gilles Deleuze's concept of repetition and its intrinsic potential for change. In constructing this interpretation, I draw on Briginshaw's notion of transformative quality, but I also focus on the choreomusical collaboration, analysing the structural devices and semantic strategies employed in the work alongside the mode of repetition.

Briginshaw explores the resonances between the 'transgressive character of Deleuze's notion of repetition, which does not repeat the same, but reveals singularities', and the minute variations of the duet's movement patterns, which expose the repetitions to uncertainty, making them unpredictable and therefore 'productive rather than reductive' (2005, pp. 16, 19). This element of surprise accounts for the openness of the work, which, as Briginshaw argues, breaks the notions of replica,

origin and representation, suggesting new ways of conceiving the relationship between dance and music and thus acquiring a radical, transformative potential.

Repetition clearly informs the process of construction of *Both Sitting Duet*, since transcribing a musical score into a choreographic piece involves reproduction. Yet a translation is never an exact copy of an original and always assumes an element of adaptation, which implies unplanned and possibly unintended changes. One of the unexpected effects of the translation of *For John Cage* into *Both Sitting Duet* is related to the mood and atmosphere of the work (Briginshaw, 2005). While working on the choreography, Burrows and Fargion were surprised to see that what they had always considered as a 'hovering, rocking, quiet' piece of music was transforming through their gestural execution into a 'more jolly and folkdancey' work (Burrows, in Hutera, 2003, n.p.). Commenting on this unexpected shift, Fargion said: 'we were not following the mood, but using the score as a map' (in Cripps, 2004, p. 18).

Nevertheless, in *Both Sitting Duet* difference is not only the ineluctable result of the replication process. As in Feldman's score, it is also deliberately employed in shaping the composition. Through the use of variations, the same patterns can be reproduced in simplified or more complex versions, or they can be manipulated to alter the relationship between the two performers. When at one point, about six minutes into the piece, the two performers simultaneously swing their arms down along their torsos, with fast and energetic movements, Fargion's hands stop and rest on his knees every four swings, against Burrows' every five. A couple of minutes later, when Burrows starts a pattern placing his right hand on his right knee, palm up, and his left hand on his left knee, palm down, and then turning both hands over towards the left, Fargion picks up the phrase but in a shortened version, without the final turning over of the hands – in what seems to be a deliberate and almost obstinate attempt to avoid the exact replica of his partner's gesture. Analogous variations occur on a structural level. For instance, when Fargion, about 20 minutes into the performance, places his hand on Burrows' shoulder, it is to introduce a change into the types of physical contact featured in the piece – so far confined to each performer's own hands, arms and legs, and now extended to touching the other. Similarly, when Burrows stands up for the first time a few minutes later, it is to break the sedentary nature of the piece; and when, towards the end, they mutter and shout monosyllabic sounds and interjections, it is to interrupt the silence. Changes are also introduced in relation to the

musical score, especially with regard to the tempo. In contrast with its regularity throughout Feldman's piece, the tempo is altered in three specific moments in the choreography, with the intention of breaking the 'monolithic' uniformity of the score (Fargion, 2005, n.p.).[5]

The introduction of variations in the chains of gestures undermines the regularity of the structure and exposes its fluidity and instability. Difference generates shifts in the sequences of gestures, disrupting and rewriting perceived correspondences between movements, images and contexts, thus opening meaning to a multiplicity of interpretations. By deconstructing the unity of the gestural signs and the fixity of their arrangement, the choreography draws attention to the gaps left by what has been removed and to the place occupied by what has been added. In a Derridean sense, the discrepancies in the texture expose the 'floating' nature of signification (Derrida, 1978, p. 289).

Hence, as Briginshaw (2005) points out, although the piece appears to be composed of a series of repetitive patterns, its predictability is deceptive since the dividing line between reproduction and change, stasis and mobility is blurred. This is also what seems to hold the attention of the spectators. Several reviews have reported that both spectators and critics have been captivated, almost hypnotised, by the piece: 'the audience was rapt' (Tobias, 2004, n.p.); 'one of the most enchanting things I've ever seen' (Brown, 2003b, n.p.); 'and we look, are held, are thrilled, as our eyes become accustomed to this minute and searching exercise ... and we learn to see differently, more clearly' (Crisp, 2004, p. 17). Although *Both Sitting Duet* is a highly choreographed work, which does not allow for improvisatory elements, it appears to generate an element of change, through both its composition and its execution. Thus the work can be said to overcome the dichotomy between openness and closure, freedom and discipline, improvisation and set material in performance – a duality that Burrows himself has said he is interested in breaking down:

> the standard view is that improvisation is more free and set material is more restricted, and my personal experience is that it is not always as simple as that. Sometimes the fact that I'm able to operate within set material and bypass my conscious mind – that's a freedom.
> (Burrows et al., 2004, p. 10)

At the intersection between two worlds

Drawing on Deleuze's notions of individuation and difference, Self and Other, Briginshaw (2005) investigates how the subversive potential of

the piece lies also in the relationship between the two performers, and calls attention to their intense interaction, evident intimacy and subtle complicity, which several critics have linked to their long-standing friendship and many years of artistic collaboration (Brown, 2003a; Frater, 2004; Parry, 2004). Their relaxed attitude and the unselfconscious looks and gestures they exchange throughout the piece reveal the ease with which they work together, sharing each other's art and inhabiting each other's space.

Difference is at play here also, in its Derridean sense of a deferral of completion and of the need for a 'supplement', which 'is added to make up for a deficiency, but as such it reveals a lack' (Harari, 1979, p. 34). Burrows' and Fargion's expressivity is enhanced by their respective differentiation from one another, which undermines the logic of centrality and hierarchy, suggesting a new way of collaborating that is neither one of dependence nor of independence of one from the other, but is built around the space between them. This new mode of relating to each other is embodied in the duet by the musical notion of counterpoint, which informs many combinations of patterns of gestures in the movement sequences, and by the interpretation of it that the two performers have discovered in working on the piece. As Burrows explains, while his understanding of counterpoint had always implied 'a tension between the parts', Fargion introduced the new perspective that 'counterpoint assumes love between the parts' (Burrows, 2002, p. 28). This reading suggests ideas of complementariness and desire, of completing one another and filling each other's voids, which seem to be the principles on which the choreography is constructed.

Hence, the distinctive traits of Burrows' and Fargion's performance on which several critics have commented – 'the greater fluidity, the greater speed' of the dancer's movements and the 'solidity, [the] strong base' of the non-dancer's (Crisp, 2004, p. 17) – can be read in terms not of a binary opposition but of two worlds, dance and music, interacting and being enriched by their interconnection. As Jowitt has observed, 'we can admire the differences in the men's personal styles: the dancer and the musician as musician-dancers' (2004, n.p.). By not reiterating the dichotomy and by blurring the distinction between simple, everyday movements and dance, the duet also questions perfection and virtuosity as codes of description and evaluation. Furthermore, from the point of view of the partnership it establishes, *Both Sitting Duet* challenges preconceived ideas of what the relationship between a choreographer and a composer should be and suggests new ways that they can collaborate and enrich one another.

Generating modes of signification

Innovation at the level of composition, which proposes an unconventional approach to the relationship between music and dance, can be seen to extend its transformative quality to the processes of reception and signification. Because of Burrows' interest in exploring the potential of ordinary movement and in challenging choreographic conventions, his work can be read in the context of what Susan Leigh Foster (1986) has described as 'reflective' rather than 'replicative' dance, a dance that reflects on itself rather than representing thoughts and emotions, pioneered by Cunningham and explored further by the Judson Church choreographers. Significantly, American early postmodern dance is a professed reference point for Burrows' choreographic research, especially in its questioning attitude towards the conventions of the discipline and the traditional rigidity of its linguistic and structural composition (Burrows, 2005).

The reflective quality of Burrows' choreography can be read in the light of the visual art theoretician Filiberto Menna's study of the 'analytic' attitude of several twentieth-century artistic investigations (1975).[6] Menna argues that through the theoretical and self-reflective analysis of its own language art assumes a 'hermeneutic' function, which leads to the discovery of new contexts of reality (1975, p. 99). Hence it could be suggested, following Menna, that the semiotic dimension of Burrows and Fargion's duet, despite its apparent disengagement from what is beyond its own linguistic codes, is inevitably accompanied by an interpretive quality, which enables the work to transcend its own boundaries and engage in a dialectical and critical relationship with the real.

Burrows (2003) explains the process of creation of the movement material as a somehow arbitrary one, whereby he and Fargion did not follow any specific criteria in choosing the gestural patterns. However, drawing on a semiotic analysis of the movement sequences and on the examination of various reviews of the work, I suggest that, from the point of view of their relationship with external references, and therefore of their mechanisms of signification, the simple gestures of the piece can be loosely grouped in three categories. Some patterns reproduce movements that have a relationship with a specific context, whether they are drawn from the everyday or from dance techniques, and, although separated from it and juxtaposed with unrelated gestures, still bear traces of that connection. Other movements do not appear to be linked with any external reference and are read as trajectories that specific parts of the body

execute in space and time, which do not obviously resonate with cultural meanings. Other gestures, despite not being explicitly connected with a recognisable context, have evoked images and associations in the minds of some spectators. The first movements can be described as 'displaced', the second ones as 'deferred' and the third as 'discursive'. These three types of movements should be read as fluid groupings that can intersect and overlap, and are intended essentially as useful tools for a preliminary, structural reading of the choreographer's work.

Included in the first group are several gestures in the piece that resemble ordinary, practical actions (pushing something away, picking up a speck of dust from the floor with a finger, stopping one's ears), movements belonging to a commonly shared gestural language (thumbs-up sign, OK sign, hands-up surrender sign), as well as phrases from specific dance and music techniques (a classical *port de bras*, an arm pattern from English Morris dance, sol-fa exercises). The second group contains those movements that are best described in formal terms. These are generally more complex and involve the rotation and swinging of arms, the sliding of hands on other parts of the body or on each other, the rolling of shoulders, and so on. The non-referential quality of these movements emerges also in relation to the structure of the piece and in the merely accidental order of the gestural patterns (Burrows, 2004). The last group, the most volatile of all, comprises all those gestures to which meanings have been attributed as a result of personal associations sparked in the mind of the viewers. For example, a repetitive turning of the torso sideways with elbows bent brings to mind the act of making one's way through a crowded market; hands rotating in the air are reminiscent of the arm patterns of the tarantella; blunt and jerky hand gestures resemble a heated discussion between two Italians. Or, as reviewers have written, 'their gesticulations seem to mime waving or washing or greeting' (Frater, 2004, p. 43); 'two men on stage are an instant story. Brothers, rivals, work-mates, lovers, Laurel and Hardy, Blair and Brown, the Flowerpot men. All these evocations emerge like a wispy genie out of [the piece]' (Brown, 2003b, n.p.).

Besides these three types of movements, a fourth group can be identified, made of the looks and gestures that Burrows and Fargion exchange throughout the performance, and of the pauses to breathe or turn a page of their notebooks. The role of these elements can be compared to that of stock phrases and deictic expressions in verbal language, where they give rhythm to the exchange and create the mood of the conversation. These are the elements that in *Both Sitting Duet* establish a more direct contact with the spectators, make them focus on minute details

and on their complex interweaving, and allow them to experience the intimacy and familiarity between the two performers.

The movements in *Both Sitting Duet* that have been described as 'displaced' can be examined in the light of Ferdinand de Saussure's (1959) principle of the arbitrariness of the sign and of its relational nature. These are gestures removed from their contexts of reference and employed in a new context, through the application of compositional strategies, such as repetition and variation. This dislocation of signifiers from their frame of reference jeopardises their connection with their respective signified, thus showing the constructed nature of this relationship. A trace of that link remains via their retained denotation, but their displacement, which brings into question their connotative meanings, enhances the ambiguity of the signs. This strategy of signification is not new in Burrows' works and can be found in his early pieces, such as *Hymns* and *Stoics*. Here Burrows plays with the juxtaposition of elements from contrasting cultural contexts, for example combining strongly connoted musical scores with unconventional, almost irreverent, movement material, thus wrong-footing the expectations generated by the music and creating an affect of displacement.[7]

Burrows' 'deferred' signs can be read in relation to Roland Barthes' notions of 'myth' and of a 'degree zero' of writing. Examining the issue of traditional literature as a myth, in *Mythologies* Barthes defines 'writing as the signifier of the literary myth, that is, as a form which is already filled with meaning and which receives from the concept of Literature a new signification' (1993, p. 134). He then analyses the crisis that traditional French literature underwent from the middle of the nineteenth century, in which 'the subversion of writing was the radical act by which a number of writers have attempted to reject Literature as a mythical system (p. 135). The terms and results of this revolution are analysed in *Writing Degree Zero* (1968), in which the adoption of a transparent, neutral style of writing is seen as a means of taking a position against the literary myth. Despite the differences in time and context, it is possible to recognise a similarity between the methods by which writers try to beat the literary system, as described by Barthes, and the strategies adopted by Burrows in challenging conventional codes of dance through the use of non-expressive movements.

The most radical way to defeat the literary myth is described by Barthes as an 'ideal absence of style', whose aim is 'to create a colourless writing, freed from all bondage to a pre-ordained state of language' (1968, pp. 77, 76). A similar 'neutral' quality, which 'reaches the state of a pure equation' (pp. 77, 78), can arguably be recognised in those signs of *Both Sitting Duet* that appear to have lost both their denotative and

connotative meanings. These movements can be found already in some of Burrows' works from the mid-1990s, and especially in *The Stop Quartet*, which is mainly concerned with issues related to the construction of the piece according to a set of internal rules. This strategy of signification in Burrows' pieces can be described as metalinguistic, in that, by radicalising its formalisation, the dance becomes self-referential. It becomes a dance about dance, that is, according to Barthes' definition of metalanguage, 'a system whose plane of content is itself constituted by a signifying system' (1973, p. 90).

Both these first two types of movements, the 'displaced' and the 'deferred', show a degree of decontextualisation, which nevertheless – as it can be argued following both Menna's (1975) and Barthes' (1968) discussions – is not symptomatic of an uncommitted attitude. On the contrary, the adoption of strategies that question codified processes of composition and signification in dance with the intent of reflecting on the formal aspects of the discipline shows Burrows' position towards the 'institution' of dance and demonstrates his radical choice and critical engagement. But with the third type of movements, the 'discursive' ones, which arguably make their first appearance in *Both Sitting Duet*, Burrows' reconfiguration of the language of choreography defies traditional semiotic readings through the deconstructive force of its concept and challenges conventional strategies of signification. By subverting relations between signs, contents and contexts and by questioning their binary correspondences, the piece generates a mode of communication in which the distinction between meaning and absence of meaning is blurred.[8]

The patterns of movements of the duet have liberated the imagination of some viewers, and occasionally spectators even confided to Burrows that, watching this silent, yet intensely rhythmical choreography, they thought they could hear the music (Brown, 2003a). Despite occasional negative responses by audiences (Percival, 2003–4) and critics (Witchel, 2004), the bodily movements apparently devoid of denotative meanings of the duet have generated a communication with the audience, opening the piece to a dialogue with other worlds and contexts. Together, displaced, deferred and discursive gestural signs transform the duet in a weave of 'texts' and 'traces' to which the spectators can give voice by ascribing to them their own personal images and connotations. *Both Sitting Duet* deconstructs oppositions: between telling signs and empty signs, between signifier and signified, between choreography and music composition, between text and performance, between absence and presence; thus the dance can be said to become the site of an intertextual discourse.

Notes

1. Feldman, a member of the so-called New York School, comprising both visual artists and composers, created works using individual notes and micro-tones which, instead of being arranged closely together to create continuity, are treated as fragments, as sounds that 'exist in themselves' (Feldman, in Friedman, 2000, p. 35). *For John Cage* was composed on the occasion of Cage's seventieth birthday.
2. In Anatolian rugs, which Feldman started to collect in the 1970s, the repetition of stitches from the borders to the centre creates patterns that are continuously modified through slight variations in shape and shade (Bernard, 2002).
3. For an analysis of *For John Cage*, see the note accompanying the 1999 recording (Feldman, 1999). A detailed study of the composition and its structural principles can be found in York (1996).
4. About the use of a 'found' score as a material onto which to construct the choreography, Fargion has commented: 'that was the right score at the right time. ... This was a piece that we both loved. ... It wasn't just *a* piece, it was *the* piece' (2005, n.p.).
5. Although Burrows and Fargion have described their duet as a 'direct transcription ... bar for bar, note for note' of Feldman's score, they have also acknowledged the introduction of 'small changes of tempo' from the original 70 minutes of the musical piece. 'That's why the performance lasts about 45 minutes. It shrunk', from the original 70 minutes of the musical piece (Burrows and Fargion, cited in Hutera, 2003, n.p.). However, these variations are carried out in line with the spirit of Feldman's work, which, as Fargion puts it, is about being 'true to the material', that is, composing in a linear fashion rather than following preconceived ideas, and thus being open to change (2005, n.p.).
6. Menna traces this attitude back to Seurat and Cézanne and analyses works by the Cubists and Duchamp, as well as examples from Suprematism, Constructivism and Conceptual Art (1975).
7. Burrows combines religious hymn tunes with child-like playful and aggressive behaviour in *Hymns*, and the *Blue Danube Waltz* with a comic, almost cartoon-like choreography in *Stoics*.
8. Burrows acknowledges that the reception of the piece has gone beyond the creators' intentions and finds this particularly fascinating: 'people ... have been interested in how *Both Sitting Duet* references gesture but in a non-specific way ... It takes gesture out of its normal context, so that the meaning of the gesture is there in one sense and not there in another sense' (Burrows, 2004, n.p.).

References

Barthes, R. 1968 *Writing Degree Zero* New York: Hill and Wang
—— 1973 *Elements of Semiology* New York: Hill and Wang
—— 1993 *Mythologies* London: Vintage
Bernard, J. W. 2002 'Feldman's Painters'. In S. Johnson (ed.), *The New York Schools of Music and Visual Arts*. London: Routledge, pp. 173–215

Briginshaw, V. A. 2005 Difference and Repetition in Both Sit' 1, January, pp. 15–28

Brown, I. 2003a The Vanishing Man of British Dance. *Tl* October, p. 19

—— 2003b Eloquent in Their Stillness. *The Daily Telegrapi.*

Burrows, J. 2002 'Playing the Game Harder'. *Dance Theatre Journu.* pp. 25–9

—— 2003 Unpublished conversation between J. Burrows and the author, 15 December

—— 2004, Unpublished conversation between J. Burrows and the author, 7 April

—— 2005 Unpublished conversation between J. Burrows and the author, 26 November

——, Le Roy, X. and Ruckert, F. 2004 'Meeting of Minds'. *Dance Theatre Journal* 20, 3, pp. 9–13

Cripps, C. 2004 'Sitting out the Dance: Are You Ready for a Duo Who Won't Move from Their Chairs for Your Entertainment?' *The Independent* 4 November, p. 18

Crisp, C. 1996 Dance Reinvented. *Financial Times* 10 June, p. 15

Crisp, C. 2004 Both Sitting Duet, Clore Studio, London. *Financial Times* 18 November, p. 17

De Kunst, S. 2003 The Delicate Musical Choreography of Burrows and Fargion (English translation). *De Morgen* (Belgium), 3 January, n.p.

Derrida, J. 1978 *Writing and Difference.* London and Henley: Routledge & Kegan Paul

—— 1981 *Positions* London: The Athlone Press

Dunning, J. 2004 A Conversation Composed of Gestures. *The New York Times* 19 March, n.p.

Fargion, M. 2005 Unpublished conversation between M. Fargion and the author, 14 September

Feldman, M. 1999 *For John Cage.* Therwil (Switzerland): Hat Hut Records

Foster, S. L. 1986 *Reading Dancing: Bodies and Subjects in Contemporary American Dance.* Berkeley and Los Angeles: University of California Press

Frater, S. 2004 Brothers in Arms are Making Waves. *The Evening Standard* 12 November, p. 43

Friedman, B. H. (ed.) 2000 *Give My Regards to Eighth Street: Collected Writings of Morton Feldman.* Cambridge, MA: Exact Change

Harari, J. V. (ed.) 1979 *Textual Strategies: Perspectives in Post-structuralist Criticism* Ithaca, NY: Cornell University Press

Hutera, D. 2003 Both Talking: Interview with Jonathan Burrows and Matteo Fargion. *Dance Umbrella News*, Autumn, n.p.

Johnson, S. 2002 Jasper Johns and Morton Feldman: What Patterns? In *The New York Schools of Music and Visual Arts* London: Routledge, pp. 217–47

Jowitt, D. 2004 Joyride to Noirville: Some Folks Ride the Bucking World in Drastic Style and Try not to Fall; Others Domesticate it. *The Village Voice* 29 March, n.p.

Lepecki, A. 1999 Skin, Body, and Presence in Contemporary European Choreography. *The Drama Review* 43, 4, Winter, pp. 129–40

ۥkrell, J. 1987 The British Ghetto–Foreign Visitors: Umbrella '86. *Dance Theatre Journal* 5, 1, Spring, pp. 28–31

Menna, F. 1975 *La Linea Analitica dell'Arte Moderna: le figure e le icone* Turin: Piccola Biblioteca Einaudi

Parry, J. 2004 Dance: There's No Need to be so Modest. *The Observer* 14 November, n.p.

Percival, J. 1988 Dance: Onward Christian Soldiers. *The Times* 25 June, n.p.

—— 1992 Moving beyond Dance. *The Times* 30 October, p. 32

—— 2003–4 Jonathan Burrows/Matthew Hawkins. *Dance Now* 12, 4, Winter, pp. 74–5

Saussure, F. de 1959 *Course in General Linguistics*. New York: The Philosophical Library

Sabbe, H. 1996 The Feldman Paradoxes: A Deconstructionist View of Musical Aesthetics. In T. DeLio (ed.), *The Music of Morton Feldman*. New York: Excelsior Music Publishing Company, pp. 9–15

Tobias, T. 2004 Is Less More? *Arts Journal* 18 March, n.p.

Witchel, L. 2004 The Theater of the Mundane. *The DanceView Times* 12 March, n.p.

York, W. 1996 For John Cage. In T. DeLio (ed.), *The Music of Morton Feldman*. New York: Excelsior Music Publishing Company, pp. 147–95

9
Lea Anderson, Dancing and Drawing the Past into the Present

Henia Rottenberg

What Anderson has done, while remaining true to the mechanics of Schiele's implied movement, is to create a vision of an artistic milieu which draws out of the connections between Schiele's own Viennese party animal days and the way his influence has permeated over the decades.

(Watson, 1998, p. 6)

The Featherstonehaughs Draw on the Sketch Books of Egon Schiele was created in 1998 by the contemporary British choreographer Lea Anderson for her all-male group, The Featherstonehaughs.[1] The dance, 60 minutes long, was first performed in the 1998 Spring Loaded Festival, at the Place Theatre, London.[2]

Anderson started to choreograph in 1984, with the foundation of her all-female company, The Cholmondeleys.[3] Since then, she has enjoyed popular success as well as critical acclaim. After establishing a second company, the all-male group The Featherstonehaughs in 1988, which was concerned with images of masculinity, Anderson's reputation as a leading choreographer was assured.[4] Since then she has introduced two series of dance programmes on television, toured extensively in Britain and Europe, and her dances have become part of dance syllabuses in the British educational system at GCSE and A level. As Martin Hargreaves encapsulates, 'her cut-up take on choreography... continues to place her at the cutting edge of British contemporary dance' (2002, p. 19).

In appropriating Egon Schiele's painterly images and making them her own, Anderson is not the first choreographer to work within hybrid, time-shifting genres across dance and painting. Well-known and distinctive examples range from Vaslav Nijinsky's *L'Après-midi d'un*

faune (1912) after Greek vases, to Ninette de Valois's *The Rake's Progress* (1935) after Hogarth, and Glen Tetley's *Anatomy Lesson* (1964) after Rembrandt. Anderson's mode of reworking this genre, however, generates new manifestations in postmodern culture which differ from all their antecedents in crucial respects.

Anderson, who systematically categorises her ideas and images in notebooks, is engaged in another dance here, one with Schiele's sketchbooks instead of her own. As she recollects, 'when I found a reproduction of the Schiele sketch-books I was completely amazed by their similarity choreographically to my little drawings of dances' (in Robertson, 1998, p. 19).

The process of making the dance, she acknowledges, involved sticking closely to Schiele's pictures instead of her own. She combines the conventions he used, of pictorial art movements and gestures, the flat surface, colour and the rhythm of the brushstrokes, with her own discipline. Anderson's choice of images shows her representing not only the movements and gestures of Schiele's models but reconstructing an artistic structure within which they could be performed. Aware of this process, she comments: 'so I decided to have a go at finding his "lost" dances by linking the movements in the drawings and paintings' (in Parry, 1998, p. 7) – a strange objective given that such dances never existed.[5] She copies Schiele's movements and gestures only to incorporate them into another aesthetic, that of a contemporary dance. In this complicated process, the dancers had to acquire new muscle 'memories', resulting in a quality described by Hutera as producing 'expressed feeling on the outside of the body' (1998, p. 34).

Schiele, whose art is appropriated by Anderson into her own artistic medium, is regarded by art historians as one of the major exponents of Viennese Expressionism (Powell, 1974; Comini, 1978; Kallir, 1981; Vergo, 1993). He produced in his short life (1890–1918) an *oeuvre* of paintings and drawings ranging from landscapes to provocative nudes that shocked society. What distinguishes this art movement is not only the content – the passage from the façade to the psyche, according to Comini (1990) – but also the new approach to form – from the environmental to the existential. Exposing and probing the psyche in an attempt to locate its essence became the new aim of art in Expressionism.

The Featherstonehaughs Draw on the Sketch Books of Egon Schiele is more than a bringing together of the art of dance and painting. Anderson's engagement with Schiele's art becomes a point of departure for another distinctive hybrid relationship, between British postmodernism of the

late twentieth century and Viennese Expressionism of the early twentieth century. The work shows a postmodern choreographer in the late twentieth century playing with modern concepts of art. These relationships, however, become problematic since the work challenges modernist art while, at the same time, creating a link with the past by addressing it and recalling it visually. Through this process Anderson undermines some of the profound characteristics of modernism – uniqueness and authenticity – and thus expresses her own view of Schiele's art and of Expressionism, as well demonstrating, wittily, the relevance of these ideas to our time.

In light of the multiplicity of discourses that constitutes Anderson's dance, a theoretical paradigm that acknowledges the specific characteristics is constructed. As Adshead-Lansdale (1999) argues, the constant change in the activity of dancing affects changes in interpretation and, therefore, it is important that dance theory reflects the form on which it comments. Hence, within the framework of juxtaposed discourses and ideas, the investigation of the dance is divided into two primary approaches. The first utilises a process of observation and analysis of the dance in order to determine its properties and conventions. For that purpose a practical framework is constructed, based loosely on the practical theory of dance analysis set out by in *Dance Analysis: Theory and Practice* (Adshead, 1988). Since hybrid relationships comprise a diversity of aesthetic practices and discourses, it is necessary to go beyond the field of dance studies in order to construct a framework of analysis. The disciplines and concepts applied are chosen with regard to their relevance to key features of hybridity and their specific operation within Anderson's dance-text.

Anderson confronts and juxtaposes memory and modes of representation in the art of both dance and painting, challenging traditions through her employment of deconstruction and pastiche.[6] The argument here is that the specific manifestations of her play with the past and the present endow the past with meaning in the present. Certain issues are raised in consequence, such as the significance of a contemporary artist playing in a different mode with a past model of visual art – in this case, Expressionism. And what is special in Anderson's way of copying Schiele's art? From an historical point of view, does the return to a model of art from the past support the development of a new practice, or does it challenge it? The engagement with appropriation as a critical tool, not of documentation, but of knowingly representing the past, is quite distinctive.

Replaying with Schiele

Walking slowly backwards with their hands in their trouser pockets, six dancers enter centre stage from left. They move to the sound of Drostan Madden's original rhythmic music with his mechanical version of Strauss's *The Blue Danube*. Lit by neon tubes arranged in an enclosed rectangular configuration on the ground (designed by Simon Corder), the dancers move in the last section of the dance at a slow pace. When they reach centre stage they pause tilted backwards, as if they had to cease movement abruptly, almost suspended in the air, their heads and upper bodies distant from their feet. These poses refer to Schiele's expressionistic idiom – the unique, unsupported, upright poses of his models. Anderson creates the illusion that her dancers, like Schiele's models, float and hover in empty space.

They are arranged in three couples; each couple performs a half-turn independently several times, pausing with their upper bodies twisted against their lower parts. Each time they pause they face the audience; sometimes they turn their backs to the audience, and at other times their upper bodies are twisted towards the spectators. Throughout this section, the gestures are borrowed from Schiele's drawings and paintings: heads tilted to the right, legs bent, hands in pockets, arms crossed in front of the upper body, or one arm across the front and the other behind.

The exact reproduction of Schiele's movements and gestures within the dance makes the concept of 'copy' indispensable. Rosalind Krauss (1985) argues that modernist avant-garde art movements can be seen as a function of the discourse of originality and the repressed concept of 'copy'. To that end, she refers to Auguste Rodin, who, she claims, was 'the last artist' to address the issue prior to the avant-garde, and to his sculpture *The Gates of Hell* (1978). This sculpture was cast after Rodin's death from plaster pieces that had been stored.[7] As no example of the statue was completed during Rodin's lifetime, there was no guide to the artist's intentions of how the finished cast should look. All the casts made after his death were examples of multiple copies that existed in the absence of an original, claims Krauss (1985), as a production of multiples, triple-casts or repetitions of the artist's plaster.

This particular play with the concept of copy flourished in the work of a group of young visual artists in the 1980s, who challenged canonical artwork through their replication of photographs, drawings and paintings. One of these artists, Sherrie Levine, was accused of violating

the copyright of Edward Weston with her re-photographs of Weston's son, Neil. Krauss (1985) argues that this accusation is false since Weston's 'original' had already been taken from models provided by others. Levine's alleged act of theft, she suggests, opens up the 'original' from behind to that series of stolen models. Similarly, Anderson copies from Schiele and, at the same time, draws our attention to the notion that Schiele himself was appropriating other artists, such as the decorative background borrowed from Gustav Klimt, or the motif of a model depicted in isolation in an empty space taken from Rodin.

In responding to Schiele's art, as illustrated in her watercolour *After Egon Schiele* (1983), Levine introduces 'her hand' into it, which is to be understood as a 'kind of feminist correction or revision' of male desire. It is her way of challenging an art system that celebrates the objects of male desire, in which she, as a woman artist, did not know how to situate herself, since she was 'only allowed to represent male desire' (Marzorati, 1986, p. 97). However, Levine chooses to copy man's desire and does so 'without extinguishing the fire', and while these works are considered 'most tender' they carry 'plenty of nonfeminist connotations' as well (Marzorati, 1986, p. 98).

In an interesting analogy, Anderson talks about her wish to examine Schiele's approaches as they unfold in the sketchbooks he kept, to use them as a structure for the movement in the dance, or to invent new 'muscle memories'. In one of the opening scenes, five almost naked dancers lie within the marked neon tube space. This space brings to mind a sheet of paper from a painter's or choreographer's sketchbook, on which s/he draws various signs that may later develop or evolve into an idea that will serve as the foundation for a work. It is there for the artist to draw on, to mark on its margins, and to move on from it to another page. This particular space offers a direct correlation between the choreographer's and the painter's approaches. The lights, which are repeatedly turned on and off during the dance, suggest the action of leafing through an artist's sketchbook. A dancer dressed in a suit enters and crosses the framed space diagonally from upstage left to downstage right, representing, by his posture, both one of Schiele's models and a contemporary dancer. He walks, slicing the space in which the 'naked' dancers lie, his upper body facing the down left corner, his arms held tensely down and away from his body.[8] As he moves, the dancers, each on his individual mattress, constantly change positions, exposing parts of their bodies – a foot, a forearm, a head. This creates tension between the 'void' and the physical figure, resulting in a powerful emotional intensity in relation to both the drawings and the dance.

Anderson transfers the image from page to stage, while subjecting Schiele's movements and gestures to her own choreographic rules. The dance has its own obsessions, capable of being appreciated even without knowing who Schiele was. At the same time, Anderson does not try to erase or block the primary memory of Schiele's art; rather, she puts it into another art form. Consequently, an ambiguous relationship is created with Schiele's art. On the one hand, she challenges the notion of authenticity in his modernist art when she copies his movements and gestures, and on the other, she alerts the viewer to traces of its continuing manifestations through the history of art.

This ambiguity is intensified since Viennese Expressionist art 'became a poor cousin twice removed from the sphere of world culture events' (Kallir, 1981, p. 7) as a result of the rise of Germany to become a dominant force in German-speaking Europe. Furthermore, Anderson makes the choice not to draw directly on Schiele's paintings and drawings but to work with his sketchbooks, which also include paintings. Although avoiding the grand narrative of Schiele's work, many of the images here are very well known and comprise a major part of Schiele's acknowledged *oeuvre*. Thus, she creates another dialectical relationship with the notion of elitist art, which is also about the idea of ownership and commodity.[9] It raises the infinitely repeated possibility of appropriation, by Schiele of himself and by Anderson of herself as well as Schiele, since she too has a body of work to draw on.

Feeling expressed on the outside of the body

When Anderson uses Schiele's drawings and paintings as sources for her dance, she makes his Expressionist art her point of departure, not the 'subject' of her work. Shifting Schiele's art from its usual place in our culture and transforming its traditions, the distance that separates us from what Schiele's sketchbooks offer and repress becomes the subject of the dance. As she takes a fresh look at the historical record of modernist Expressionism, Anderson must find ways to relate her own work of art not only to another art, but also to another era. The physicality of Schiele's work, Anderson declares, inspires, appeals and strongly suggests choreography to her. Raw material – Schiele's movements and gestures – is transformed into dance, and given shape and form. Her wish to represent Schiele's art within her dance is apparent when she says:

> they're scribbled little coloured diagrams with a kind of proscenium arch around them. And I suddenly thought, I wonder

what it would be like if I just reconstructed the 'Lost Dances' of Egon Schiele?

(in Robertson, 1998, p. 19)

A similar approach can be seen in her dance *Futurists* (1987–8), which refers to the ideas of Futurism, the artistic movement that erupted onto the Paris scene in 1909.[10] In this work Anderson embraces different per-spectives of revolution, involving images taken from the Futurists and from the Russian Revolution. The result is a radical juxtaposition of various dance representations of historical events, which occurred in different times and places. Conceptually, representation in Anderson's artistic work is based on Schiele's actual drawings and paintings, as Anderson says, in order for it 'to constitute [his] kind of aesthetic' (in Robertson, 1998, p. 19). However, Anderson subjects Schiele's artistic qualities, which she describes as distinguished by 'rawness and sense of exposure' (in Hutera, 1998, p. 34), to her own needs. Therefore, my scholarly objective is to analyse representation within Anderson's work and in relation to Schiele's art, rather than to trace its history.

As a term, 'representation', while complex, is often seen to have two basic meanings (Prendergast, 2000). The first lies in the capacity to 'make present again', the reappearance of an absent person or object by means of a simulacrum. This aligns the concept of representation with the notion of illusion and within the notion of illusion are two inter-related facets: the spatial and the temporal. In other words, it is spatially present and present in the related temporal sense of the present moment. Hal Foster (1996) points out that poststructuralist critics advance the simulacral reading, formulated in relation to pop art based on Roland Barthes' (1989) argument, suggesting that the objective of representa-tion, in 'making present again', desymbolises the object. In this process, the image is released from 'deep meaning into simulacral surface' (Foster, 1996, p. 38). In this disruptive process of representation, he con-tinues, the artist does not stand behind his/her work and is, therefore, situated at the surface of the picture, which has no depth of meaning. Hal Foster (1996) juxtaposes Jean Baudrillard's statement that the object 'loses its symbolic meaning' with Barthes' view of an avant-garde disruption of representation to emphasise what Baudrillard sees a ' "total integration" of the art work into the political economy of the commodity-sign' (in Foster, 1996, p. 38).

The second meaning of representation, standing for something or someone absent, rests on a principle of substitution. While there can be only one kind of simulacrum, there can be many kinds of substitution,

which is a wider sense of representation that can, in theory, cover the entire field of culture. Representation within contemporary culture is complex. Prendergast asserts that it 'behaves in a whole variety of different ways according to context, intellectual discipline, and object of inquiry' (2000, p. 3). Dance critics and scholars advance the referential view of Anderson's choreographic art and tie her work to various themes and discourses, such as popular culture, video dance or gender issues, also demonstrating her socio-political engagement with ideas and non-dance sources (see Jordan, 1988; Briginshaw, 1995; Dodds, 1995; Burt, 1998). My argument, however, is that one can read Anderson's dance as both referential and simulacral, connected and disconnected, oscillating between the two primary meanings of artistic representation – 'making present' and 'standing for' – but with the latter as a more significant mechanism.

The visibility of theoretical ideas and discourses in the dance make it more interesting. In the 'Voyeurism' section of Anderson's dance, for example, a dancer dressed in a tight body leotard, as if 'naked', moves and poses on a mattress. Two dressed dancers enter from upstage left, and one after another sit beyond the rectangular space on a folded mattress. The 'naked' dancer is posing for them, while also being aware of the audience in the theatre. The audience watches a drama in which the gazing spectators on stage and the dancer are participating. They watch the dancer move and pose before them, his legs wide apart, placing his hands over his genitals and raising his pelvis. Anderson uses poses that are similar to those of Schiele's subjects, but at the same time draws the audience's attention to the relationship established between artist and model, a distinct theme in pictorial art. This manifestation of the chain of gazes comprises spectators/artist, models/dancers and audience, and exposes the dancer/model as both an object and voyeur. Anderson, however, pushes this theme further by enabling the audience to become consumers, not of feminine sexuality as in Schiele's paintings and drawings, but of images of male sexuality as objects of desire.

This displacement of attention sees 'the representational field as a field to be policed and the subject of representation as a kind of policing agent' (Prendergast, 2000, p. 11). In the 'Voyeurism' section, two dancers/spectators approach each other upstage left. One dancer tilts his torso backwards, leaning his body weight on his partner, who holds his head in his hands. The standing dancer walks his supported partner out unhurriedly, while a third dancer/spectator stands and looks at the audience, who watch the intimate occurrence on stage. I argue that Anderson creates a powerful female spectator's look, avoiding what Laura Mulvey refers to as a certain 'masculinisation' of spectatorship

(in Doane, 1982). The woman spectator, no longer the image, obtains her desire in relation to the process of imaging.

In consequence, questions of representation can also become questions of politics in a broad sense of the term. Applying this to an interpretation of Anderson's dance, the complexity of form and pattern suggests a type of expressionism that is different from Schiele's picturesque use of structure and space in that it shifts attention towards the subject, towards the way Anderson exposes and transforms his notions of Expressionist art.

When Anderson is quoted as saying that 'every single position [in the dance] comes from a painting or sketch of [Schiele's]', the simulacral meaning of the dance becomes apparent (in Hutera, 1998, p. 34). At the same time, like Schiele's paintings and drawings, the dancers expose and present their emotions as well as their flesh. Anderson's desire to *substitute* Schiele's art is evoked by the sense of exposure portrayed in Schiele's paintings and drawings. The traces of the past found in Anderson's present work are represented as a duality between two layers of time, past and present. These are juxtaposed in a parodic postmodern manner, remaining separate in the dance, and the resulting contradiction between the two narratives is not resolved; rather, they coexist heterogeneously (Hutcheon, 1989).

When Anderson draws on the discourse of the relationship between the artist and model, revealing the field of power and its limitations, she demonstrates that every point of view is only relative, and the spectator's point of view is not the ultimate or definite one. In doing so she indicates her self-awareness and up-to-date knowledge of art history and cultural theories, which she incorporates into her dance. Furthermore, Schiele, like his predecessors, had no doubts in his art and did not use irony or any other means that might provoke the audience to disbelieve him. Anderson, who imitates and exaggerates Schiele's poses and facial expression, sometimes provoking laughter, draws on this discourse to present it in her dance with irony and pastiche.

Although the boundaries of the present and the past are frequently transgressed, they are never dissolved, as is evident in the mix of two music styles composed and played live by Drostan Madden. The contemporary feel and fashionable atmosphere of rock music are combined radically with the historical Viennese waltz, as illustrated in 'The Marionettes' section of the dance, when two dancers walk and manipulate their partner to the deconstructed sound of a waltz.

The fusion of original rock music and Strauss's *The Blue Danube*, a popular social dance, is unavoidably political in the sense that the

original contemporary music deconstructs the coherence of the juxtaposed traditional waltz. This scene draws our attention to Vienna, the 'City of Dreams' (Comini's appellation [1978]) where corruption and illusion reigned.[11] The writer Heinrich Laube, who came to Vienna in 1833, describes the dance mania phenomenon:

> The couples waltz straight through any accidental hindrances in their joyful frenzy; no god holds them back, not even the intense heat which is carried backwards and forwards in penetrating waves, as if driven by African desert winds...These orgies last till the early morning...the waltzes stir the blood like the bite of a tarantula.
>
> (Comini, 1978, p. 7)

The deconstructed sound of the waltz played in Anderson's dance, with its mechanical quality, is a self-critical manifestation of the myths of Schiele's era, from which he himself wanted to be liberated. Since turning to the aesthetic of the past becomes a question of representation and not of objective recording, the process keeps the choreographer, who narrates in the present events of the past, and the audience, who are forced to acknowledge that path, from nostalgia. They are freed from nostalgia as 'cultural melancholia' (Sacks, 2000), which evokes and refuses to let go of the images of the past.

At the same time, Anderson enables the changes that have transpired since then to become visible in her dance in, for example, the 'mock-nude' costumes in the dance which indicate some reflection about the construction of eroticism and how desire is to be expressed on the surface of the body. The dancers' 'skin' is painted with Schiele's coloured brushstrokes; but while Schiele expressed his inner feelings on the flesh of his female models, it is male dancers that Anderson and her costume designer Sandy Powell dress in tights. Dougill takes the view that these are 'painted not only with Schiele's startling flesh tints but also hermaphroditic body parts' (1998, p. 8). Anderson's interest, however, is in fluid gender identities rather than in pseudo-biological ideas located in hermaphoditism.

Anderson has long focused on stereotyped definitions of gender identities and heteronormative culture in a way characteristic of contemporary feminist critique, and which simultaneously conveys a political message. In her dance *Metalcholica* (1994), for example, the fashionable motorcycle obsession demonstrates tension between subject matter and the gender of the performers. Another illustration can be found in the last scene of *Perfect Moment* (1992) in which the dancers remove their

clothes and arrange them in a pattern that is only completed when they lie down among them. Consequently, the complexity of representation in Anderson's dance becomes an active force, which is part of the entire structure rather than an expressive device.

Tolerance of ambiguity

'Tolerance of ambiguity and acceptance of diversity in interpretation in the arts', Adshead-Lansdale argues, 'is not necessarily the weakness that it is assumed to be – in poststructuralist thinking it is unavoidable' (1999, p. 6). The principle of ambiguity within literary texts is described by Umberto Eco (1979) as the 'moral disposition and dilemmatic construct' of the 'open' work, which is part of a cultural phase in which aesthetics is concerned with the notion of openness and its expansion. In a 'work in movement',[12] Eco argues that 'open' works of art are 'stripped of necessary and foreseeable conclusions' (1979, p. 58). However, the infinite, contained within finiteness, he asserts, and the positive property of the 'open' work, which admits different conclusions and solutions, have structural validity.[13] The author of the dance, who proposes a number of possibilities accompanied by specifications for proper development, offers the completion of the work to the addressee, the performer or the interpreter. Eco concludes that the 'open' work sets up a new cycle of relationships between the artist and his audience, a new mechanics of aesthetic perception.

Anderson creates a vision of an artistic milieu that delineates the connections between Schiele's art, created in *fin-de-siècle* Vienna, and traces the way his influence has permeated other art forms over the decades. At the same time, she presents us with a conscious violation of the concepts of period style, authenticity and originality. The representations of the composed images and movements, functioning as transparent documentary representations within a temporal work, call into question the universality of grand narratives. Hutcheon argues that what has surfaced in postmodernism (with reference to literary texts) is 'something different from the unitary, closed, evolutionary narratives of historiography as we have traditionally known it' (1995, p. 66). Anderson being historically aware of Schiele's art, and regarding it from today's point of view as a rebellion against old traditional forms, subverts the closure and causality of the historical narrative.

Despite its historical accuracy, the dance speaks more about the culture that produced it and the choreographer than the realities of life in modernist Vienna. Anderson challenges the 'objective representation of the

past' in Schiele's artwork by using the artist's sketchbooks for her art; at the same time, in placing great value on the sketchbooks, she returns to the historical subject 'with a twist', since these are considered to be primarily preliminary work in a creative journey (Ross, in Graham 1973; Wittgenstein, 1969). In his book *Egon Schiele: Sketch Books*, Nebehay considers these 'a hitherto untapped source of insight into the artist's working methods' (1989, p. 7).[14]

Foucault problematises the very notion of *work* in his article 'What is an Author?' (1984), in which he rejects the notion of the author. He argues that even when an individual is accepted as an author, one cannot define one 'work' amid the millions of traces left in it by other 'works'. This opens up the way to consider Schiele's sketchbooks not only as papers on which he ceaselessly drew, but as a *work*. Kallir (1994) supports this view, claiming that most of Schiele's drawings and watercolours were not studies, but fully conceived as independent works of art.[15] At the same time, Anderson refers to Schiele's wider *oeuvre*, by using his 'actual drawings and paintings to constitute the kind of aesthetics (in Robertson, 1998, p. 19). The fact that the choreographer did not choose to concentrate on the artist's grand narrative but on his sketchbooks allows her to deal with the artist's pictorial material without becoming nostalgic for the past it represents. The discursive context of Anderson's use of Schiele's sketchbooks, which articulates the notion of the *text* as ambiguous, is also expressed in the dance. This ambiguity is illustrated when Anderson combines Schiele's two-dimensional poses with her three-dimensional movement, giving Schiele's modernist work a different interpretation.

On a dark stage, two dancers enter from the side wings, pulling mattresses and placing them outside the neon-tube-framed rectangular space situated on the stage. They perform in the periphery of the defined, restricted space, which suggests the act of drawing and sketching on the margins of a sheet of paper. Drawing in the margins (like in a sketchbook) is considered a preparation for the act of painting and therefore inferior to it. The dancers echo each other's movements and gestures, which are not clearly seen, and at the same time maintain their individual movement quality. They fall and recover on and near the mattresses as if the force of gravity draws their heavy, weighted bodies towards the ground. The repetition of these falls suggests that Schiele's floating figures cannot stay in his voided space, and reinforces the sense of their and the dancers' powerlessness, their ineffectiveness in confronting that force. After performing this pattern a few times, hands with fingers spread appear and withdraw through the side wings, pulling the audience's attentions even further from the action on the

periphery of the stage to the space beyond, thus blurring the boundaries between the visible and the invisible within theatrical space.

In addition to the dance's appropriation of Schiele's movements and gestures, another element of pictorial art is also appropriated – the act of drawing itself, manifested in the sound of a pencil scribbling on paper and of crumpling scraps of papers that are heard. The act of drawing, which indicates Schiele as an author while also presenting his absence, creates a tension between presence and absence within the dance. The force of absence or the absent is present in the choreographer's and the dancers' artistic world. This makes the choreographer and the dancers operate, as Watson describes it, as if 'each move is a direct translation of one of his [Schiele's] angst-ridden, sinewy studies' (1998, p. 5). Schiele's continuous powerful influence, permeating a performance at the end of the twentieth century, is presented with a sense of death that Watson claims haunts the space as well as the performance, resulting in 'a very dark show...with some quite disturbing sequences' (1998, p. 5).

Although an accentuation of the notion of the 'copy' contributes to the decline of authorial control over language and meaning, Anderson's broadened definition of what is 'original' creates a plurality of voices that may be heard in the work without entirely eliminating the authorial voice. This ambiguity becomes even more complicated with Anderson's employment of the notion of 'copy', transforming Schiele's desire of female nudes by using her all-male company. The act of reading, which is also made up of what the spectator brings to it, thus focuses on the notion of sexual differences and fluid gender identities, indicating social meanings and ideologies of gender. The ambiguities that are embedded within the dance thus impose on the spectator multiple perspectives from which the dance can be viewed and understood.

Choreographer and audience as readers

The attentiveness of the art of dance to other artistic practices, such as pictorial art, and the act of fusing them together influences the properties of both art forms. Levinson (1984), who formulates a framework of the scope of artistic hybrid relationships, argues that the hybrid art form achieves two effects, the integrative and the disintegrative, which are opposed to each other. In the first, the elements work together or cooperate towards a common end; in the disintegrative alternative 'the complexity and richness function in service of an ideal not of unity, but of complete fragmentation and rampant uncoordination' (Levinson,

1984, p. 12). Anderson 'bombards' the spectator with information and ideas from diverse discourses, creating an un-unified field. The confrontation of historical discourses with another discipline (pictorial art) enables her to seek out new material and make it part of her dance. The reader of her dance – be it a spectator, critic or theorist – is therefore actively engaged with her text, trying to unravel the threads of the dance's possible interpretations and meanings.

For these reasons, *The Featherstonehaughs Draw on the Sketch Books of Egon Schiele* is more than a merging of dance and painting, or a fusion of the aesthetics of postmodernist and Expressionist art. Both the choreographer and the spectator are fully aware of the breakdown of familiar temporal relations. What makes this dance special is not only the effort one is required to make in order to become accustomed to its particular style, but the layered issues and discourses embodied in it. The hyphenated-hybrid nature of the relationship between the two arts, juxtaposed through the use of the fragmentation effect, creates an artwork in which so much is going on that the viewer has no choice but to become aware of its complexity and multiplicity.

The open structure of the dance inundates the viewer with multiple ideas and meanings. Eco argues that this kind of relationship invites the spectator to 'make his own free choices and reevaluate the entire text from the point of view of his final decision' (1979, p. 34). Adshead-Lansdale (1999), who develops this argument further in relation to dance studies, suggests that in the interpretation of a dance as an open construction in which the reader is subject to the play of various codes, both the choreographer and audience become 'readers'. Thus, they are

> equally dependent upon an ability to identify the conventions within which a work is constructed and operates, and to reflect on their own use of such conventions.
>
> (1999, p. 7)

Anderson's inclusion of multiple discourses in her dance not only allows her to distance herself from the past, but also involves her and the audience in a participatory activity. The multilayered dance is made with constantly changing images that are left open-ended; it is a complex text that resists any meaningful closure and unified meaning.

Conclusions

Anderson's play with Schiele's art within her dance emphasises the distance and fluctuation between the two, and becomes her point of

departure. Appropriating Schiele's exact images becomes a critical tool to challenge what Connor (1997) argues is the impossibility of representation in modernist culture. Anderson's application of imitation and pastiche as a critical device enables her to deconstruct the conventional and accepted meaning of Schiele's art.

The incorporation of distinct discourses and ideas into the work encourages a view of it as open in nature; however, as Eco (1979) suggests, this does not imply that it allows any interpretation. The open structure of the dance contains oppositions and altered contexts – familiar things seen in an unfamiliar way and from unexpected points of view – thus allowing a multiplicity of meanings to be read into it. At the same time, the juxtapositions within it create rhythmic complexities and contradictions, all flourishing within the same text. In the last analysis, what matters are not the various issues referred to in themselves, but the web-like structure of the text. It is demonstrated when pictorial ideas of another style and time penetrate and enrich the dance, and the engagement with such discourses which undermines normative power structures. The final interpretative task is left to the spectator/reader.

Notes

1. Pronounced Fanshaw.
2. To the core quartet of the all-male company – Frank Bock, Dan O'Neill, Stephen Kirkham, and Rem Lee – were added Eddie Nixon and Luca Silverstrini.
3. The name of the company (pronounced Chumley) is borrowed from a painting of the British School bearing a similar title – *The Cholmondeley Ladies*, painted c. 1600–10 (Tate Britain).
4. Anderson chose the company's name, as stated, from English culture. She found it in a book of pronunciation of old English names. As she declares, it was the word that 'had the longest spelling and the shortest pronunciation' (Anderson, 1994, p. 23).
5. In 2002 Anderson and Kevin McKeirnan created a 9-minute video-dance, *The Lost Dances of Egon Schiele,* for the BBC and the Arts Council of England.
6. Hutcheon (1989) argues that in postmodernism art forms install and then destabilise convention in parodic ways, pointing to their inherent paradoxes and their critical or ironic re-reading of the art of the past.
7. *The Gates of Hell* was recast as part of Rodin's exhibition in the summer of 1978 at the National Gallery in Washington, 60 years after the artist's death in 1918.
8. Anderson's 'naked' dancers are dressed in tight Lycra leotards, simulating the appearance of Schiele's naked models.
9. The fact that Anderson keeps in her archive an article on the legal battle between museums and private owners over the ownership of Schiele's portrait of *Wally Neuzil* (1912), Schiele's mistress, indicates her awareness of the

issue of artworks' ownership. The portrait was borrowed from the Austrian government to be exhibited in the New York Museum of Modern Art in 1998, and was then reclaimed by two Jewish families from whom it had been seized by the Nazis.

10. For the movement's contribution to artistic development, see Goldberg (1996), Lynton (1995) and Martin (1968).

11. In the first year of the First World War, for example, the news of defeat was kept from Kaiser Franz Joseph, while operettas were being composed and played to divert public attention from what was actually happening on the battlefield.

12. Eco likens 'open' works or 'works in movement' to pieces of instrumental music that leave considerable autonomy to the individual performer in the way he chooses to play them (1979).

13. 'Open' works, according to Eco (1979), are deployed within limits of given tastes, predetermined formal tendencies and the performer's manipulation.

14. Comini (1974) states that Schiele kept a diary, which the art critic Arthur Roessler published in 1922. His German edition has been the basis for the English translation of the diary presented in her book. She suggests that Roessler 'may have tampered with the diary, even perhaps to the extent of having changed or suppressed certain entries' (1974, p. 37). According to Benesch (1950, 1973), a series of drawings and watercolours that were also created in prison can be counted among the most moving documents in the history of art.

15. Jane Kallir (1994) states that Schiele executed ten times more works on paper as on canvas or panel, unlike other twentieth-century artists.

References

Adshead, J. (ed.) 1988 *Dance Analysis: Theory and Practice*. London: Dance Books

Adshead-Lansdale, J. 1999 Creative Ambiguity: Dancing Intertexts. In J. Adshead-Lansdale (ed.), *Dancing Texts: Intertextuality in Interpretation*. London: Dance Books, pp. 1–25

Anderson, L. 1994 *A Resource Pack of the Production of Flesh and Blood*. NRCD

Barthes, R. 1989 That Old Thing, Art.. In P. Taylor (ed.), *Post-Pop*. Cambridge, MA: MIT Press

Benesch, O. 1950; 1973 Egon Schiele as a Draughtsman. In E. Benesch (ed.), *Collected Writings* IV. New York: Phaidon

Briginshaw, V. 1995 Lea Anderson Talks to Valerie Briginshaw about Flesh and Blood. *Dance Matters* 13, Summer, pp. 4–8

Burt, R. 1998 Re-Presentations of Re-Presentations. *Dance Theatre Journal* 14, 2, pp. 30–3

Comini, A. 1974 *Schiele in Prison*. London: Thames & Hudson

——— 1978 *The Fantastic Art of Vienna*. New York: Alfred A. Knopf

——— 1990 *Egon Schiele's Portraits*. Berkeley, Los Angeles and London: University of California Press

Connor, S. 1997 *Postmodernist Culture: An Introduction to Theories of the Contemporary*. Oxford: Blackwell

Doane, M. A. 1982 Film and the Masquerade: Theorising the Female Spectator. *Screen* 23, 3–4, September–October, pp. 74–88

Dodds, S. 1995 'Perfect Moments, Immaculately Framed': Lea Anderson and the Television Text. *Border Tension: Dance & Discourse*. Proceedings of the Fifth Study of Dance Conference. Guildford: University of Surrey, pp. 95–100

Dougill, D. 1998 Moving Pictures. *The Times* 15 February, p. 8

Eco, U. 1979 The Poetics of the Open Work. *The Role of the Reader: Explorations in the Semiotics of Texts*. Bloomington and Indianapolis: Indiana University Press

Foster, H. 1996 Death in America. *October* 75, pp. 37–59

Foucault, M. 1984 What Is an Author? In P. Rabinow (ed.), *The Foucault Reader*. London and New York: Penguin Books, pp. 101–20

Goldberg, R. 1996 *Performance Art: From Futurism to the Present*. London: World of Art

Graham, M. 1973 *The Notebooks of Martha Graham*. New York: Harcourt Brace Jovanovich

Hargreaves, M. 2002 Profile Lea Anderson. *Dance Theatre Journal* 18, 3, pp. 16–19

Hutcheon, L. 1989 Modelling the Postmodern: Parody and Politics. *A Poetics of Postmodernism: History, Theory, Fiction*. London: Routledge, pp. 22–36

—— 1995 *The Politics of Postmodernism*. London and New York: Routledge

Hutera, D. 1998 The Boys get into a Viennese Whirl. *The Times* 10 February, p. 34

Jordan, S. 1988 The Cholmondeleys, Spring '88. *Dance Theatre Journal* 6, 2, Fall, p. 27.

Kallir, J. 1981 *Austria's Expressionism*. New York: Rizzoli, Galerie St. Etienne

—— 1994 *Egon Schiele*. New York: Harry N. Abrams

Krauss, E. R. 1985 The Originality of the Avant-Garde. *The Originality of the Avant-Garde and Other Modernist Myths*. Cambridge, MA and London: MIT Press, pp. 151–70

Levinson, J. 1984 Hybrid Art Forms. *Journal of Aesthetic Education* 18, 4, pp. 5–13

Lynton, N. 1995 *The Story of Modern Art*. London: Phaidon

Martin, W. M. 1968 *Futurist Art and Theory, 1909–1915*. Oxford: Clarendon Press

Marzorati, G. 1986 Art in the (Re)Making. *Artnews* 85, 5, pp. 90–9

Nebehay, M. C. 1989 *Egon Schiele: Sketch Books*. London: Thames & Hudson

Parry, J. 1998 Sketch a Lech. *The Observer Review* 15 February, p. 7

Powell, N. 1974 *The Sacred Spring: The Arts in Vienna 1898–1918*. New York: Graphic Society

Prendergast, C. 2000 *The Triangle of Representation*. New York: Columbia University Press

Robertson, A. 1998 G'day Schiele! *Time Out* 31 December–7 January, p. 19

Sacks, A. 2000 Learning to Live with Loss. *Dance Theatre Journal* 15, 4 April, pp. 16–19

Vergo, P. 1993 *Art in Vienna, 1898–1918*. London: Phaidon

Watson, K. 1998 Men Behaving Sadly. *Dance Theatre Journal* 14, 2, pp. 4–6

Wittgenstein, L. 1969 *Notebooks 1914–1916*. Ed. G. H. Wright and G. E. M. Anscombe. Oxford: Basil Blackwell

Videography

Anderson, L. and McKeirnan, K. 2002 *The Lost Dances of Egon Schiele*. London: BBC and the Arts Council of England

10
Mad Hot Ballroom and the Politics of Transformation

Sherril Dodds

It's about politics, it's about racial harmony, it's about working together, it's about almost everything but ballroom dancing.

(Agrelo, 2005)

Given that *Mad Hot Ballroom* (2005) is a documentary that takes ballroom dance as its subject, it is somewhat surprising that its director, Marilyn Agrelo, should suggest that the film is not about the dance. *Mad Hot Ballroom* focuses on a ballroom dance programme, initiated by a ballroom teacher, Pierre Dulaine, in 1994, for fifth grade children from New York City schools. Over 60 schools from Manhattan, Brooklyn, the Bronx and Queens participated in the ten-week course, which was taught by instructors from the American Ballroom Theater (ABrT). The film follows the children from three schools: Public School (PS) 112 in Bensonhurst, which is a predominantly Italian and Asian area; PS115 in Washington Heights, uptown Manhattan, which has a large Dominican population and where reputedly 97 per cent of the community live below the poverty line; and PS150 in TriBeCa, an affluent part of downtown Manhattan (www.imdb). *Mad Hot Ballroom* charts the children's progress from the very first lesson through to a final, city-wide competition held at the Winter Gardens of the World Financial Center in which the best teams compete for the coveted Challenge Trophy.

Although *Mad Hot Ballroom* positions itself as a documentary in the social realist tradition, I want to demonstrate how different modes of analysis reveal it to be a site of contradictory readings and I commence with a textual analysis of the film. Rooted in linguistics, in particular semiotics and structuralism, Johnson (1996) describes this approach as a formal and technical analysis of textual forms, and Barker (2000) conceptualises it as an in-depth study of the sign-systems that constitute

cultural representations. The film is variously described by critics as 'joyfully positive' (French, 2005, p. 10), 'a heartwarmer' (Bradshaw, 2005, p. 8), 'charming and moving' (Rockwell, 2005, p. E5) and a 'feel-good story' (James, 2005, p. E1). These reviews indicate a somewhat utopian narrative, while Agrelo's quotation at the opening of this chapter suggests that the film deals with major life issues that surpass the dance itself. I argue that a textual analysis of *Mad Hot Ballroom* produces this type of favourable reading as the film purports to demonstrate the transformative potential of dance for disadvantaged New York schoolchildren.

In the field of cultural studies, however, critical debates have highlighted that, although textual analysis can produce a complex level of interpretive versatility, it frequently neglects the political, economic, social and historical framework of cultural production (Agger, 1992; Ferguson and Golding, 1997). Thus I suggest that a deeper contextual analysis of *Mad Hot Ballroom*, which introduces a political economy and socio-historical critique, exposes a range of competing readings. To demonstrate this I consider, first, how film operates as an economic enterprise and how this impacts on documentary genre as a rhetorical device. Secondly, I investigate the construction of idealised social identities and how those sit in relation to a socio-historical overview of ballroom dance. Thirdly, the relationship between competition and capitalist aspiration is exposed and the extent to which this facilitates real opportunities for social mobility is discussed. Through these different strands of analysis I attempt to make evident that the dance is absolutely central to the film and that issues of transformation, identity construction and political ideals are embodied through the dance practice itself.

Mad Hot Ballroom: a tale of transformation

In his study of documentary film, Nichols (2001) suggests that one strand of this genre can be characterised by its attention to identity issues. He states, 'the political voice of these documentaries embodies the perspectives and visions of communities that share a history of exclusion and a goal of social transformation' (Nichols, 2001, p. 160). It is therefore significant that in reviews of *Mad Hot Ballroom*, several writers have identified notions of transformation inherent in its narrative. Maconie describes the film as 'following the inspirational journey of pre-teen kids bettering themselves through ballroom dance' (2005), and French observes how the ballroom dance programme is 'a way of

encouraging self-respect, physical discipline, a sense of style and harmonious relations between 11-year-old boys and girls' (2005, p. 10). In her seminal essay on dance within fictional narratives, McRobbie argues that dance carries a 'transformative power' in 'its ability to create a fantasy of change, escape, and of achievement' (1997, p. 210). Although she refers specifically to fictions aimed at girls and young women, I would suggest that the same 'fantasies of achievement' are embedded in the documentary narrative of *Mad Hot Ballroom*. To illustrate how concepts of transformation are central, I present a textual analysis examining key events of the film as represented through its visual images and the subjects' voices.

Mad Hot Ballroom begins with a series of establishing shots that depict a harsh New York winter: snow flurries whip across the wet streets as bodies huddle under umbrellas and thick padded clothing. The scene quickly cuts to the exterior of PS115 as a male voice states 'Morning class!' and a chorus of juvenile voices responds. The voice of the ABrT tutor continues, 'Can I have everybody stand up nice and tall like you're about to enter a ballroom' as the shot cuts to the interior of a school gymnasium and the children enter in a higgledy-piggledy line of male–female couples. Standing in a circle, the teacher demands that they stand up straight and that the 'gentlemen' tuck their shirts in. The action then moves to PS150 as the children learn for the first time how to execute a ballroom hold. Finally, the scene shifts to PS112 where the children are corrected for the sloppy use of their arms in the Merengue. Already the children's bodies are undergoing a complex process of reconstruction through which they will acquire the codes and conventions of the ballroom technique.

Almost from the beginning the children are positioned as socially disadvantaged. Clarita Zeppie, the principal of PS115, explains that a high proportion of them are brought up by a single parent or extended family and there is frequently more than one family living in the same home. She emphasises that whereas middle-class families have the financial means to support their children in extracurricular activities, the ballroom programme is free and therefore affords an opening for children of low-income backgrounds to learn, and be successful at, something new. As one mother walks along the street with her young daughter she describes how her parents emigrated to the United States in search of a better life and that she too wishes her daughter to take advantage of the opportunities on offer. The chance for new social possibilities is then played out as the following scene shows the children of PS112 learning Swing, a dance, it is emphasised, from the United States.

At first the children are awkward and clumsy in relation to both the intimate partnering and movement vocabulary of the dance, but as the film progresses they become increasingly competent at a range of dances – the Tango, Foxtrot, Rumba, Merengue and Swing. There is a clear, embodied transformation from raw and self-conscious dancing bodies through to young people who demonstrate increasing confidence in their technique and who have the capacity to engage with each other through sustained eye contact and secure holds. Scenes of the children determinedly practising at school are intercut with them in their private lives talking about their plans for the future, their feelings about the competition, their hopes and aspirations, and their thoughts on the opposite sex. In one significant scene a few of the children rehearse on wasteland while musing on life. They talk about the wasted potential of gang members and the ills of negligent and adulterous parents. One girl suggests, 'this is the right path', followed shortly by shots of the children practising. The scene firmly suggests an increasing autonomy through the children's desire to dance outside the formal boundaries of the class and to reflect on life in an independent way.

The first moment of competition occurs when the children are selected to represent their schools in the quarter-final heat. This is depicted through shots of the teachers announcing the names of those who will compete. The children clap supportively those who have got through, while a delicate and reflective piece of music forms part of the soundtrack, which adds a sense of sentimentality to the children's achievement. The quarter-finals are meanwhile introduced with an air of dynamism: the track *Everybody Dance Now* blasts out as background music while the children knot ties, twirl in dresses, pin on sashes, race down corridors, style hair and fasten cuffs. The result is a frenzy of anticipation. From the beginning there is a strong ethos of encouragement and support. Dulaine, the compère for the event, states, 'All you beautiful young ladies and young gentleman have achieved a wonderful level of dancing just by being here today'. This sense of empowerment is then carried through into the dancing experience. A small boy called Michael and his partner perform a stiff and awkward tango with barely a hint of movement chemistry between them, but on completion of the dance they break into enormous smiles of satisfaction.

At the end of the competition, the camera dwells on PS150 as the results are announced. When they discover they have failed to make it through to the next round both the teacher and the children's faces crumple in disappointment and many begin to cry. Yet the ABrT instructor immediately focuses on the positive: 'Whatever you got from this

programme, this is for the rest of your life.' The film moves on from this disappointment with passages of the calm and reflective music heard earlier and shots of everyday New York street scenes. While PS115 rehearse for the semi-finals, PS150 are shown discussing their failure to qualify with their school teacher. Again, the emphasis is on constructive dialogue as the teacher gently guides the children away from criticising the other teams to commenting on their own reflections of the experience. This is followed by a somewhat comical scene of the PS112 children throwing themselves into an orchestra rehearsal only to make a cacophonous din. The implication is that what the children lack in talent is more than compensated for in enthusiasm. This is the last we see of PS150 and PS112.

The semi-final heat follows PS115, now wearing matching costumes, as the camera dwells on the movement of the dancers. The transformation from ungainly fledglings to self-assured performers is evident as the children execute the dances with style and aplomb. As the competitors embark on a Rumba, the PS115 school teacher, ABrT instructor and crowd of spectators go wild at the sophistication and sensuality of one young couple who undulate in precise unison while gazing into each other's eyes. As the results are announced, anxiety and excitement are inscribed on the participants' faces; on hearing they have qualified, they scream, jump and hug each other.

On the day of the finals, we see the children enter the opulence of the Winter Gardens. As the children come on stage, their teacher and school principal brim with pride, almost like idealised surrogate parents. For this final stage of the competition, considerable screen-time is devoted to each dance to allow the viewer to comprehend fully the movement transformation that has taken place. There is a clear rapport between partners and their movement is precise and carefully executed according to the stylistic nuances of each form. The results are impressive and this is echoed both by the whooping and cheers from the audience and that PS115 are ranked in the gold medal category. Yet notions of transformation reside not only in movement capability. The suggestion is that the dance experience has led to other changes in the children's lives. The final part of the competition involves the Challenge Trophy whereby randomly selected gold medal couples perform a dance other than the one they are officially entered for. As the PS115 couple dance to the sultry strains of the Rumba, Zeppie is heard describing Kelvin, who was

> very close to being a street kid ... maybe even down the road to being a criminal, but as we got started with the programme ... we started to

see a change in him. He became almost like a little gentleman, very polite, really committed to his team, to his dance partner and he has been such a role model for other kids.

Significantly, she conceives this as a permanent development that has emerged through the dance experience: 'I think that Kelvin is going to be fine ... a big success. He's on the right path now and I attribute a large percentage of that to the dance programme.' This suggests that the embodied transformation through dance facilitates change at a personal and social level. As a perfect ending to this narrative, it is the underdog team PS115 that wins the Challenge Trophy.

Economic enterprise and the documentary rhetoric

At a textual level *Mad Hot Ballroom* is clearly positioned as a narrative of personal change and social mobility. Yet I argue that this reading is limited and that a further exploration of its context of production offers both alternative and contradictory interpretations. I commence with an examination of the economic framework of film-making and how that impacts on the form and content of documentary. Through this approach I suggest that *Mad Hot Ballroom* is constructed as a fiction that has similarities with Hollywood fantasy narratives.

The past few years have been marked by an influx of documentary film releases which have been well received by audiences and critics (Carjaval, 2005). It is partly the easy access to relatively cheap digital film-making equipment that has allowed increasing numbers of budding film-makers to realise their artistic vision (James, 2005). Yet although digital technology has facilitated cheaper and faster film-making opportunities, documentary still demands considerable financial investment. As Carjaval (2005) indicates, even the development of a 35 mm master print costs in the region of $25,000. Thus it is in the interests of the film-makers to exploit a film's commercial potential and *Mad Hot Ballroom* clearly found a keen market. Waxman (2005, p. AR31) describes how it prompted a 'bidding war' when it was previewed at the Slamdance Film Festival and consequently became a lucrative commodity. Paramount Classics and Nickelodeon Movies reputedly paid $2 million for the distribution rights (James, 2005) and it is the 'seventh top-grossing documentary of all time' (Cadwalladr, 2005, p. 5).

As it is in the film-makers' interests to recuperate at least the initial financial outlay in documentary production costs, this has an impact

on the type of work that is produced. One obvious consideration is to create a work that will appeal to a wide audience. Significantly, several critics suggest that *Mad Hot Ballroom* utilises a formulaic narrative and I argue that the use of a tried-and-tested model is one means of attracting audiences. Rockwell (2005, p. E5) refers to it as a 'copycat' film in that it is a 'saga of plucky young people struggling for the prize'. Scott (2005, p. E20) sees it as 'the latest crowd-pleasing documentary to use a narrative device long relied upon by fictional sports movies: the road to the big game'. What is perhaps most interesting about these comments is the allusions they make to the use of the 'dramatic narrative' in *Mad Hot Ballroom*.

In order to consider how *Mad Hot Ballroom* could be described as a 'fiction' it is worth examining the documentary genre within the field of film studies. Nichols (2001) asserts that naming a text as 'documentary' is a delimiting strategy in that it immediately positions the film within a tradition that calls on the spectator to view it as 'non-fiction'. This therefore begs the question of what demarcates documentary from fiction. Nichols (2001) states, 'documentaries address *the* world in which we live rather than *a* world imagined by the film-maker' (author's emphasis, Nichols, 2001, p. xi). Thus whereas fiction trades in images of fantasy (although they may bear remarkable likeness to our perceived reality), documentary looks to the everyday world for its subject matter, however esoteric that may be. Yet in spite of the emphasis on accessing reality, it is apparent that documentary film is a representation, re-creation or reconstruction of the world.

Several scholars suggest that the boundary between documentary and fiction film is far from stable and that documentary draws heavily on devices normally associated with classic narrative fiction. Trinh (1993, p. 96), for example, argues that the subject matter is 'made vivid' and 'dramatized' to solicit the interest of the audience; Renov (1993, p. 2) insists that 'nonfiction contains any number of fictive elements, moments at which a presumably objective representation of the world encounters the necessity of creative intervention'. Indeed, various filmic strategies drawn from the conventions of fiction are used in documentary: characterisation, poetic language, narrative structure, dramatic peaks, music to intensify emotion and so on (Renov, 1993). In reference to *Mad Hot Ballroom*, Cadwalladr (2005, p. 5) comments on its tenuous relationship with reality: 'the most unlikely thing about the film … is that it all happened to be true … *Mad Hot Ballroom* isn't much like life. It's much, much better than that.' Perhaps the key reason that documentary has such a distorted relationship with reality is that,

although it seeks to present an excerpt of social life, it does so in a rhetorical voice. The way that documentaries represent their subjects is filtered through the values and beliefs of the film-maker (Trinh, 1993; Nichols, 2001). While documentary may appear to operate objectively, as a genre it seeks to stimulate ideas and feelings (Rabinowitz, 1994). Consequently, it is oratory in style; it takes a particular line of argument or point of view by drawing on issues that are not concerned with scientific proof, but that are open to question and debate (Nichols, 2001).

Although *Mad Hot Ballroom* is positioned as a social realist documentary, it is also possible to see how it is structured as a fantasy narrative and how the dancing fabricates a sense of performance. Renov (1993) and Rabinowitz (1994) state that documentaries organise their images and events through narrative forms in that they present a 'story' of social life. Not only does *Mad Hot Ballroom* use a clearly defined narrative structure but, as previously mentioned, it trades in a formulaic paradigm to recount its story. As Scott (2005, p. E20) states, 'the built-in suspense of the road to the final tournament (and the serendipitous development that at least one of the three schools makes it that far) gives "Mad Hot Ballroom" its shape'. Although I appreciate that *Mad Hot Ballroom* is faithful to the real-life chronology of the dance programme as it moves from the classroom lessons to the final competition, I argue that this teleological form is one option among several and that the stages of the competition are the dramatic arcs that locate the film within a tradition of fantasy narrative.

Clearly the film-makers could have opted against employing a structure that shifts from the quotidian images of the weekly classes to the glamour and excitement of the Challenge Trophy. Yet by using this narrative organisation it creates a sense of anticipation and climax that mirrors the drama of classic fictional forms through its play on competition, suspense and winning. One only has to think of popular Hollywood dance films to see how the same elements of challenge and success are played out: *Flashdance* (1983) deals with the journey of a female welder and erotic dancer who aspires to go to ballet school, and *Billy Eliot* (2000) follows a young lad from a mining community who dreams of becoming a professional dancer. In each case, the protagonist wins her or his goal.[1] The division of *Mad Hot Ballroom* into each stage of the competition is explicitly enunciated in the order of shots and the intertitles that announce the quarter-finals, semi-finals and the final. In the early stages of the film, as the children embark on the ten-week course, there are plentiful scenes of them at play, at home and discussing their lives.

As the film progressively gets closer to the final competition, the scenes outside the actual dancing remain focused on this pinnacle event: the children on a shopping trip for costumes; preparing hair and make-up; reflecting on their concerns and hopes for the final. The camera is also quick to exploit moments of drama. As PS150 and PS112 are knocked out of the quarter-finals, it is significant that the film-makers chose to focus on PS150. As the results are announced both the children and the school teacher break into tears and this climactic emotional moment is fully exploited as several shots follow of the children sobbing at their failure to win.

Renov (1993) asserts that it is difficult to separate the documentary performance from an actor's fictional performance as both are constructions. Although the documentary camera may purport simply to record the behaviour of its subjects, there is still the opportunity for the film-maker to 'direct' the actions and for the subjects to 'play' to the camera. Since only a selection of shots is used in the final cut, the subjects that we see are partial representations. Consequently, the documentary performances are reduced to particular types. For instance, one of the children from the more affluent PS150 is shown at home choosing which dress to wear for the quarter-finals while her 'devoted' mother looks on; out on the street explaining to the camera that she wishes to become a famous performer; and then crying in disbelief that her team does not go forward to the semi-finals. The image is of a 'spoilt rich kid' who has plenty of opportunities in life and is used to easy success, although there is not enough detail about her background to fully support this assessment.

There is also a notion of 'performance' operating in the final round of the competition. The competition event is presented as a 'staged performance' watched by the teachers, ABrT instructors and other friends and family, and the filmic audience is inserted into that viewing position. It is also a 'performance' in that it is the denouement of the narrative drama and this is constructed as the pinnacle of the film, the key moment of theatrical climax. This is enacted through the anxiety on the children's faces as they await the results. On winning, they cluster around the trophy and raise it in the air. This shot is played in slow motion and uses filtered lighting to give a dream-like quality to maximise this moment of glory. I argue that *Mad Hot Ballroom* employs the type of narrative suspense typical of fictional drama, hence its subject matter is presented in an accessible manner, which allows it much potential for financial remuneration through its ability to appeal to a wide spectrum of viewers.

The construction of idealised identities
across class, race and gender

As part of the fantasy narrative of personal achievement and transformation that underpins *Mad Hot Ballroom*, I propound that the film offers possibilities of social mobility across class, race and gender and does so through the production of idealised identities. It is made explicit that some of the children come from underprivileged backgrounds as they 'talk of broken families and the constant threat of abuse' (French, 2005, p. 10). Yet irrespective of class position, the film implies that the children are awarded the opportunity to dance and to be successful at it and this experience has the potential to refocus their attitudes and behaviour in a positive direction. Part of the utopian narrative is tied to racial and national identities whereby notions of difference are unchallenged. Indeed a multicultural rhetoric is employed to create a sense of unproblematic globality. For instance, there is much emphasis in the film about the 'national origins' of the various dances: in the competition, Dulaine repeatedly describes the Tango as Argentinian, one of the children correctly guesses that Swing is from the United States and another knows that the Merengue is from the Dominican Republic. The concept of a global 'melting pot' is further developed as children from diverse racial backgrounds, including African Americans, Asian Americans, Italian Americans and Latin Americans, learn these 'national dances'. Thus the suggestion is that the dance cuts across national and racial boundaries.

Within the film, there is also considerable emphasis on gender and related concepts of sexuality. There are plentiful excerpts of the children musing on the differences between 'boys' and 'girls' and there is a clear sense of separatism. Yet as the film progresses, these boundaries are slowly effaced as a somewhat romantic view of male–female relations is cultivated. In one of the early lessons the PS150 children are encouraged to check the colour of their partner's eyes. Although this may well be a strategy to encourage the eye-to-eye contact that typifies the ballroom style, the ABrT instructor plays on notions of romance by describing their eyes as 'beautiful'. Later, Allison Sheniak, the PS150 class teacher, tearfully recognises a gendered transformation: 'I see them turning into ladies and gentleman.' *Mad Hot Ballroom* clearly exploits notions of transformation through the possibilities that the dancing body offers: class mobility (from street kid to studious individual), dismantling of national and racial boundaries (through sharing dances from diverse national origins across different racial groups) and

the construction of harmonious gender relations (through the experience of male–female couple dancing). Yet many of these ideas are problematic as they fail to take into account the social and political complexities that underpin the dance practice.

Throughout the film, the children are repeatedly referred to, and encouraged to act like, 'ladies and gentleman'. Cadwalladr (2005, p. 5) states, 'there's something quaint and old-fashioned and ever so slightly sexist about the terminology'. However, it is more insidious than that. This constant reinforcement of male and female etiquette complies with a normative heterosexual model without any opportunities to acknowledge difference within gender and sexuality. A constant theme that runs through the film is the 'civilising influence of dancing' (French, 2005, p. 10) through which the children slowly shift from potentially deviant behaviour patterns to model frameworks of respectability. The idea that the children are in a fragile social position and in need of guidance is evident as Sidney Grant, one of the ABrT instructors, suggests that in the absence of 'role models' such as Fred Astaire or Gene Kelly, the male dance instructors offer a form of positive reinforcement. In response, French (2005, p. 10) contends, 'surprisingly, no-one refers to Bill "Bojangles" Robinson, Sammy Davis Jr, Gregory Hines or the Nicholas Brothers, or to the fact that 40 years ago black and whites didn't dance together on the screen or in large parts of America.' French's (2005) concern perhaps speaks to the uneasy relationship between the ballroom institution that delivers programmes, whose lineage is located in the social codes of white European bourgeois culture (Stern, 2000), and the children from underprivileged African American (and other ethnic) backgrounds who participate. Yet this irony remains unseen by director Agrelo (2005), who comments,

> this is a community of immigrants. If you go into this neighbourhood in New York, you hardly hear the English language spoken. It's a little enclave of people who are struggling economically. There's challenges there, but the one thing these kids have, which is part of their culture and it's part of their genetic make-up almost, is this incredible ability to dance.

A closer analysis of these different arguments offers a complex challenge to the idealised identity positions that the film appears to promote. First, I would propose that the Agrelo quotation exposes an essentialist understanding of race. The idea that the 'immigrant communities' have

an innate ability to dance is a romantic mythology. Indeed, *Mad Hot Ballroom* provides plentiful evidence to demonstrate that the children struggle to acquire these dances and it is only after weeks of intense coaching that they learn to embody these alien movement forms. The second issue is that although several of the dances may have evolved from the cultural communities to which some of the children belong, they bear little resemblance to those origins. An historical overview of the dances that constitute the ballroom genre reveals a complicated process of appropriation, transmission and modification. The selection of dances that form the Latin American strand of ballroom dance are ones that have been primarily appropriated from African-Caribbean and Latin American social dances (Penny, 1999; McMains, 2001–2). Significantly, these dances have largely developed through migration patterns to the United States in that they travel with the communities from which they originated (Stern, 2000). Yet the dances have all undergone an element of change in that they are simplified and codified (Penny, 1999; Stern, 2000). McMains (2001–2) describes how the ballroom versions are revised by English, European and American dancers so that they resemble an aristocratic model of social dance: vertical upright torso, high centre of gravity, appearance of minimum labour and extended limbs.[2] Thus I assert that there is a paradox in this 'double appropriation'. Not only have these dances been taken and modified from the very communities from which they originated, but the children participating in the competition must 're-embody' them according to the codes and conventions of a white Euro-American aesthetic.

McMains (2001–2, p. 55) argues that competition ballroom represents a 'utopian community' in which differences of class, race and nationality coexist, but in reality this ideology conveniently erases the Eurocentrism and colonialist narrative that underpins the field. The third concern that emerges from this critique is the evolutionist perspective tied to the civilising rhetoric that is awarded to the children's dancing experience. Yomaira Reynoso, the PS115 teacher, describes how, as Wilson began to learn the dances, he also began to learn the language. The implication is that not only can the dancing have a wider pedagogic benefit around the discipline and focus required in learning, but it also suggests a civilising process in that the child is becoming acquainted with moving and speaking in an Anglo-American way. This again speaks to an imperialist model in that notions of 'civilisation' are positioned in a white Anglo-American ideal.

Competition, capitalism and the potential for social transformation

The Anglo-American ideal promoted in *Mad Hot Ballroom* is also rooted in the notion of competition which underpins its fantasy narrative, while the emphasis on winning produces a sense of capitalist aspiration. Although there is constantly a feeling of 'support for all' and 'everyone is a winner' in that all the participants achieve some level of personal fulfilment by gaining ballroom dancing skills, this is perpetually undercut by the narrative which leads towards winning as the pinnacle of the film and the project. Rockwell describes how a flood of 'ballroom images' in the media is connected through the way that they 'emphasize competition based on the flashest moves and glitziest costumes' (2005, p. E5). French observes, 'we see a lot of their teachers, all of them dedicated, competitive and participatory (2005, p. 10). Indeed, Yomaira Reynoso, the PS115 teacher, states that she wants to win the Challenge Trophy and, as the children return to rehearsals after the quarter-final round, she enunciates, 'I'm tired, but I'm gonna win this competition' to galvanise the children as they practise.

This motivation to succeed is also apparent in the children. As Scott observes, 'these kids show tremendous pluck and discipline, as well as a sometimes overwhelming desire to win. Not all of them can, of course, which is one of the hard lessons competition teaches' (2005, p. E20). In one scene prior to the quarter-finals, Dulaine and the ABrT instructors discuss how to deal with the children who don't go forward. The PS112 ABrT instructor emphasises that one strategy is to praise the children and to make a big deal back at their school. Yet in an almost comically abrupt response that completely shatters the inclusive ethos of the programme, Dulaine states, 'You can say whatever you like, you either win or lose. If you haven't got number one, you have not won ... you've lost.' This immediately prioritises the concept of competition. This emphasis on winning as the only possible goal is then played out at the quarter-finals when the PS150 children and teacher weep on losing. Cyrus, one of the children from PS150, queries the result with Dulaine and sadly reflects, 'I still really don't understand what happened'; and in the debriefing session another states, 'If we did so good, why didn't we go to the semi-finals or finals?' Clearly for these young people, losing is a difficult situation to accept.

Although the programme is presented as a social inclusion project, in actuality it instils a capitalist aspiration to achieve through winning. The links between individual self-expression and democratic ideals and

the conformity of codified partner dancing and a more conservative ethos become further apparent when considering the emphasis on competition in *Mad Hot Ballroom*. Stern (2000) argues that ballroom versions of social dance are dependent on sameness of interpretation rather than individualised performances. This sense of 'sameness' is strikingly obvious as the children, of PS115 in particular, move through the various stages of the competition. Early in the film the children are presented as a mix of personalities, looks and dancing styles and abilities. Yet as they slowly come to embody these formal and codified dances, notions of difference are gradually ironed out. At the quarter-finals the children wear outfits of their choice, but in preparation for the semi-finals, the PS115 children go on a shopping trip with their class teacher to purchase team costumes. All of the girls begin to style their hair in a similar way, scraped back from the face and tied up in a small bun or French twist. Thus by the finals, dressed identically, the children are no longer presented as individuals but dance like cloned performers according to the aesthetic codes of competition ballroom. Consequently, the individual is lost for the good of the 'mass body' and all are united by a common purpose: the desire to win. The film clearly privileges winning since the children who do not make it beyond the quarter-finals are quietly erased.

The transformation that takes place in *Mad Hot Ballroom* is tied to notions of conforming and disciplining the body to the ballroom style. This commitment to a goal of personal achievement and the glory of winning links it nicely to a model of capitalist aspiration. Although the ballroom programme calls attention to an inclusive spirit and relies on team participation, it nevertheless demands a desire in the individual to want to succeed against personal odds and to strive to beat others, and in doing so constructs a duality of success and failure. The very idea of the 'survival of the fittest' and the 'will to compete' clearly reflects the individual competition that characterises the philosophy of a free market economy and the 'American dream'. Indeed, it is fitting that the final part of the competition takes place in the glamorous surroundings of the World Financial Center. As a signifier of wealth and class, it is somewhat ironic that the competition should culminate in a site so far removed from the harsh socio-economic realities of the children's everyday lives.

Given that the narrative thrust of the film is so geared to winning the competition and the discourses that underpin this journey speak to notions of transformation, I question the extent to which the film offers real opportunities for social mobility. A number of film writers have

been extremely critical of the way that *Mad Hot Ballroom* neglects to tackle the realities of transformation and whether this can ever move beyond the dancing body itself. Andrews comments,

> A little more sociological backbone would have helped. The statistics of life before and after the ballroom dance teaching programme was introduced…fly by almost too quickly to catch. And as a reality check we might like to know the average set of life-choices for a Puerto Rican not kissed by Terpsichore.
>
> (Andrews, 2005, p. 16)

In a similar vein, James argues,

> While the film coaxes the audience to cheer for 11-year-olds doing the rumba (and who is churlish enough to resist that?), it glosses over the sociology behind its uplifting story. The Washington Heights school at the center of the film is attended largely by children of immigrants from the Dominican Republic, many from poor or troubled homes. All this is mentioned and breezed past, which leaves viewers with a nagging question: just what are we, and these children, being uplifted from?
>
> (2005, p. E1)

Although I propose that the embodied experience of learning any dance form can introduce participants to important transferable skills (teamwork, focus, discipline, communication, tenacity and commitment), I concur that the film fails to demonstrate how this feeds into changes that might produce some degree of socio-economic transformation. Significantly, throughout the film, a number of the children state that they wish to become professional dancers; yet there is no indication as to what opportunities may be realistically on offer within this clearly competitive field. In one of the few pessimistic moments in the film, PS115 teacher Yomaira Reynoso reflects, 'You bring arts, you bring out all these programmes and a few years down the line you see these kids out on the street.' The suggestion is that the dancing experience fails to offer opportunities for at least some of the children.

This chapter does not set out to criticise the project given that there are some fundamental pedagogic and social values embedded in it. Rather, it is an attempt to demonstrate how different modes of analysis reveal diverse and competing readings of *Mad Hot Ballroom*. Whereas a textual analysis produces a fantasy narrative of social transformation,

the introduction of a political economy critique of film documentary and a socio-historical overview of ballroom dance clearly questions this utopian tale. Although the film admirably captures the pleasure that participants can gain from couple dancing and the additional social skills that can be acquired during the learning experience, it neglects to tackle the difficult issues of the ethics around cultural appropriation, the civilising rhetoric that conforms to an Anglo-American ideal, how the emphasis on winning is modelled on a capitalist logic that sits uncomfortably with the socially inclusive ethos of the project, and whether the dance can offer real opportunities for socio-economic transformation. To return to the opening quotation which states that *Mad Hot Ballroom* is 'about almost everything but ballroom dancing' (Agrelo, 2005), I contend this assertion. To suggest this denies that the dance has any kind of agency. Instead I argue that it is through the dancing body that issues regarding appropriation, identity politics, concepts of civility and etiquette, notions of competition, and physical and personal transformation are played out. Throughout the film there is substantial footage of the dance itself and it is in those scenes that these social ideas, values and meanings come to the fore. Consequently, the dance is central to *Mad Hot Ballroom* and it is the children's embodiment of this form that gives rise to a complex and at times contradictory network of social, political, historical and economic issues. Without the dance, there would be no 'mad, hot ballroom'.

Notes

1. Indeed, the degree to which *Mad Hot Ballroom* lends itself to a fantasy narrative is evident from *Take the Lead* (2006), which is a fictionalised reworking of *Mad Hot Ballroom* with Hollywood heartthrob Antonio Banderas as the Latin American dance instructor and the children now a sassy group of older teenagers.
2. Although McMains refers specifically to Dancesport competition, many of the issues that she raises are pertinent to competition ballroom.

References

Agger, B. 1992 *Cultural Studies as Cultural Theory.* London: Falmer Press
Agrelo, M. 2005 *The Cinema Show.* BBC4, 19 November
Andrews, N. 2005 How to Defeat the Devil with Post-Feminism. *Financial Times,* 24 November, p. 16
Barker, C. 2000 *Cultural Studies: Theory and Practice.* London: Sage
Bradshaw, P. 2005 Film and Music. *Guardian,* 25 November, p. 8
Cadwalladr, C. 2005 Dance: How to Foxtrot. *The Observer,* 20 November, p. 5

Carjaval, D. 2005 Compared with Their Film-makers, the Penguins Have it Easy. *New York Times* 28 September, p. E1

Ferguson, M. and Golding, P. (eds) 1997 *Cultural Studies in Question*. London: Sage

French, P. 2005 And the Rest. *The Observer* 27 November, p. 10 http://www.imdb.com/title/tt0438205/. Accessed 26 October 2006

James, C. 2005 Nonfiction is Flavor of Moment for Films. *New York Times* 25 May, p. E1

Johnson, R. 1996 What is Cultural Studies Anyway? In J. Storey (ed.), *What is Cultural Studies?* London: Arnold, pp. 75–114

Maconie, S. 2005 *The Cinema Show*. BBC4, 19 November

McMains, J. 2001–2 Brownface: Representations of Latin-ness in Dancesport. *Dance Research Journal* 33, 2, pp. 54–74

McRobbie, A. 1990 Fame, Flashdance and Fantasies of Achievement. In J. Gaines and C. Herzog. (eds), *Fabrications: Costume and the Female Body*. London: Routledge, pp. 39–58

—— 1997 Dance Narratives and Fantasies in Desmond, J. (ed) *Meaning in Motion* Durham and London: Duke University Press pp. 207–231

Nichols, B. 2001 *Introduction to Documentary*. Bloomington: Indiana University Press

Penny, P. 1999 Dance at the Interface of the Social and the Theatrical: Focus on the Participatory Patterns of Contemporary Competition Ballroom Dancers in Britain. *Dance Research* XVII, 1, Summer, pp. 47–74

Rabinowitz, P. 1994 *They Must Be Represented: The Politics of Documentary* London: Verso

Renov, M. 1993 Introduction: The Truth about Non-Fiction. In M. Renov (ed.), *Theorizing Documentary*. London: Routledge

Rockwell, J. 2005. Little Cheek to Cheek, But Lots of Vegas Flash. *The New York Times* 15 June, p. E5

Scott, A. O. 2005 Where the Rumba is as Much a Part of School as Recess. *The New York Times* 13 May, p. E20.

Stern, C. 2000 The Implications of Ballroom Dancing for Studies of 'Whiteness'. In *Dancing in the Millennium*. Conference Proceedings, Washington, 19–23 July, pp. 394–9

Trin T. Minh-ha, 1993 The Totalizing Quest of Meaning. In M. Renov (ed.), *Theorizing Documentary*. London: Routledge

Waxman, S. 2005 The Week Ahead. *New York Times* 15 May, p. AR3

11
Mapping the Multifarious: the Genrification of Dance Music Club Cultures

Joanna Louise Hall

> Dance cultures are fluid, multifarious formations, which will always exceed any attempt to map them.
>
> (Gilbert and Pearson, 1999, p. vii)

Whilst the term 'dance music' can refer to any musical form that is used to dance to, in late twentieth-century western musical discourse it has taken on a specific significance. The term denotes a number of synthesised musical styles that can be grouped together by shared characteristics, including a preference for cyclical repetition rather than linear narrative, a concentration on timbre and bass line rather than melody and harmony, and the use of vocals (if any) as part of the rhythmic syntax of the piece. However, dance music sub-styles conform to these characteristics to a greater or lesser degree: some include more vocals or heavier bass sounds; some are polyrhythmic or include more instrumentation, minimalism, repetition or cyclicity. Although, as Hesmondhalgh (2001) also notes, most forms of popular music have some sort of relation to dancing, a consistent factor that links sub-genres of dance music is that they are devised, produced and consumed with the dance floor in mind. Thus, in order to gain a greater understanding of the genre of 'dance music' a reader is encouraged to look further than the stylistic characteristics of the genre to the dance cultures that produce and consume them.

Despite an active focus by cultural analysts on club and rave events where dancing is the central focus and where 'dance music' is played, the dancing body is noticeably absent from discussion (Rietveld, 1998; Redhead, 1993; Thornton, 1995; Bennett, 1999; Malbon, 1999; Pini, 2001). Previous club cultural scholars have also failed to differentiate among sub-genres of dance music due to a perceived difficulty in

mapping the rapid proliferation and mixing of styles of 'dance music' that occurred during the 1990s (Thornton, 1995; Malbon, 1999; Pini, 2001). Although fieldwork studies in the British club culture context have revealed little demographic variety in the audiences they have observed, significant differences exist in their accounts that indicate a diversity of social groupings. These findings reveal a tension between club cultural accounts and contemporary writings in the field of post-subcultural studies that describe fluid boundaries between club cultures where clubbers have multiple memberships of different dance club groupings (Bennett, 1999). Whilst musicologists, such as Middleton and Beebe (2002), also identify an increasing eclecticism in the listening practices of contemporary youth, Huq notes that 'exclusivity and separatism persist in dance culture which is highly segmented with its own multiple elites' (2006, p. 106). In this chapter I explore the affiliations and distinctions that exist among club-goers by investigating diachronic and synchronic relationships between dance music sub-styles on and around the club dance floor.

As part of this investigation I draw on genre theory, which examines the relationship among texts, such as examples of literature, film or music, and among classes or groups of such texts, in order to understand how genres are used in everyday life to support knowledge and understanding of culture. Poststructuralist writers have reinvigorated traditional genre theory by reconceptualising genre as an ongoing process rather than an attempt to set static and bounded categories. Whilst theorists such as Frow (2006), Altman (1999) and Kallberg (1996) have used such approaches to genre to examine the relationships among literary, filmic and classical musical texts, it has not previously been employed to explore the relationships among dance music sub-styles, and their attendant dancing communities. A new approach to the trope of subculture arises from this exploration to encourage future study of the specific and diverse dance cultures that are part of the 'dance music' generic matrix.

In mapping elements of the historical development of dance music it is not my intention to provide a comprehensive or 'accurate' account, as I recognise that all versions of history are constructs rather than 'truths'. Sources used to construct this history include some academic texts, although it is popular texts, which are often personal accounts of the development of dance culture,[1] discussions from internet forums and 'word of mouth' gathered in and around the club 'field', that inform much of its content. Where differences have existed among sources, material that has been confirmed by several informants has assumed

greater authority. Tracing the historical development of dance music within the confines of this chapter will inevitably lead to the exclusion of many key producers, tracks and club communities, as well as many of the micro-genres that exist in contemporary dance music club cultures. In this account I cannot claim to reflect fully the diverse nature of the dance music community or its history, but I do reveal the links between genres of dance music and explore their relationships within dance club culture by investigating the communities that are an integral part of them.[2]

While the open-endedness of genre prevents the identification of a specific starting point for a discussion of dance music, it might be argued that the development of three musical styles in the United States during the 1970s and 1980s, House, Techno and Breaks, constituted a significant development in popular music which signalled the beginning of a new period of cultural practices that became known as dance music club culture.[3] Whilst I have incorporated these divisions to demonstrate the diversity and specificity of stylistic characteristics and associated ideologies, it is important to note the cross-fertilisation and mutual modification between genres of dance music and contemporary dance club cultures.

House music

Following the demise in the popularity of Disco in the late 1970s, two African American DJs from New York, Frankie Knuckles and Larry Levan, began to experiment with creating new sounds from a montage of existing records (Brewster and Broughton, 1999). The House music aesthetic developed on the night club dance floor from a re-editing of Disco tracks played on a reel-to-reel tape and cassette player over a rhythm track created by a Roland TR808 drum machine (Reynolds, 1998).[4] The explicit citation of other musical texts and genres, remixed to create new sounds, has become a defining characteristic of House and other forms of dance music (Rietveld, 1998; Gilbert and Pearson, 1999; Bennett, 2001).

The first House track to be made in vinyl format was Jesse Saunders and Vince Lawrence's *On and On* (Jes Say Records, 1983), which was produced using a Roland TR808 drum machine, a Korg Poly 61 keyboard, a TB 303 Bass Line synthesiser and a four-track cassette recorder (Garratt, 1998; Reynolds, 1998). The use of the Roland TR808 and TR809 drum machines has become a key characteristic of House and other genres of dance music. Japanese and European Synth-pop artists, such

as the Yellow Magic Orchestra and the Human League, were popular in the US at this time and key producers, such as Frankie Knuckles, have acknowledged their influence: 'a lot of people I have worked with were influenced by... [Depeche Mode]. I know that Jesse Saunders was a big fan' (Knuckles, in McCready, 1989, p. 98). The fusion of Japanese and European Electronica sounds and technology with African American Funk and Soul influenced Disco tracks is described as 'an intercontinental collision at the heart of Chicago house' (McCready, 1989, p. 100) and reveals the quintessentially intertextual or inter-generic nature of House music.

The labelling of new genres of dance music is an informal and often localised process. Genre names are sometimes taken from the location where the style became popular (e.g. Chicago House or Detroit Techno) or are descriptive terms (e.g. 'boompty', 'hard' or 'funky' House). These labels are established or become recognised through common usage by producers, DJs, record shop owners and reviewers of recorded tracks or club nights. This is similar to Altman's (1999) account of genrification in the film industry, where he describes how adjectives often become used as nouns.[5] The label for the dance music sub-genre, 'House', is taken from the name of the Chicago nightclub where Knuckles became DJ in 1977, the Warehouse. In the late 1970s the term 'house' became used between club-goers to describe an attitude that reflected a wealth of subcultural capital.[6] You would be 'house' if you visited the right clubs and bars, wore the right clothes and played the right music, for example, that played by Knuckles at the Warehouse (Brewster and Broughton, 1999). However, the record producer Chip E, who worked in the Chicago record store Imports Etc, claims that the term 'house' grew from his labelling of tracks played by Knuckles as 'Warehouse Music', which gradually became shortened to 'House' (Brewster and Broughton, 1999). The New York club, the Paradise Garage, where Levan became DJ in 1977, also provided the name for the more gospel-influenced sub-genre of House: Garage (Brewster and Broughton, 1999).[7]

Bhatia describes genres as 'highly structured and conventionalised with constraints on allowable contributions' (1993, p. 13). Similarly, Derrida (1980) states that the logic of genre establishes rules and boundaries that *limit* a text: a law of purity and one that opposes miscegenation. However, there is also a 'principle of contamination' at the heart of the workings of genre as the creation of any new text will be determined by a repetition and modification of previous textual structures (Derrida, 1980). This ongoing process of change and development produces an unstable relationship between text and genre, a relationship

described by Schryer as only ever 'stabilised-for-now or stabilised enough' (cited in Frow, 2006, p. 28). Thus, while genres are historically specific, identifiable categories, they are open-ended, fluid and constantly shifting and redefined by the creation of new texts and their relationship to others. The film scholar Altman also discusses the indeterminate nature of a genre's morphology, stating that genres are inter-fertile and 'may, at any time, be crossed with any genre that ever existed' (1999, p. 70). Whilst theoretically this level of free exchange would seem possible, in dance music cultures there are clear networks and associations present in the development, and consumption, of sub-genres that indicate that limitations, dictated by musical, or wider (sub) cultural factors, are at play.[8]

In the late 1970s club goers and DJs at the Warehouse and the Paradise Garage were predominantly African American and Hispanic gay men and the atmosphere described as one of hedonistic celebration (Reynolds, 1998). The development of the Gay Liberation Movement in the US, following the Stonewall Riots of 1969, had enabled a growth in confidence of the gay community, leading to the establishment of several small, predominantly African American and Hispanic clubs that were instrumental in the development of Disco and subsequently House music (Brewster and Broughton, 1999). By the early 1980s clubbing crowds at the Warehouse and Paradise Garage were becoming increasingly mixed, and House's historical association with the gay clubbing community continued in clubs that played a new, faster, heavily Disco-influenced sub-genre of House: Hi-NRG. In contrast, this style became popular with predominantly Caucasian gay communities, such as those found at the New York club The Saint and London's Heaven (Brewster and Broughton, 1999).[9] Thus, while stylistic characteristics distinguish this new sub-genre of House music from previous forms, the dance cultures that surround the music are an important part of the generic structure.

Traditional genre theory conceptualises the relationship between text and genre to be one of type/token, where a particular instance of a text would be located 'in' one genre, the text being solely describable in the rules of that genre (Friedman, cited in Frow, 2006). However, Friedman states that it is more useful to think of genre as sets of 'intertextual' relations where texts are in dialogue with each other and are defined by their similarities and differences. Kallberg (1996) describes how composers use characteristics from different genres within a single musical text and notes that this can be with passing or more substantial reference.[10] Whilst some texts can be described in the terms of one genre, others will make reference to a multiplicity of genres: they may have

characteristics that appear to refer the reader to several different generic frameworks with varying levels of force. In addition, the intertextual relationship may be one of direct citation where there is either an explicit or implicit reference to specific texts (Adshead-Lansdale, 1999).

In *The Law of Genre* (1980) Derrida states that a text will never *belong* to a genre, but will *participate* in one or several. He describes the 'law of genre' as 'participation without belonging – a taking part in without being part of, without having membership in a set' (Derrida, 1980, p. 59). Derrida's conceptualisation of the relationship between text and genre uses similar terminology to that of post-subcultural scholars discussing participant involvement in contemporary social groupings, such as those that exist within club culture. Rather than 'belonging' to one subculture, contemporary club goers or music consumers are described as 'participating' in (one or) several genres (Bennett, 1999; Ueno, 2003).

It can be argued that in contemporary club culture the genre of 'House' is no longer an adequate descriptive term to differentiate among a number of different musical styles. Whilst it is possible to identify a House rhythm (a heavy, four-to-the-floor[11] kick drum) a number of other sub-genres have been developed that incorporate musical elements from other styles such as Funk (Funky House), Techno (Tech House), Jazz (Jazzy House) and Hip Hop (Hip House). These 'fusion' genres cite musical elements from the two named styles with varying generic force. However, references and citations from other genres may also be apparent to a greater or lesser degree. Similarly, other House sub-genres may incorporate intertextual and inter-generic references from several other styles without such obvious acknowledgement, alongside the direct citation of particular musical texts by sampled melodies, bass lines or vocals.

Techno

Techno developed alongside House in the early 1980s in Detroit, where three African American school friends, Juan Atkins, Derrick May and Kevin Saunderson, are credited as the 'founding fathers' of the genre (Reynolds, 1998). At this time many of Detroit's automobile factories had began to close and the city, it is sometimes said, was being transformed from the US capital of car production into the US capital of homicide (Reynolds, 1998). Far removed from the atmosphere of liberation and celebration of Chicago and New York House clubs Atkins states

that his early tracks, recorded as part of a production duo named Cybotron (with Rick Davies), were a social commentary on the degradation and depression all around them (Atkins, in Reynolds, 1998). Although these tracks were initially referred to as House music, the three friends were confident they had found their own sound: 'music that goes beyond the beat ... a hybrid of post-punk, funkadelia and electro-disco' (Cosgrove, 1988, p. 93), demonstrating that 'when discourse is linked to a particular genre, the process by which it is produced and received is mediated through its relationship to prior discourse' (Briggs and Bauman, in Frow, 2006, p. 48).

Atkins, May and Saunderson were regular listeners to DJ Charles Johnson, 'the Electrifiyin' Mojo's' Detroit radio show, which featured African American Electro-funk artists, such as Afrika Bambaata, Parliament and Funkadelic, as well as European experimental Electronica and Synth-pop bands, such as Kraftwerk (Brewster and Broughton, 1999). The consequent Detroit sound has been described by Derrick May as a fusion of these textual and generic influences: 'it's like George Clinton [from Funkadelic/Parliament] and Kraftwerk stuck in an elevator' (May, in Brewster and Broughton, 1999, p. 356). Atkin's subsequent record label, Metroplex, under which May and Saunderson released tracks during the late 1980s, dominated the first-wave Detroit Techno scene. Influenced by Kraftwerk's futuristic ideology, as well as novels such as Alvin Toffler's *The Third Wave* (1980), the three producers embraced technology and cyber-culture (Reynolds, 1998). Atkins, May and Saunderson saw themselves as 'warriors for the technological revolution' and, in the face of new rival electronic artists, were in battle, 'fighting to keep the standards high' (Atkins, in Reynolds, 1998, p. 11).

Genres are systems of use and often most visible as methods of classification such as in libraries and catalogues, in marketing and publicity, and in the formal and informal practices of reviewing, listing and recommending texts to others. Consumers, readers and creators of texts are constantly learning and refining their knowledge about genre systems through their active interaction with examples. This dialogic process can result in difficult and precarious judgements, a type of 'folk classification', which, on closer analysis, may appear arbitrary and lacking in coherence. However, as Frow (2006) states, such inconsistencies can be seen as largely irrelevant since genre systems continue to exist with norms and characteristics that are largely identifiable and sharable. The delineation of sub-genres of dance music, such as Techno, has been described as problematic as they are transient and evolutionary (Thornton, 1995; Gilbert and Pearson, 1999; Malbon, 1999; Huq, 2006),

failing to recognise that all genres and sub-genres are subject to a continuous process of change and development (Kallberg, 1996; Frow, 2006). Reviews of recorded tracks and club events within specialist dance music magazines (for example, *DJ*, *DJ International*, *MixMag* or *Knowledge*), alongside record and club promotional material, reveal a consistency of labelling and categorisation that demonstrates that an identifiable, shared genre system exists across national and international dance music and dance club communities.

> For a long time techno was more of an adjective than a noun. The word was first used as the name for a completely separate genre as late as Before that its creators were happy to be labelled 'house' and thrown in with the Chicago scene.
>
> (Brewster and Broughton, 1999, p. 355)

The term 'Techno' became attached to this new genre of dance music in 1988 when British Northern Soul DJ, Neil Rushton, convinced Virgin Record's 10 label to release a compilation album in the UK (Brewster and Broughton, 1999). The compilation's working title was originally *The House Sound of Detroit*, but it became apparent that the music from Detroit had developed into a new distinct style and was renamed *Techno! The New Dance Sound of Detroit* (1988). Techno was recognised as distinct from House, and the new form of African American dance music from New York, Hip Hop, in that it looked directly to European Synth-pop bands for much of its inspiration, incorporated futuristic ideologies and made a break from its past:

> Techno is probably the first form of contemporary black music which categorically breaks with the old heritage of soul music. Unlike Chicago House, which has a lingering obsession with Seventies Philly, and unlike New York Hip Hop with its deconstructive attack on James Brown's back catalogue, Detroit Techno refutes the past. It may have a special place for Parliament and Pete Shelley, but it prefers tomorrow's technology to yesterday's heroes.
>
> (Cosgrove, 1988, p. 94)

Detroit Techno had reached its peak during 1988–9, with DJs such Derrick May and Kevin Saunderson playing to large, mixed crowds at Detroit clubs such as The Shelter and the Music Institute (Reynolds, 1998). Although the style's popularity had began to wane by the early 1990s, affected by an increasing interest in alternative Hardcore Rave

styles from Europe, a second wave of Detroit Techno producers began creating new, tougher tracks.[12] Underground Resistance (UR), originally formed by Jeff Mills and Mike Banks, was influenced by industrial Euro Body Music and Belgian New Beat as well as the 1980s sounds of Electro-funk and European Synth-pop (Reynolds, 1998).[13] The result was a new, 'hardcore' sound of Detroit similar to the brutalism of Hardcore Rave music from Britain, Holland and Germany. Similar to Atkins, May and Saunderson's obsession with their battle with future technology, UR had an affiliation with the military. They presented themselves as a paramilitary unit of 'sonic guerrillas' engaged in a war with 'the programmers' (the mainstream entertainment industry) (Reynolds, 1998).

Fowler suggests that 'in reality genre is much less of a pigeonhole than a pigeon' (in Kallberg, 1996, p. 4), since genre is a communicative concept that guides a reader's interpretation of a text (Adshead, 1988; Bhatia, 1993; Kallberg, 1996). Genre provides more than an understanding of stylistic devices and recognisable characteristics, by assisting in creating meaning and value that Frow refers to as 'effects of reality and truth, authority and plausibility' (2006, p. 1). Kallberg (1996) also discusses the 'rhetoric of genre', describing its persuasive force in guiding a reader's experience of the text. However, the 'effects of meaning and value' are not stable and do not 'belong' to genres, but rather are the uses of them (Frow, 2006). This knowledge is both culturally and historically dependent, rather than essential: 'genre is pragmatic not natural, defined not found' (Rosmarin, in Frow, 2006, p. 102).

Altman emphasises the dynamic, interactive and fluid nature of genres by describing them not as a 'permanent product of a singular origin but a temporary by-product of an on-going process' (1999, p. 54). Genres are subject to constant redefinition and, as mentioned above, are shaped by the creation of new texts: 'to some degree every work written alters the genre to which it belongs' (Kallberg, 1996, p. 10), as well as the processes of *reading and interpretation*. It is generally agreed that new texts are never 'one of a kind' as they have a relationship with previous texts. Similarly, the reading and interpretation of a text is never a singular event, as it is always in the *context* of a reader's knowledge and experience of others (Frow, 2006). Therefore, even when a text disrupts expectations by performing outside an established norm, the reader's understanding of genres will be shaped by these changes.

In the early 1990s Belgium was the home to a new, raw style of Techno, where producers such as Lenny Dee, Mundo Musique and the British DJ producer Joey Beltram took Techno harder and faster (Reynolds, 1998). Beltram's *Energy Flash* (1990), released by the R & S record label, contains

dark whispers of 'acid, ecstasy' heard above a fast, electronic vacuum of noise described by Reynolds as a 'speedfreak's drug "flash", like being plugged into an electric mains' (1998, p. 108). Belgian production teams, such as Cubic 22, T99 and Incubus, developed their own distinctive brand of Techno where melodic pattern was replaced by industrial and synthesised noise. This style of dance music became popular in the European rave scene, including the UK, and is known as Hardcore Techno or European Hardcore. Detroit Techno retained a focus on experimental composition, with artists such as Richie Hawtin returning to making more soulful and complex tracks from 1992. In contrast to the new Hardcore styles, Techno's stylistic and ideological links with avant-garde Electronica has encouraged writers to describe the genre as 'degree level dance music' (Brewster and Broughton, 1999, p. 346).[14]

Hardcore genres of dance music, such as Gabba from Rotterdam, flourished in Europe from the early 1990s and were connected stylistically by a preference for intensely fast and repetitive rhythms, but also through the surrounding subculture and the identities of its consumers. Reynolds describes how UK Hardcore rave events attracted predominantly working-class male youths with a 'nutter mentality' (1998, p. 114). He also describes the atmosphere on the dance floor as 'somewhere between a National Front rally and a soccer match' (Reynolds, 1998, p. 112), evoking the image of a white, male, aggressive crowd. A typical Gabba club-goer is described as 'small, shaven head with bright pink ears sticking out from the skull...pale, gaunt, speedfreak torso' (Reynolds, 1998, p. 259), and the term 'Gabba' refers to a hooligan or 'a guy that is low-class, maybe jobless' (Darkraver, in Reynolds, 1998, p. 257). While it is impossible to say whether these participants were from working-class backgrounds, these comments do highlight the existence of a particular identity construct that has become associated with this genre of dance music culture.

Breaks

In the US in the early 1970s, Clive Campbell, a Jamaican American living in the Bronx, developed innovative DJ-ing techniques that would later lead to the establishment of Hip Hop and Rap sub-genres of dance music. At this time groups of young, African American male dancers at parties or in night clubs would wait for the 'break' section of Funk or Disco record, when the melody or vocals would cease and the percussion would take over, before they would dance (Brewster and Broughton, 1999). Campbell, who had started to DJ at small local parties as 'Kool

Herc', developed a technique that would allow participants to continue to dance by cutting straight from one break in a record to another, using two turntables (Brewster and Broughton, 1999).

Joseph Saddler, or 'Grandmaster Flash', was also from the Bronx and was inspired by DJ Kool Herc's new techniques, but also wanted to use techniques from Disco DJs to match the timing of records so that they would mix together with greater precision. The combination of a faster cut from different 'break' sections of tracks and seamless mixing combined to create the Hip Hop style. With this new technique Grandmaster Flash was able to sample manually, and loop different sections of records, to create a distinctive new sound; a technique that prefigured digital sampling technology used in contemporary dance music composition (Brewster and Broughton, 1999). Grandmaster Flash was also the first DJ to introduce the 'Beatbox' to the compositional mix, using rhythms created by a Vox drum machine in addition to the 'breaks' from records (Brewster and Broughton, 1999).

Contemporary forms of Hip Hop and Rap have changed considerably from the intertextual cut and mix of long breaks from Funk and Disco records to new methods of digitalised musical composition. However, DJ Kool Herc was the instigator of a new musical form that became solely focused on syncopated and percussive bass and drum sounds. The contemporary category of 'Breaks' now includes the sub-genres Breakbeat, Jungle, Drum 'n' Bass, Hip Hop, Garage and Grime. Breakbeat (also referred to as Nu Skool Breaks) contains influences from Electro (Electro-funk bands such as Afrika Bambaataa), Drum 'n' Bass, Hip Hop and Techno. Maintaining the fast poly-rhythms that came from the break sections of old Funk and Soul records, Breakbeat merges syncopation with futuristic synthesised sounds from Techno. Jungle (which later became known as Drum 'n' Bass) developed in the UK from the Hardcore Breakbeat sounds of the early 1990s when artists such as Shut Up and Dance began to introduce syncopated rhythms from Hip Hop into Hardcore.

Applying Frow's ideas to dance music, it is possible to see how genres such as Breaks, Techno and House form systems of historically shifting hierarchical order within specific, limited domains (2006). Frow states that this is especially true for fields that are governed by institutional discourse, such as literary genres, and less so for more informal domains, such as everyday conversation. This is interesting given the everyday nature of music dance club culture and my analysis is a challenge to this assumption. While academic study has moved beyond British subcultural debates regarding 'authentic' subcultures (those seen as fitting

within politically resistant, class-based homologies) or 'non-authentic' subcultures (those that do not), hierarchical divisions within dance club cultures continue to exist (Thornton, 1995; Gilbert and Pearson, 1999; Huq, 2006). Previous club cultural scholars such as Thornton (1995) and Malbon (1999) have explored these issues but do not distinguish among particular genres of dance music.[15] Although dance music cultures are not governed by a formally recognised institution, they are subject to a form of institutional discourse generated by various groups, such as record producers and reviewers, record shop owners, club promoters and consumers. This controlling discourse not only affects the hierarchical order of sub-genres of dance music that shift diachronically, but exists in many different pools of discourse, each having its own shifting value system. Rather than having an objective existence, these communities are the processes by which dance music genres come and go.

The genre of Breaks and the sub-genres contained within this category differ from those grouped under House, Acid House, Techno and Hardcore as they have retained an association with Black producers and club audiences. Huq comments that 'Jungle and Garage...are "black", whilst some techno styles are more "white" in terms of principal artists and audience base' (2006, p. 105). Belle-Fortune (2004) recalls how MTV executive producer Stephen Wright assumed that Jungle was 'a black, male thing' (2004, p. 5) when planning to make a documentary about the musical genre in 1998. Gilbert and Pearson describe Jungle as a largely Black, working-class phenomenon which came 'out of the urban penumbra of London' (1999, p. 79); and Reynolds (1998) describes how Jungle was first heralded as Britain's first truly indigenous Black music.[16] However, like House, Techno and Breaks, the genres of Jungle, Garage and Breakbeat all take influence from previous musical styles (from America and Europe) and are thus quintessentially intertextual and hybrid forms.

Discourse regarding the controversial notion of racial ownership of musical forms and detailed discussion of the racial identities constructed and reiterated within club culture exceeds the limitations of this chapter. However, it is possible to affirm that sub-genres grouped under the category of Breaks, particularly those forms that originated in the US (Hip Hop and Rap) are generally regarded in western society as 'Black music'. Rose defines Rap as 'a black cultural expression that prioritises black voices from the margins of America' (1994, p. 2) and Johnstone (in Huq, 2006, p. 111) describes the genre as 'black punk'. In contrast, Huq's (2006) study of French Rap describes how non-Black ethnic groups

(white and Asian) are producing Hip Hop and Rap tracks as their own form of cultural expression. Rap has also influenced the development of new Asian dance music through a fusion of Bhangra and Hip Hop in the early 2000s (Huq, 2006). What is evident is that the 'racial branding' of musical genres, which may lead to differentiation among social groupings within club culture, is not solely dependent on the stylistic features of the music, but includes the wider rhetorical features of the generic frame: subcultural (or club-cultural) practices and their associated social and political identities.

Expressive capacities

All genres possess historically specific and variable expressive capacities that act as frameworks for constructing meaning and value. Why a reader chooses to engage with particular texts rather than others is guided by knowledge of the specific possibilities of meaning and value that they will offer. These 'truth effects' are generated by the discursive qualities of the generic structure (Frow, 2006), while the rhetorical function of genre can be seen as more than the internal and external cues produced by texts to include the surrounding subcultural communities that give them life through their usage: '[genres] can easily be seen as tiny *subcultures* with their own habits, habitats, and structures of ideas as well as their own forms' (Colie, cited in Frow, 2006, p. 93; my emphasis).

I argue that genre can be understood as extending *further* than the immediate expressive capacities of a group of texts since the subcultural communities that make use of them are integral to their schematic world and are part of their structure. The shifting value systems between related genres and the truth effects that are generated by them are reflective and *formative* of the social and political identities of the users; a relationship that is contingent but never arbitrary. Although there is the potential for new genres to develop through mixing with 'any other genre that ever existed' (Altman, 1999, p. 70) family groupings and patterns exist between genres. Whilst music scholars have identified a tendency for contemporary consumers to listen to a more eclectic range of music (see Middleton and Beebe, 2002), and post-subcultural scholars describe participation in social groupings as fluid and transient where 'there is therefore no absolute or universal belonging' (Ueno, 2003, p. 108), these accounts fail to acknowledge how participation in dance music cultures is led by identity-based affiliations and distinctions, which are an integral part of their generic structure. The sociologist

Rupa Huq states that the crossover among social groups within dance club cultures is limited as 'different music appeals to different groups' (2006, p. 105). By exploring the historical development of dance music sub-genres, the subcultural identities of producers, DJs, listeners and dancers, it is possible to gain a deeper understanding of the relationships that exist in the different areas of dance music culture. Through conceptualising genre *as* subculture it is possible to account for the affiliations and distinctions that exist among these social groupings.

Conclusions

Dance music sub-genres are inherently intertextual and inter-generic as texts sample, recycle and mix with previous records and musical styles. However, this process is never contingent as there are connections and limitations by virtue of the identities, and subcultural contexts and practices of producers, DJs and club-goers. These (generic) structures provide networks of association and differentiation within club culture, establishing social groupings that have 'crossover' potential. This concept not only accommodates recent post-subculturalist writings that discuss fluid boundaries between areas of dance culture (Ueno, 2003; Bennett, 1999), but also accounts for the inconsistencies that exist in descriptions of the demographics of club cultural communities: 'they all have validity if they are taken to apply to sectional audiences' (Huq, 2006, p. 105).

In this chapter I do not claim to have reconstructed an accurate and comprehensive history of dance music, but I have illustrated some of the differences in musical genres through reference to context, stylistic characteristics, associated club cultural practices and the social and political identities of the producers and consumers. The rapid proliferation of sub-genres of dance music in the early 1990s has complicated the generic matrix but does not prevent a tracing of its major developments. Huq's statement that 'contemporary youth cultures are cumulative rather than successive, constructed of a panoply of influences' (2006, p. 108) is here applied to (the dance music) genre, and the hybrid identities that are part of its history and framework.[17]

All classifying systems are subject to a degree of 'folk' logic and the boundaries between genres are often fuzzy and not clearly defined (Frow, 2006). However, I oppose Huq's statement that in the context of dance music cultures 'one man's garage may be another man's handbag' (2006, p. 95). I have, instead, clearly illustrated the diversity and specificity of genres grouped together under the category of dance music.

Dance music club cultures are multifarious and increasingly complex, but through investigation of the similarities and differences among genres it is possible to understand more about their distinctive features and the communities that use (and dance to) them:

> In one important sense…these shortcomings and inconsistencies are irrelevant. Genre classifications are real. They have an organising force in everyday life.
>
> (Frow, 2006, p. 13)

Notes

1. See Collins, (1997); Garratt, (1998); Reynolds, (1998); Brewster and Broughton, (1999).
2. For example, it has not been possible to include an analysis of UK Acid House and the consequent rave scene that developed in the late 1980s and early 1990s. For further information on this period see Redhead (1993), Garratt (1998) and Reynolds (1998).
3. It might also be argued that a discussion of the historical development of 'dance music' should include early Disco, with key figures such as the DJ Francis Grasso and club promoter David Mancuso. For further information on this period, see Brewster and Broughton (1999).
4. Giorgio Moroder was the first to produce Disco tracks entirely synthesised by combining European Synth-pop with American Disco; his 1977 hit with Donna Summer, *I Feel Love*, had no set chorus or verse but improvised vocals over a rhythmic soundtrack (Reynolds, 1998). This heavily synthesised strain of Disco, named Euro-Disco or Italo-Disco, is regarded as the precursor to House music.
5. Altman (1999) uses the example of the film genre the Western, stating that before the term became recognised as a separate genre it was used as an adjective to categorise types of other genres, for example, the Western epic, Western romance or Western melodrama. This is also a clear example of how texts have shared memberships with other genres. An example from dance music cultures would be the fusion genre of Tech House: a combination of Techno and House music.
6. The term subcultural capital is taken from Thornton (1995) and refers to objectified or embodied forms of 'hipness': subcultural worth in the form of fashionable haircuts, records, slang or dance styles.
7. The term Garage was also used in the late 1960s to refer to guitar-based bands such as the Stooges, the precursors to Punk (Huq, 2006).
8. This can be seen by the manner in which different dance music genres are featured together (often in two separate dance spaces) during one club event. For example, a Drum 'n' Bass club may provide a Garage or DubStep space but would be unlikely to play Acid House or Trance music; Techno events may also have a Tech House room but would be unlikely to feature Handbag House. However, at a rave or festival event an individual would have access to several different arenas playing styles across the [dance] music spectrum.

9. UK Hard House also became popular at gay club events in the early 1990s, featured at club nights such as London's Trade with resident DJ Tony De Vit.
10. For example, Kallberg describes Mozart's use of minuets in the piano concertos K.271 and 482 (1996, p. 8) as inter-generic.
11. This term refers to a heavy four/four drum beat (Reynolds, 1998).
12. Hardcore Rave was a new genre of dance music that became popular in the early 1990s in the UK and Europe. It took influences from the late 1980s genre of Acid House, that spurned the development of British rave culture, as well as European forms of Techno that had become popular in the early 1990s.
13. Euro or Electronic Body Music (EBM) was a form of popular music in the early 1980s which fused German Electronica with Industrial music of bands such as Throbbing Gristle. Belgium New Beat developed from EBM in the late 1980s and is seen as the precursor to European forms of House music.
14. Some music journalists now claim that the 'intellectualisation' of Techno was a strategy invented by them during the late 1980s rather than the intention of the original artists (Brewster and Broughton, 1999).
15. In *Discographies: Dance Music and the Politics of Sound* (1999), Gilbert and Pearson do provide a highly informative and detailed discussion of the differences among selected sub-styles of dance music. However, this work often focuses upon consumption away from the club context.
16. My own fieldwork studies conducted in Drum 'n' Bass club culture in the UK in the early 2000s reveal a perception of the music as 'Black' because of Jungle's association with African British and Jamaican British youth in the early 1990s, when a large majority of the club-goers are of Caucasian ethnicity.
17. As DeFrantz (2002) notes, the term African American, which is crucial for an accurate understanding the development of dance cultures, should lead to a consideration of the implications of cultural hybridity and invention it suggests.

References

Adshead, J. (ed.) 1988 *Dance Analysis: Theory and Practice*. London: Dance Books
Adshead-Lansdale, J. (ed.) 1999 *Dancing Texts: Intertextuality and Interpretation*. London: Dance Books
Allen, G. 2000 *Intertextuality*. London: Routledge
Altman, R. 1999 *Film/Genre*. London: BFI
Belle-Fortune, B. 2004 *All Crews: Journeys Through Jungle/Drum and Bass Culture*. London: Vision Publishing
Bennett, A. 1999 Subcultures or Neo-tribes? Rethinking the Relationship Between Youth
———— 2001 *Cultures of Popular Music*. Maidenhead: Open University Press
Style and Musical Taste. *Sociology* 33, 3, August, pp. 599–617
Bhatia, V. 1993 *Analysing Genre: Language Use in Professional Settings*. New York: Longman
Brewster, B. and Broughton, F. 1999 *Last Night a DJ Saved My Life: The History of the Disc Jockey*. London: Headline
Collin, M. 1997 *Altered State: The Story of Ecstasy Culture and Acid House*. London: Serpent's Tail

Cosgrove, S. 1988 Seventh City Techno: Dancing in Detroit. In R. Benson (ed.) 1997 *Night Fever: Club Writing in The Face 1980–1997* London and Basingstoke: Boxtree, pp. 93–6

DeFrantz, T. (ed.) 2002 *Dancing Many Drums: Excavations in African American Dance* Madison, WI: University of Wisconsin Press

Derrida, J. 1980 The Law of Genre. Trans. A. Ronell. In *Glyph* 7, Spring, pp. 55–81

Frow, J. 2006 *Genre.* London: Routledge

Garratt, S. 1998 *Adventures in Wonderland: A Decade of Club Culture.* London: Headline

Gilbert, J. and Pearson, E. 1999 *Discographies: Dance Music and the Politics of Sound.* London and New York: Routledge

Hesmondhalgh, D. 2001 British Popular Music and National Identity. In D. Morley and K. Robbins (eds), *British Cultural Studies: Geography, Nationality and Identity.* Oxford: Oxford University Press, pp. 273–86

Huq, R. 2006 *Beyond Subculture: Pop, Youth and Identity in a Post-colonial World.* London: Routledge.

Kallberg, J. 1996 *Chopin at the Boundaries: Sex, History and Musical Genre.* Cambridge, MA: Harvard University Press

Malbon, B. 1999 *Clubbing: Dancing, Ecstasy and Vitality.* London, Routledge

McCready, J. 1989 Did Depeche Mode Detonate House? In R. Benson (ed.) 1997 *Night Fever: Club Writing in The Face 1980–1997.* London and Basingstoke: Boxtree, pp. 98–102

Middleton, J. and Beebe, R. 2002 The Racial Politics of Hybridity and 'Neo-eclecticism' in Contemporary Popular Music. *Popular Music* 21, 2, pp. 159–72

Pini, M. 2001 *Club Cultures and Female Subjectivity: The Move from Home to House.* Basingstoke: Palgrave Macmillan

Redhead, S. (ed.) 1993 *Rave Off: Politics and Deviance in Contemporary Youth Cultures.* Manchester: Manchester University Press

Rietveld, H. 1998 *This Is Our House: House Music, Cultural Spaces and Technology.* Aldershot: Arena.

Reynolds, S. 1998 *Energy Flash: A Journey through Rave Music and Dance Culture.* Basingstoke: Picador.

Rose, T. 1994 *Black Noise: Rap Music and Black Culture in Contemporary America* Hanover, NH: Wesleyan University Press

Thomas, H. 2003 *The Body, Dance and Cultural Theory.* Basingstoke: Palgrave Macmillan

Thornton, S. 1995 *Club Cultures: Music, Media and Subcultural Capital.* Cambridge: Polity Press

Ueno, T. 2003 Unlearning the Raver: Techno-Party as the Contact Zone in Trans-local Formations. In D. Muggleton, and R.Weinzierl (eds), *The Post-Subcultures Reader.* Oxford and New York: Berg, pp. 101–18

Worton, M. and Still, J. 1990 *Intertextuality: Theories and Practices.* Manchester: Manchester University Press

12

Harpies and Pyjamas: the Making of *Heart Thief* (2003)

Deveril

There is no beginning.

Introductory Annotation:
The structure of this chapter may be somewhat unconventional as it attempts to develop a writing style to represent the complexity of the hypertextual and intertextual modes of analysis.

It is made up of theoretical contemplations

and

case study: *Heart Thief* (2003) by Litza Bixler
and Deveril

Personal information is interwoven. For example, I held an informal interview with Litza Bixler in the Café of The Place on Wednesday, 11 July 2007 in order to check that I hadn't forgotten anything.

The processes of watching and analysing a dance piece are complex and require a number of skills in order to make 'sense' (in personal and interpersonal ways) of the work, and the related experiences: the creating, the dancing, the watching, the interpreting, and so on. The background training and sociocultural experiences of a person will direct their interpretations of a dance piece, as they will affect any cultural experience. For example, I can describe what I have seen in a number of ways: as a dancer or as a choreographer or as a writer of

dance. I can adjust my vocabulary to suit the listener and the context. The ways in which we describe the movement will therefore be shaped by our training, expertise and knowledge, experiences and cultural background. A person's 'tastes' and preferences for particular forms of dance are shaped by these experiences, and, as a combination, are unique to every person. The ways in which these experiences play off each other when watching a dance piece form the basis for an interpretation, which takes form when it is expressed (including 'thought') as language, verbal or written.

In 2002 I was engaged on a research project entitled 'Decentring the Dancing Text', (DDT) written by University of Surrey Professors Janet Lansdale and Khurshid Ahmad of the Dance and Computing Departments, respectively, to explore the interface between Intertextuality and Hypertextuality in the interpretation of dance. (In this context the words 'dance' or 'dance piece' referred mostly to a performance that was recorded or specifically created for the screen.)

During this time I was also commissioned by Channel 4 and the Arts Council of England to co-direct a screen dance piece with Litza Bixler (choreographer). The resulting work was entitled *Heart Thief* (2003). It was a short piece (4 minutes and 30 seconds), which drew on a range of influences, stories and texts.

The *Heart Thief* process began in the November of 2002, following a phone call between Litza Bixler and Deveril, in which the former said that she had been asked to submit a treatment for a Channel 4 commission. She stated that she had a vague idea that she wanted to do something about a woman with wings (a recurring image in her work).

The roles of dance analyst and dance film-maker when combined can produce a problematic mixture of theoretical attitudes with artistic actuality; intellectual beliefs and pragmatic responses; informed intuitions about how to make an artistic work, alongside

concerns of how it will be interpreted. It is difficult to unpick these threads and often the concerns of the two roles can create challenges during the creative process.

Sometimes I want to express some metatextual information. The role of personal involvement and the subsequent reflection on that involvement in a creative process form part of the 'argument' of this chapter. There is neither a method nor one tool put forward as being the means by which these processes should be carried out, but instead a demonstration of an analytical process following its theoretical foundations. It is advised that the approaches undertaken favour the denial that there is any *one* way of reading a work of art, or a definitive meaning to be had by uncovering the artist's intention. As François Rastier (1997) and others argue, to find out *one* (or any) intention of the artist or author is conjectural and open to misrepresentation or worse.

In my PhD thesis 'Digital Dialogism: Dance at the Edge of Language' (Deveril, 2002) I used 'there is no beginning' as a refrain, and attempted to construct a non-linear exploration of the processes of writing a thesis about the creative (and self-reflective, self-referencing) processes of choreography, writing and technological mediation of human experience. The resulting sprawling assemblage of texts was intended to allow for associative reading; it problematised the interpretive process rather than described it. But without an argument, a neat narrative, articulated one point to the next, there is perhaps a sense of dissatisfaction in reading such a textual collage. But it is just another kind of book, one that reflects the chaotic multiplicity of the world (and its 'author'): 'a book all the more total for being fragmented' (Deleuze and Guattari, 1987, p. 6).

One thing to note in any analysis of a screen-based dance piece is that it is an end of a process but not always *the* final result. For example, the *Heart Thief* that was aired on Channel 4 (twice in 2003) is different in a number of respects to the version that is now being used by the filmmakers to represent their work, but only in some minor details that do not change the main elements that go to make up the piece.

The DDT project was an investigation into how it might be possible to create a hypertextual system that begins from the analysis of a dance piece, but develops into a web of references, reminiscences, related texts and readers' notes. Restated, a primary aim of this project was to develop a hypertextual model for the intertextual analysis of digitised dance video. The proposal rested on the notion that any analysis of a dance piece is an on-going and open process, producing a continuously evolving set of interpretations and 'meanings', which do not exist in a strictly linear relationship to one another, but can be seen as forming a hermeneutic network.

When I asked Litza at The Place 'Are there new *meanings* you derive from it that you hadn't expected to be there?' she answered that she herself had analysed it so much during the making that it held nothing new for her when she watched it. However, she was often surprised when people had the unexpected response that they found it 'a little bit scary' (particularly the baby doll under the bed). She also suggested that it's difficult to have an emotional reaction to your own films; it's hard to turn off from seeing faults (things that could have been done differently or improved).

A linear argument or narrative (as I have argued before; Deveril, 2002) is a construct that requires a reduction or reshaping of chaos into order. The organisational skills of an academic writer are often finely tuned and well developed; there are techniques that can be learnt and employed. The structure of a work of art is often at odds with this approach, although the processes of creation are similar, even if the result is seemingly random or non-sequential.

For example, the narrative of a film is often constructed from moments that could be said to follow on one after the other in an illogical or chaotic way, yet if the transitions are successfully articulated the moments create an internal logic, and thus a story is told. In an analysis of a chaotic or multifaceted work or text, there are methods of structuring the flow of ideas stemming from the piece and the thinking around it.

Conclusion:
This chapter has intended to demonstrate the process and subsequent analysis of the process of creating a dance film. The difficulties of the intertextual and hypertextual modes of analysis can be understood when an attempt is made to compress the reading and compose a linear analysis. There are many possible nodes and links that could be indicated, many references suggested in the notes, and many personal comments that have different 'voices' and tones—how can all of these things be combined?

In recent years there have been developed various models for semantic, semiotic and hermeneutic analysis of texts. They might focus on the thematic, the structural, the linguistic and the narrative relationships within the text itself or as part of a genre, for example. Textual elements that network and intersect can be difficult to represent or map; any attempt to structure a *phenomenological* response to a text relies predominantly on language and a learnt ability to organise thoughts. Following on from Staten (1984) in his discussion of Derrida and Wittgenstein, I suggest that we acknowledge the influence on thought and interpretive processes of culture and social uses of language and other expressive modes of communication that have led to prior interpretations. If, as Staten suggests, the texts of phenomenology are buried under these previous layers of interpretations, deconstruction is the process of making use of the findings (cf. Foucault's notion of archaeology). This proposed combination of hyper and intertextualities is one way of allowing the opening up of these layers of interpretation.

Oxford English Dictionary Online:

hypertext, n. [NB the OED does not contain an entry for the word 'hypertextuality'.]

Text which does not form a single sequence and which may be read in various orders; spec. text and graphics (usu. in machine-readable form) which are interconnected in such a way that a reader of the material (as displayed at a computer terminal, etc.) can discontinue reading one document at certain points in order to consult other related matter.

1987 PC Week 6 Oct. 69/1 The layout of a magazine or the front page of a newspaper, with sequential text, inset illustrations and boxes, is hypertextual in nature.

intertextuality, n. [ad. F.
intertextualitı (coined by J. Kristeva
1967, in Critique XXIII. 444)]

The need for one text to be read
in the light of its allusions to and
differences from the content
or structure of other texts; the
(allusive) relationship between
esp. literary texts.

[Back-formation f.
*INTERTEXTUALITY n.,
after Fr. intertextuelle (coined
in J. Kristeva Semeiotike (1969)
115).] Denoting literary criticism
which considers a text in the
light of its relation to other
texts; also used of texts so
considered.

The terms 'hypertextual' and 'intertextual' are used here to describe the ways in which culturally-produced items and works (including written texts, other visual texts such as paintings, photographs, films, and aural texts) relate and connect to other cultural 'objects'.

The relationships between many cultural objects are often characterised by terms such as 'genre' or 'style', and these can form the basis for creation and subsequent analysis according to the conventions and defining qualities of a given style. When a work imitates the style or content of another work or genre, it can be said to reference or quote the previous example. This allows both the maker of the new work and the person analysing it the chance to play with what meanings can be derived from a knowledge of and familiarity with different genres and styles, and the ways and contexts in which they have been used in the past. Sometimes this relationship may take the form of pastiche or parody, destabilising the original form and creating a new, often socio-political and critical, set of meanings.

The first research I undertook was into the mythological creatures the Harpies; indeed the title was a corruption of the word Harpy. The early version of how the Harpies were represented was of most interest: as beautiful winged women (wind spirits) whose responsibility was to carry souls to Hades. Later tarnished as brass-clawed robbers and thieves, the Harpies also had the ability to contaminate everything with a strong smell of decay. As I read this mythology it seemed connected with the ballet *Giselle* (a key reference point for Litza, she reminded me) and in particular the Wili characters: 'they are the

embodiments of the spirits of dance-loving brides who died before their wedding day. They perform their ghostly rites... until dawn breaks, when the Wilis must return to their graves' (Koegler, 1977, p.221). We know that Gautier got his idea for the wilis from Heine [Heinrich Heine's 1835 work *De l'Allemagne* after a Slavic legend...] (Puccini's first opera is based on the same legend, in Italian *Le Villi*.) In Serbia they were maidens cursed by God; in Bulgaria they were known as samovily, girls who died before they were baptized; and in Poland they are beautiful young girls floating in the air atoning for frivolous past lives.

Charles, 2001

In *hypertextuality*, connections, known as (hyper)links, can be considered to be the major factor in the defining of something as a 'hypertext'. For example, as Espen J. Aarseth writes: Hypertext, for all its packaging and theories, is an amazingly simple concept. It is merely a direct connection from one position in a text to another. Aarseth in Landow (ed), 1994, p.67

The piece of the film that Litza mentioned to me as being the moment in which 'everything came together' in *Heart Thief* was the baby under the bed.

'Hypertextuality' can be taken as the *state of being* that a 'hypertext' has. A computer user can navigate their way around a series of connections made by the author of the hypertext. However, for the most part these connections do not hold much inherent interest beyond the possibilities of being able to move from one related text to another very quickly. Some hypertexts though do develop strategies for linking and creating networks for reasons other than just allowing the user the chance to go from one piece of text to another, and back again. The kinds of devices used allow the writing of non-linear fictions in which the reader can choose the narrative from the options presented to them; academic articles that wish to make use of a wide range of sources, often allowing the reader to compare and contrast

a number of materials at once; philosophical and theoretical papers which require that the reader be directed to definitions and explanations of terminology; and interpretative analyses of literary texts which can run the text and analysis side by side.

In the case of *intertextuality*, connections can be born at the 'production stage' of a text or when it is 'read' by another person. The concept of intertextuality, to state it in simple terms, suggests that many works of art, or texts as they are known (regardless of form), gain much of their meaning and relevance to people by virtue of these connections. This complex interconnectedness is what can be described by constructing intertextual readings and interpretations of a particular text, drawing in the other texts as the interpreter sees fit. It must be stressed, however, that intertextuality as an approach is not rigidly defined, and it can be viewed as a 'way of seeing' rather than as an authoritative system of analysis. With an emphasis on open-ended interpretations, as opposed to closed, definitive readings, intertextuality also challenges the concept of a *finished* work of art. But this, in practice, is difficult to maintain when each interpretation must be presented in some 'finished' form. Despite this issue, intertextuality has been used to analyse literature, film, music, and latterly, theatre and dance.

In the original treatment for *Heart Thief*, I had written in a golden box (that rises from the sleeping man's chest), which was inspired by John William Waterhouse's picture *Psyche Opening the Golden Box* of 1903. Apuleius' tale of Eros (Cupid) and Psyche is also relevant to the story of *Heart Thief*, except we have reversed the characters' genders. In the myth it is the male, winged Eros who visits Psyche in her bedchamber each night. He forbids her from looking at him, until Psyche goes against the deity's advice and visits him in his bed. Unfortunately the oil lamp Psyche needs to see Eros asleep, drips some oil and awakens the god, who leaves her to contemplate her folly. After upsetting Aphrodite, Psyche is sent into Hell with a golden box to get some beauty from Persephone. Once out of hell, Psyche decides to obtain some beauty for herself, but upon opening the box she is sent into a deep sleep. It is her former lover who saves her from an eternal sleep, and together Eros and Psyche ascend Mount Olympus, where

Zeus grants Psyche immortality. *L'Amour et Psyché, enfants* by William-Adolphe Bouguereau from 1889 represents Psyche as a child with the wings of a butterfly, and Eros has bird's wings; Bouguereau's other paintings of Psyche also give her butterfly wings.

Litza Bixler had made a piece for Resolution at The Place in January 1999 entitled *Only Angels Have Wings* (for which I constructed the sound) in which the concept of human flight was loosely explored. The image of wings has featured in her work before and since.

The notion of butterflies and transformation is also related to this series of images. In *Heart Thief*, Litza suggested, there is a rebirth from a state of grieving and a blurring of life and death, a suspension of living. When the winged woman urges the man to 'open his eyes' he awakes from his period of slumber, he is reanimated and reinvigorated as in *Sleeping Beauty* (albeit not by a kiss, although he is kissed during the dance).

One reason why the intertextual approach may be appropriately represented in a hypertext model is tenuously supported by the claim of 'some hypertext enthusiasts…that hypertext is the most natural way to organize human ideas because its semantic network-like structure matches the human brain' (Nielsen, 1995, p.90); interpreting intertextually allows for the tangential and various thoughts humans have when engaged in any activity. Many writers have been led into theorising the nature of hypertext and how it can be used for practical and critical purposes.

It is frequently linked to concepts of intertextuality and other poststructuralist notions.

This may in part be due to the hypertext principle that in its ideal form allows for a reader to take a number of reading routes through a network of interlinked texts, or fragments of text (and these can include images, sounds and combinations of these)—nodes. (For an example explanation, see Keep, McLaughlin & Parmar, 1995.) Therefore, hypertexts invite and require an active reader, interaction and decision-making. They should allow for the hypertext user to be able to create a new path each time.

Hypertexts are predominantly experienced on computers; Johan Svedjedal gives a broad definition that 'sees hypertext as a certain structural form,

possible to achieve in any medium, but nevertheless best realized when texts are digitized and available in computer networks' (Svedjedal, 1999).

The terms used to describe the structure of hypertexts are often borrowed from literary criticism discourses, yet hypertext is seen most regularly as, in a way, the opposite to traditional literary works. If traditional works are defined as linear or monosequential, then hypertexts 'may be called non-linear, multilinear, multisequential, or multicursal' (Svedjedal 1999); they invite and require an active reader, interaction and decision making.

They may allow for the hypertext user to be able to create a new path each time. A number of writers make connections between the principles of hypertext and what Aarseth calls 'ergodic literature' and 'cybertext' (Aarseth, 1997).

In Aarseth's overview of cybertexts, hypertext is a *type* of digital ergodic text, with a (mostly) distinctive set of characteristics, born out of the original conceptualisations of the form. The number of literary and critical hypertexts is growing. See, for example, John Cayley's *Hypertext/Cybertext/Poetext* (1996) and Talan Memmott's *Lexia to Perplexia: Hypermediation/Ideoscope* (2000).

OED Online: ergodic: Of a trajectory in a confined portion of space: having the property that in the limit all points of the space will be included in the trajectory with equal frequency. Of a stochastic process: having the property that the probability of any state can be estimated from a single sufficiently extensive realization, independently of initial conditions; statistically stationary. Also, of or pertaining to this property.

The Internet has also already been used to analyse such texts as a key section of the film *Singin' in the Rain* (1956). In this academic hypertext the analysts incorporate QuickTime movies of the piece into what they describe as 'not so much an essay as a *text* in the deepest sense: a fabric of ideas deeply and multiply connected' (Miles, 1998; original emphasis); a collection of linked theoretical and interpretive nodes.

Another inspiration (for me) was *The Depository: A dream book* by Andrzej Klimowski (1994). This book doesn't contain words, but a series of almost two hundred and fifty drawings in heavy black. The surreal narrative is a writer's dream containing book-winged spirits and a collector who imprisons them:

> *A wordless novel, The Depository is open to many interpretations—political, sexual, psychological. Looking through Klimowski's powerful drawings many readers will recognize a visual analysis of the power of human possession and domination that is unsettling and unforgettable.*
> *Klimowski, 1994,*
> *Back cover*

> *Wittily subversive and sexy, Klimowski's challenging imagery often draws on Polish mythologies surrounding angels and demons.*
> *Anon, Undated*

The importance and relevance of dream symbolism and structures was also the key to some of the choices in the film *Heart Thief*. It has been argued (for example by Potter, 1990) that films and dreams share similarities such as time compression, symbolism and associative connotations.

At The Place, Litza suggested that we remained clear in our choice of genre, being a surrealist dance film. We created an on-screen phantasy world. This allowed us to play with unnatural elements (self-opening draws and dancing screws, rapid re- or de-composition and decay) often achieved through stop-motion animation. The inclusion of various references became more open at this stage.

Bakhtin's concept of dialogism and other theories of analysing texts are a basis for describing some of the principles possibly at work here (Kristeva, who coined the term 'intertextual' in 1969, was influenced by Bakhtin). In his work on discourse in the novel, Bakhtin provides the foundations for looking at aesthetic and creative discourses in both social and subjective ways; it rests on language use and the notion that dialogue (in all its diverse forms) is the basis for understanding and expressing existence (co-being without metaphysical or spiritual overtones) and meaning creation.

The concept of heteroglossia is fundamental to this notion of intertextuality:

The novel orchestrates all its themes [...] by means of the social diversity of speech types [*raznorečie*] [...] Authorial speech, the speeches of narrators, inserted genres, the speech of characters are merely those fundamental compositional unities with whose help heteroglossia [*raznorečie*] can enter the novel; each of them permits a multiplicity of social voices and a wide variety of their links and interrelationships (always more or less dialogized). These distinctive links and interrelationships between utterances and languages, this movement of the theme through different languages and speech types, its dispersion into the rivulets and droplets of social heteroglossia, its

dialogization—this is the basic distinguishing feature of the stylistics of the novel.

Bakhtin, 1981, p. 26

Just as intertextuality can be viewed as a form (or re-definition) of heteroglossia so can hypertextuality:

Linda Flower (1994) sees Bakhtin's notion of heteroglossia as giving "a vivid image of how a cognitive network—the construct of an individual mind—is at the same time an intensely social representation andhow the construction of meaning for a text can be an ongoing negotiation with the 'presence' of other voices" (p. 98). Hypertext makes this cognitive "network" a form of real communication by making it accessible to others, externalizing the associative paths of links and nodes as computer-mediated

links and lexia. Because constructive hypertexts can be annotated and expanded, each lexia is in fact part of a heteroglossic network, and through the act of linking, each lexia is "interanimated," or juxtaposed with every other lexia. We no longer need to imagine "how knowledge might function as a voiced, intentional speech act (what Bakhtin refers to ... as the Word)" (Flower, 1994, p. 99)— we can enact it as such.

Eyman, Undated

In The Place, Litza recollected that our initial intention for the piece was to make something unusual, a nice looking film with an easy and open narrative from which everybody could take something.

We wanted many of the elements of the design to have similar juxtapositions of the artificial or produced and the natural. This even ran through the sound design, which I undertook both prior to the choreography and shooting and during the edit process. Music was a starting point for much of the piece (Litza recalled the soundtrack for *Talk to Her* (*Hable con ella*), the 2002 film written and directed by Pedro Almodóvar, being a key inspiration, particularly the emotional qualities of the music) and it led many of the choreographic decisions.

A hypertext is a non-hierarchical form of description, allowing any person the opportunity to state their opinions in a forum that allows collaboration and multiplicity. The importance of adaptable or extensible hypertextuality (what Eyman calls 'constructive', and what has elsewhere been referred to as 'associative writing', for example) is that it allows for and demonstrates the open-endedness of dance pieces, in terms of 'meaning' and 'interpretation'. These concepts are played with and explored practically as users of hypertexts watch and respond to dance texts and to the responses of others who have contributed to the hypertext before; for example, the dance pieces may already have comments on them by their makers (the choreographers, directors, performers, composers, etc.) giving contextual and background information on sources, references, intentions and after-thoughts on the piece and its creation. This is not to be considered the definitive reading of a piece, merely another layer of material that could be incorporated into an individual interpretation.

An inspiration for the baby doll under the bed in
Heart Thief was Jan Svankmajer's film *Otesánek*
(2000; also called *Little Otik*), which contains a baby
made from the root of a tree. He starts as a model
of a baby for a woman who wants children, and
her obsessive love for him transforms him into an
animated living and growing being with an insatiable
(and murderous) appetite.

The baby doll that crawls from underneath the bed in Heart Thief is not meant to be scary, but the commissioning producer at Channel 4 questioned its inclusion in the final edit (saying that she found it unsettling). I had to persuade her of the reasons why it should be in the film. As Litza said to me, there is something about dolls that scares people and in horror films this signifier is often used. But for Litza, the baby represented the man's child self, but it is mixed up with the fears of childhood such as the monster under the bed. The stick legs made from natural wood also tie in with the idea of development and growth. The strange baby doll represents in part, for me, the nature-nurture debate.

Throughout the film, nature and human-made artefacts exist side-by-side, and almost symbiotically. The woman with the wings comes from the earth, and returns there. She brings with her natural elements into the house's interior (animals, ivy, water, and leaves). Her dance contains movements relating to a baby (a cradling in the arms of an imaginary child); maybe the implication is of a lost child, and the baby under the bed represents this loss. On her dress we clearly see the face of a doll and hear the noise of a baby. She is maternal; Mother Nature incarnate. As she enters the bedroom, she communes with a few real butterflies, as the sound of their wings is heard amplified, although it was actually the pages of a book being flicked through.

To offer an analysis, an
interpretation of a work is to
describe it in a variety of
ways. But this (process of)
description, or as it could be
termed a (personal) dialogic
encounter,

is to layer words on words;
to locate the text in various

historical, theoretical, and generic contexts; to complicate understanding; to read the text in relation to all other texts written in that genre; to disrupt the pragmatic frame; and to find words to name and evoke the writer's expressive choices within that genre.

Himley, 1991, p.12

Elsewhere in this book, Janet Lansdale states that one of her concerns 'is manifest in the making of dances, in the sense of how their elements are chosen, how structuring methods are devised, and how these might be analysed'. This is true in this chapter too, with the emphasis being on the latter part of the concern: the analysis of these elements. When confronted by the range of materials and thoughts made through an artistic experience, the issue becomes a matter of prioritisation based on subjective aims.

When the winged woman (played by Litza) animates the sleeping man, we hear some text that Litza wrote (in the style of a Victorian Love Letter) and spoke herself:

If one is out in the country, where there is silence and stars, winter can be very magical. Does it snow where you are? Where I come from, it snows all through the winter and spring. Sometimes it is so cold, your words freeze and then fall from your lips like black splinters of coal. Imagine being able to collect a pile of frozen words after you have spoken them. Would you be tempted to take them back? [To warm them with your breath and then swallow them whole like eels. Or perhaps, save them in a box with other sentimental trinkets.]

When I watch a piece of dance, on stage or on screen, I have not much time to form a satisfactorily 'analytical' response. But what response(s) do I have to offer? What I think (and feel, 'emotionally' and 'physically') as I watch a dance piece can range from boredom and an unknowing, uncertainty as to what I am watching, to what we might call 'understanding'. During the piece certain movements may inspire in the body (my body) a similar movement; or I may 'know' what it feels like to do such a movement. A similar thing happens to me when I watch a football match on television: my leg will 'kick' at the same time as the striker. (Is it related to 'mirror neurons'? Does there exist a kind of physical or experiential intertextuality?) Also, I may recognise certain movements as being characteristic of the dancer or choreographer,

part of a technique or movement vocabulary, or as a reference (deliberate or incidental) to another dance piece, or a gestural pattern from 'everyday' action.

As well as music *Heart Thief* had spoken (or sung) text in the soundtrack. The nursery rhyme 'Jack Sprat could eat no fat...' was present over an early piece of choreography. There are disputed origins of the nursery rhyme and therefore disputed meanings, but are they relevant? At which point does intertextuality get in the way of interpretation and personal resonances?

As far as I can remember we wanted a children's song that wasn't already too loaded or clichéd (if there is such a thing).

We are led to the question: what is the role of the body in 'interpreting' dance? George Lakoff suggests that many words and metaphors used in describing the experiences of human beings come from the body. Lakoff has stated that:

> The conceptual and inferential system for reasoning about bodily movements can be performed by neural models that can model both motor control and inference. Abstract concepts are largely metaphorical, based on metaphors that make use of our sensory-motor capacities to perform abstract inferences. Thus, abstract reason, on a large scale, appears to arise from the body. [... These results] require us to recognize the role of the body and brain in human reason and language. They thus run contrary to any notion of a disembodied mind.
> Lakoff in Brockman & Lakoff, 1999

This has ramifications for the ways in which we understand the language derived from interpretive processes: 'It might be argued that the [language-based] texts are the artefacts of cognitive and communicative processes, such that the relationship between image and text corresponds in some sense to the link between vision and language' (Salway, 1999, p. 3). I have previously suggested that when we watch dance, before it can be analysed for meaning it is 'translated' into language, but what we get most from dance is that which is non-linguistic.

In addition to psycho-physical responses, there are a range of things that can be considered as responses to a dance piece: other dance pieces and selected movements or gestures, pictures, sounds—many of which cannot be adequately described in words and necessitate the actual experience of 'experiencing' them. A written paper for example can direct the reader to such intertexts and references, and maybe even include some still images or written descriptions, but that is the total of the possibilities (unless extra materials are somehow attached to the paper).

In a hypertext system there is scope for the inclusion of a large number of possible references—language-based or not. A hypertext system not only enables further interpretation, but also actively encourages and prompts it. That such a system is *open* and lacking closure is of major importance; so it is that each interpretation is never finished and provocative, beckoning more and more layers of material that can be used in constructing a range of interpretations, or readings, or 'reading trails' perhaps. It can be suggested that utilising digital hypertexts and writing methods akin to hypertext, any hierarchical structure of interpretation gives way to a 'decentred' complex of meanings and interrelated texts.

At the end of *Heart Thief*, when the winged woman has returned to the earth, leaving behind a pile of shredded cloth and mementoes blowing in the wind, Litza Bixler's voice can be heard singing 'And still my heart has wings, these foolish things, remind me of you'. The jazz standard *These Foolish Things* dates back to 1936, and for us this was important to adding to the sense of (so-called) timelessness we wanted to portray in our film.

The term 'decentering' has a polysemous relationship to a number of disciplines and approaches, notably (post)structuralist analysis and intertextuality, hypertext theory, literary theories of the subject and author and certain psychoanalytical conceptualisations of the self.

According to Adshead-Lansdale (2003), 'decentring' also has a connection to the dance performances of choreographers such as Cunningham who removed the actual and metaphorical centre of the dance, for example, by allowing the audience to chose their own focus through presenting a number of actions on stage.

In hypertext theory, George Landow (1997) aligns the way in which hypertext allows us to navigate our own paths through it, thereby destabilising the concepts of reader and writer, with the Derridean suggestion that we live in a decentred world in which norms are replaced by relativity.

Deleuze and Guattari in their discussion 'Of the Refrain', refer to consistency and a rhizomatic schema:

> The philosopher Eugène Dupréel proposed a theory of *consolidation*; he demonstrated that life went not from a center to an exteriority but from an exterior to an interior... there is no beginning from which a linear sequence would derive, but rather densifications, intensifications, reinforcements, injections, showerings... the beginning always begins in-between, intermezzo.
> Deleuze & Guattari, 1988, pp.328–9 (emphasis in original)

Within the *Heart Thief* soundtrack are incorporated some old and original pieces of text. The principal aural motif for the piece was derived from a heavily deconstructed (that is, distorted) fragment of a part of the *Giselle* score. We discovered that digitally manipulating just a few seconds worth of sound could produce a wide range of aural elements, samples, which can be constructed into another score. From this reworked score, a refrain was determined. This was then recorded using a piano and digital instruments. It accompanies the movements of the main character, as though she herself is an instrument (in the original notes it was the sound of a bird that emanated from her joints).

This chapter examines the complexity of dance text analysis in the digital realms. It includes work on how to represent and map the interpretive and creative experiences. Networked and expert systems can be utilised to create open hypertexts of meanings and responses, with semantic webs and other methods of linked nodular referencing providing another layer of decentred analysis. The notion of the analytical artist is raised, along with the pros and cons of the artist writing about their own work; the 'value' of knowing what the artist thought and felt while making the work. These could include influences and approaches to generating material. Using hypertextuality and intertextuality (after Bakhtin) as theoretical and practical tools, the relevance of informatics approaches are explained and demonstrated through a deconstruction of the writer's own work as a dance filmmaker and analyst of dance texts.

There is no ending.

References

Aarseth, E. J. 1997 *Cybertext: Perspectives on Ergodic Literature*. Baltimore, MD: Johns Hopkins University Press, Introduction: Ergodic Literature http://www. hf.uib.no/cybertext/Ergodic.html Accessed 7 July 2007

Adshead-Lansdale, J. (ed.) 1999 *Dancing Texts: Intertextuality in Interpretation*. London: Dance Books

——— 2003 *DeCentering the Dancing Text*. http://www.surrey.ac.uk/Dance/Research/DDT/decentering_the_dancing_text.htm. Accessed 7 July 2007

Anon. nd Andrzej Klimowski: Senior Tutor Illustration. http://www.rca.ac.uk/pages/research/andrzej_klimowski_441.html. Accessed 7 July 2007

Bakhtin, M. M. 1981 *The Dialogic Imagination*. Austin, TX: University of Texas Press

Barthes, R. 1977 The Death of the Author. In *Image Music Text*, London: Fontana Press, pp.142–8. Reproduced in D. Lodge (ed.) 1988 *Modern Criticism and Theory: A Reader*. Harlow: Longman, pp. 167–72

——— 1988 Introduction and Conclusion to 'Textual Analysis: Poe's "Valdemar"'. in D. Lodge (ed.), *Modern Criticism and Theory: A Reader*. Harlow: Longman, pp. 172–5 and 191–4

Brockman, J. and Lakoff, G. 1999 *'Philosophy in the Flesh': A Talk With George Lakoff* [3 September 1999]. http://www.edge.org/3rd_culture/lakoff/lakoff_p4.html. Accessed 6 July 2007

Cayley, J. 1996 *Hypertext/Cybertext/Poetext*. http://www.shadoof.net/in/hcp000.html. Accessed 7 July 2007

Charles, G. 2001 *Giselle*. BalletMet Columbus http://www.balletmet.org/Notes/Giselle.html. Accessed 6 July 2007

Deleuze, G. and Guattari, F. 1987 *A Thousand Plateaus: Capitalism and Schizophrenia*. London: Athlone Press

Derrida, J. 1973 'Difference', *Speech and Phenomena.* Trans. David B. Allison. Evanston, IL: Northwestern University Press

Deveril 2002 Digital Dialogism: Dance at the Edge of Language. Unpublished PhD Thesis, University of Surrey

Eco, U. 1988 Casablanca: Cult Movies and Intertextual Collage. In D. Lodge (ed.), *Modern Criticism and Theory: A Reader.* Harlow: Longman, pp. 446–55

Eyman, D. nd *Hypertext And/As Collaboration.* http://english.ttu.edu/kairos/1.2/features/eyman/hetero.html. Accessed 7 July 2007

Flower, L. 1994 *The Construction of Negotiated Meaning: A Social Cognitive Theory of Writing.* Carbondale, IL: Southern Illinois University Press

Himley, M. 1991 *Shared Territory: Understanding Children's Writing as Works.* Oxford: Oxford University Press

Keep, C., McLaughlin, T. and Parmar, R. 1995 *Node.* http://www3.iath.virginia.edu/elab/hfl0046.html. Accessed 7 July 2007

Klimowski, A. 1994 *The Depository: A Dream Book.* London: Faber and Faber

Koegler, H. 1977 *The Concise Oxford Dictionary of Ballet.* Oxford: Oxford University Press

Kristeva, J. 1980 *Desire in Language: A Semiotic Approach to Literature and Art.* Oxford: Blackwell

Lacan, J. 1977 *Ecrits: A Selection.* Trans. A. Sheridan. London: Tavistock/ Routledge.

—— 1998 *The Four Fundamental Concepts of Psycho-analysis.* London: Vintage

Landow, G. (ed.) 1994 *Hyper/Text/Theory.* Baltimore, MD: Johns Hopkins University Press

Landow, G. (ed.) 1997 *Hypertext 2.0.* Baltimore, MD: Johns Hopkins University Press

Memmott, T. 2000 *Lexia to Perplexia: Hypermediation/Ideoscope.* http://trace.ntu.ac.uk/newmedia/lexia/index.htm. Accessed 7 July 2007

Miles, A. 1998 *Singin' in the Rain: a hypertextual analysis.* http://hypertext.rmit.edu.au/singing/. Accessed 7 July 2007. First published in *Postmodern Culture* 8, 2, 1998

Nielson, J. 1995 *Multmimedia and Hypertext: the Internet and Beyond* London: Academic Press

Potter, C. 1990 *Image, Sound and Story: The Art of Telling in Film.* London: Secker & Warburg

Rastier, F. 1997 *Meaning and Textuality.* Toronto: University of Toronto Press

Salway, A. 1993 Video annotation: the role of the specialist text Unpublished PhD thesis, University of Surrey

Staten, H. 1984 *Wittgenstein and Derrida.* Lincoln, NB and London: University of Nebraska Press

Svedjedal, J. 1999 A Note on the Concept of 'Hypertext'. http://www.hb.se/bhs/ith/3-99/js.htm. Accessed 7 July 2007

Wittgenstein, L. 1953 *Philosophical Investigations.* Oxford: Blackwell

—— 1958 *The Blue and Brown Books.* Oxford: Blackwell

Index